P9-CQK-378

MEDIApedia

CREATIVE TOOLS AND TECHNIQUES FOR CAMERA, COMPUTER, AND BEYOND

**Digital Photography • Image Editing • Type and Layout Illustration
Slide Shows • Display and Distribution • Project Ideas**

KIT LAYBOURNE

KNACK™
MAKE IT EASY

Guilford, Connecticut
An imprint of The Globe Pequot Press

To buy books in quantity for corporate use or incentives, call **(800) 962–0973** or e-mail **premiums@GlobePequot.com.**

Copyright © 2009 by Kit Laybourne

ALL RIGHTS RESERVED. No part of this book may be reproduced or transmitted in any form by any means, electronic or mechanical, including photocopying and recording, or by any information storage and retrieval system, except as may be expressly permitted in writing from the publisher. Requests for permission should be addressed to The Globe Pequot Press, Attn: Rights and Permissions Department, P. O. Box 480, Guilford, CT 06437.

Knack is a registered trademark of Morris Publishing Group, LLC, and is used with express permission.

Mediapedia™ is a trademark of Kit Laybourne.

The author thanks Vichai Chinalai for the use of his image on pages 2, 92, and 172.

Designed by Karla Baker

Library of Congress Cataloging-in-Publication Data is available on file.

ISBN 978-1-59921-401-6

Printed in China

10 9 8 7 6 5 4 3 2 1

To

Emmy and Sam

so gifted creatively
and with the chops to match.

acknowledgments vi
introduction
CREATIVITY AND COMPUTERS VIII

PART I:
the photographic image 3

chapter 1
DIGITAL PHOTOGRAPHY 8

THE CAMERA 9
KINDS OF PHOTOGRAPHY 14
PIXELS 18
LIGHT 22
POINT OF VIEW 26
LENS CHOICE 28
EXPOSURE 30
FRAMING 34
COMPOSITION 38
FOCUS AND DEPTH OF FIELD 40
BLUR 43
COLOR VS. BLACK AND WHITE 46
LIGHTING SETUPS 49
APPLICATIONS AND FILE FORMATS 52
PLAYING AROUND: PORTRAITURE 56

chapter 2
IMAGE EDITING 58

COMPOSITING IMAGES 60
RESOLUTION AND RESIZING 62
SELECTING PARTS OF PICTURES 66
GLOBAL MANIPULATIONS 69
COLOR AND BRIGHTNESS 71

LAYERS 75
EDGE TREATMENTS 77
DOCTORING 80
FILTERS 83
COMPRESSION 84
APPLICATIONS AND FILE FORMATS 86
PLAYING AROUND: PHOTOSHOP MAKEOVERS 90

PART II:
the page 93

chapter 3
TYPE AND LAYOUT 98

TEXT 100
LETTERS 102
TYPOGRAPHY 106
STRUCTURE 112
COMPOSITION 114
LAYOUT 122
APPLICATIONS AND FILE FORMATS 127
PLAYING AROUND: A GARISH SCREEN SAVER 130

chapter 4
ILLUSTRATION 132

BITMAPS VS. VECTORS 134
KINDS OF ILLUSTRATION 136
DRAWING CONVENTIONS 140
INPUTTING 146
VECTOR-BASED ILLUSTRATION 148
ANCHORS, HANDLES, PATHS, AND STROKES 150
WHEN TO USE WHICH TOOL 153

TRACING WITH ILLUSTRATOR 156

FILLS 158

SCALING AND MANIPULATIONS 160

SPECIAL EFFECTS 162

MANIPULATING TYPE AND TEXT 166

APPLICATIONS AND FILE FORMATS 168

PLAYING AROUND: ALTER EGO AVATARS 170

PART III:
sharing your work 173

chapter 5
SLIDE SHOWS 178

TYPES OF SLIDE SHOWS 181

SCREEN STRUCTURE 189

TIMING AND RHYTHM 194

IN-FRAME MOVEMENT 196

TRANSITIONS 197

SCREEN GRAPHICS 198

AUDIO 200

APPLICATIONS AND FILE FORMATS 203

PLAYING AROUND: A PARK IN FOUR MODES 208

chapter 6
DISPLAY AND DISTRIBUTION 210

DESKTOP PRINTING 211

SERVICES OUTSIDE THE HOME 214

ONLINE STORAGE, GALLERIES, AND PUBLISHING 216

SOCIAL NETWORKS, WEB SITES, BLOGS, AND WIKIS 219

CDS, CD-ROMS, AND DVDS 222

SWAG 225

FILE NAMING PROTOCOL 226

APPLICATIONS AND FILE FORMATS 228

PLAYING AROUND: TIME CAPSULE 232

chapter 7
PROJECT IDEAS 234

ROGUES' GALLERY 236

DESIGN A FONT 240

GONE BUT NOT FORGOTTEN 244

BINDING RELATIONSHIPS 248

PATTERN IN SPACE 252

LANDSCAPE TWEAKS 256

BLOGGING 260

COLLABORATIVE COOKBOOK 264

WEBISODES 268

DIGITAL STORYTELLING 272

Resources: further reading and recommended web sites 278

index 286

ACKNOWLEDGMENTS

As a producer, teacher, and someone fascinated by new media, I am indebted to many colleague pools. The academic world has taught me about film and media forms and I am indebted to mentors Howard Suber at UCLA, John Culkin at the Center for Understanding Media, and my fellow teachers in the MA Program in Media Studies at The New School with particular thanks to Elizabeth Ellsworth, Peter Haratonik, and Carol Wilder.

For me, the deepest knowledge comes through the hands and eyes. In my career as a producer I was tutored by many friends. Mickey Lemle polished my film chops. Eli Noyes embodied an unusual combination of creative characteristics and showed me the discipline of design and many nuances of art direction and animation. Kathleen Minton enabled my work as a director and together we charted some unexplored areas of production. Great work comes from great clients. I have had many of them in my years as an independent producer. I thank them for paying me to learn. At Oxygen Media, where I completed my career as an Executive Producer and Director, I am indebted to Geoff Darby, Debbie Beece, Julina Tatlock, and many more.

My go-to guys in this project number three. All started out as my students, have become colleagues and without their help I could not have completed this volume. Perri Chinalai has been a true and multi-talented companion. She wrangled all the pictures and permissions, researched the Digital Photography chapter and built out the companion site, mediapedia.net. Jamie Kruse built the on-line lexicon that preceded this volume and researched the Illustration chapter. I pulled an all-nighter (my last, I hope) with Carolina Correa as we completed screen grabs incorporating my handwritten call-outs. Carolina researched the Display and Distribution chapter.

Other student and designer friends who made substantial contributions include Heather Ben-Zvi, Jeff Ertz, Kate Garafus, Eduardo Garcia, Karl Mendonca, Vanessa Pappas, Sara Greenberger Rafferty, and Jaime Daniel Rojas.

A book about personal media should show personal media. Lots of effort went into securing publishing permissions for photographs covered

by a Creative Commons copyright. I leaned heavily on my friends, family, and students. I thank them deeply for allowing me to share their personal media: Ivan Becerra, Jonathan Berger, Todd Calvert, Chad Chinalai, Stuart Dworeck, Jesse Epstein, John Hall, Carolina Kroon, Emmy Laybourne, Sam Laybourne, Justin Liborio, Kohn Liu, Joe Maidenberg, Daniel Meadows, Stephen Nguyen, Cindy Ryley, Terri Scheinzeit, Julina Tatlock, Amanda Tinio, Amani Willett, and James Wood.

A special thanks to these very accomplished and well-known media designers and authors who have graciously let me sample their work: Burt Dodson, Peter Hastings, David Kelley, Ellen Lupton, John Maeda, Robert McKim, Paula Scher, and Christian Leborg.

There have been two key advocates for this book. Jeremy Katz, my agent, helped shape and protect what we hope will become a line of books under the Mediapedia trademark. At The Globe Pequot Press, Maureen Graney,

editor in chief, helped me understand how my subject was as much about creativity as about terms and techniques. Maureen made many important suggestions and kept me targeted on a general readership.

Karla Baker did the design for Mediapedia. Her work demonstrates the power of type and layout to bring simplicity and clarity to a complex topic, and to speed the reader towards pay dirt. Casey Shain did a great job with the book's layout. Lisa Nanamaker and Jenn Taber ably handled production.

A couple of years ago my wife concluded a keynote address to a live audience of 5,000 administrators from China National Youth Palace Association (the country's afterschool clubs) by saying, "Civilizations are not remembered by their test scores, but by their art." Geraldine Laybourne has championed my work as a media artist, that of our kids, and that of hundreds of media creators through her career as a TV executive. On behalf of all, I herewith thank Gerry.

CREATIVITY AND COMPUTERS

At first look, Mediapedia will seem to be about digital photography—or about computers. While both are certainly true, there is a deeper hook. This is a book about creativity.

This is a book for people who have a computer and a camera and want to take their work to the next level. I characterize this work as personal media.

The practitioners of personal media—you—take levels of creative expression beyond that of a casual hobbyist. Personal media pushes past snapshots, past the routine tasks of desktop publishing. Personal media transforms the power of the digital tool set into original, inventive, and nuanced communications. Personal media yields works that are worth sharing with more than just one or two people.

As a young producer of TV and animation, I often felt disappointed by the waves of big media fashion that rolled into vogue—and disappeared quickly. When a fresh idea came along, it was immediately copied. And recopied. Within the industry it was surprisingly hard to find an original creative voice. The best stuff—fresh, authentic, memorable—was coming from outsiders. And so it was that early in my career I began seeking out media expressions that were "below the radar." I've been using the phrase *Personal Media* to identify those who are creating today with clear, fresh voices and who have cleverly innovated in how they share their work with others.

To me, an unabashed lover of original creative voices who has been encouraging the development of young people for decades, this is one very cool time to be on the planet. Tools have never been so accessible. Distribution never so open. Outsiders are now insiders. Their ranks are swelling. All I want to do is throw a little more gas on the fire.

ARE YOU BIPOD BIASED?

Just as you can't open a door if you don't know it exists, there are words and associated ideas that, once you understand them, unlock creativity. Let me show you what I mean.

If you study large numbers of photographs, it becomes clear that most pictures are taken from a location between four-and-a-half and five-and-a-half feet above the ground. There is an awkward technical name for this: bipod bias. The phrase references the fact

that human beings move around on two feet. Okay. Duh. But learning this term may turn on a light bulb about a certain sameness in the photos you shoot. Next time you are out and about with your camera, your awareness of this new phrase may prompt you to try climbing up on something and shooting down. Or stretching out on your belly to get a fresh point of view. Knowing the term *bipod bias* may inspire you to try a few new things to avoid it.

I like to think this book will end up sitting beside your computer as a resource you can turn to again and again for a fresh point of view. The volume takes the form of a highly illustrated lexicon of media terms. But it is more than just a dictionary. Read the text about any single term and you will get a chunk of new knowledge that deepens your enjoyment. Photographs and illustrations are an integral part of the definitions. You will also get a shot of inspiration by seeing what other personal media makers have done.

MENUS AS MUSES

When I run into a creative snag while working on my Mac, I often lift my cursor to the menu bar that runs across the top of the screen. A list pops up. Or rather, it pops down. And there before me is a majestic list of options. Often the primary choices have nested submenus—right where and when I need them. No long passages to read. No indexes to scour. Just choices, delivered in the context that prompted the initial search.

Think of *Mediapedia* as one giant pull-down menu with 327 entries you can use in making personal media. I love lists, and I also love having choices. That's what pull-down menus do, and that's why there are so many illustrations and examples in this book. Creative choices are best made by considering variations.

THE ULTIMATE SANDBOX

Mediapedia will try to seduce you with suggested sample projects. Each chapter ends with a spread called "Playing Around," an informal activity that puts some of the chapter's content into action. These sections are fun to read, but I hope you will actually be inspired enough to try a few of them. The last chapter in the book is all projects. Here you will find ten

ideas that pull together lots of things you've read about in the book. You can do the projects as described, or use just a part to jump-start your own work. All the project ideas in Chapter 7 have passed my "this-has-got-to-be-fun" test.

WHO THIS BOOK IS FOR

I've tailored this volume for people who, like me, enjoy doing things and making things. We're impatient with instructions. We know that experimentation is the best way to learn about a new piece of gear or a new computer application. But we're not necessarily techies, or graduate students, or even designers or artists. The book assumes no prior knowledge.

My sister Cindy, sixty-eight, is a really good cook. She lives in Ottawa, where she ran a high-end catering company for a number of years. Together with my computer savvy niece, Cindy has a wiki site where she prods family members to pool their favorite recipes (you can read more about this in Chapter 7). Cindy then cooks these recipes with her Cordon Bleu training and then snaps a photo. The photos and recipes go on the wiki, but she's also producing a nicely bound book that my sister will distribute—soon, I hope—through one of the online publishing sites.

My daughter Emmy, thirty-six, is taking care of two kids—a four-year-old daughter and a one-year-old son. Emmy lives in Los Angeles, where she had a very good run as an improviser and actor in TV and a couple of feature films. When her daughter was born, Emmy started a masters in fine arts screenwriting program at UCLA. Emmy is a natural designer who compiles annual calendars that reprise a year of her kids' unruly cuteness and has them printed in small quantities for distribution to those of us who can't get enough. Recently Emmy has begun to capture short movies on the same subject. She structures them with droll references to famous movie scenes. Emmy's movie-making ventures are heading toward a series of more ambitious comedy Webisodes about a character she invented during her improv days. She'll get more ideas about making Webisodes in Chapter 7.

This book is going to be a big help as Cindy and Emmy take on new and different projects involving digital image making. My daughter embraces the media as a second language while my sister, my peers, and I feel we are mastering a foreign language.

My students, on the other hand, are native speakers of the new media. I teach in a graduate program at The

New School in New York City, and this book is also for my students. They are a highly motivated, adept, and fearless group. I always learn a lot from them. But because they have learned by osmosis, there are usually big gaps in their knowledge. I know this book can fill some of those gaps.

I wrote this book because I like figuring out how things work and because I'm in love with design. Also, I like teaching. As an undergraduate and graduate student I taught "disadvantaged" kids about photography and filmmaking. It was exhilarating to try to stay half a step in front of them.

So it seems that my bent for explaining how media forms work has been baked in from the start. My early teaching led to a book about animation that has gone on to become a standard text where animation is taught. *The Animation Book,* like parts of *Mediapedia,* started out as a set of handouts for my classes.

YOU CAN JUMP IN ANYWHERE

Flip through *Mediapedia* until you find something you are familiar with. Read a page or two and quickly get the rhythm of how the definitions, illustrations, and main text work together.

Mediapedia is divided into three parts: The Photographic Image, The Page, and Sharing Your Work. Each begins with a short essay that offers perspective. These introductions attempt to offer an abstract, more theoretical framework for the very concrete substance of the chapters themselves. The essays reference ideas from some key thinkers whose works you'll find in the Resources section at the end of the volume.

The seven chapters move quickly through Topics and Terms.

The topics are the large units of digital design awareness. There are sixty-plus of these, as you'll find in the index.

The terms are subdivisions that call out specific creative elements. The distinctions I draw provide the working handles needed in personal media making.

I have arranged both topics and terms not in alphabetical order, but with a sequence that mirrors how you are apt to encounter design elements as you expand your creative repertoire.

There is a companion Web site, Mediapedia.net, that uses the Web to do what the Web does best—to link, update, and stream rich media. The site will contain annotated references for my top recommended books, Web sites, organizations, and the like. But I am also setting up the site so it will

be easy for readers and site users to send in good links that they come upon. I also hope that folks will e-mail me samples of their projects and I will post what I can.

When you go into a bookstore, you find shelf after shelf of volumes about computers and photography and design. There's lots of how-to. But there is almost nothing about the creativity and the aesthetics of media making. And that's the trouble with how-to books in general: They give you examples of what and lots of ways for how, but seldom enough of why. They instruct but rarely inspire.

Mediapedia is a "why to" book, not a "how-to" book. Step-by-step tutorials and exhaustive case studies are terrific when you know what you want to make and are ready to narrow your focus. These pages are about showing you creative options. They are about widening your vision so that you know what's possible.

GO EASY

I want to take the hand of those who are skittish about this new digital world. As a sixty-five-year-old who has had his own wrestling matches with the world of the computer, let me offer some chicken soup for the digital terrors.

Allow for a learning curve. The first time through, anything takes much, much longer. When you sit down with a new application, figure that no real work is going to get done for quite some time.

Frustration is self-defeating. There is a point when enough is enough. If you have been working hard and have reached your limit, then simply stop where you are. Take a walk. Share your frustration with a friend. Trust your subconscious to wrestle with the problem while you direct attention elsewhere. When you return to the problem a few hours or days later, there will be a new perspective waiting.

Find the right learning aids. The Resources section at the back of the book will cite a few recommendations for books, for online help, and for organizations that can be a big help. Equally important is finding a community with shared interests.

Cheat sheets will keep you alive and well. Keep a notebook where you can jot down the protocols you use with a new application or piece of gear. Making notes helps me absorb the information better. I rarely check my own notes, but writing them makes me learn faster.

It's use it or lose it with the complex applications of computer graphics. Don't be surprised when you return to a software program after some weeks or months away only to discover you have forgotten everything you learned. Reach for your learning aid and know you can relearn what you lost.

Try to go easy. Be nice to yourself—and each other. Don't kick the machines.

AND OFF YOU GO . . .

This book is about expanding your creative options. The tone is conversational, and I have inserted a few surprises to give you a smile. My hope is that *Mediapedia* will become a trusted companion that sits beside your computer screen and offers encouragement for taking your work to the next level.

Kit Laybourne
New York City

MEDIApedia

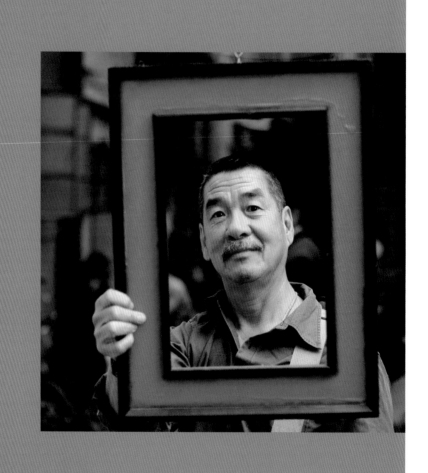

the PHOTOGRAPHIC image

Digital photography dominates. Starting in the late 1990s, every major manufacturer in the photographic industry rechanneled their products into the digital domain. In 2003 Kodak announced it would stop selling film cameras. Agfa, a one-time major producer of film for analog cameras, went out of business in 2005.

Millions and millions of digital cameras are sold each year. Most mobile phones feature built-in cameras. You can snap a photo at any time, any place, for any reason, and share it—send it, manipulate it, print it, publish it—a moment later.

This book assumes you have a digital camera and that you want to do all these things with your photos: send, manipulate, print, and publish. But here's the key difference between this book and all other technical articles and Web sites that have some of this information. This book also invites you to go a step further, to learn how to take *better* pictures and to use your photos *creatively*.

WHAT'S SO GOOD ABOUT DIGITAL PHOTOGRAPHY?

It's not hard to see why digital photography has replaced film. It can be done at low cost. Once you have a camera, memory card, and a computer where you can download the pictures, there is no incremental cost for shooting as much as you want.

Digital photography offers immediate gratification. You get fast results. This encourages trial-and-error learning—one of the most natural and dependable ways to get good at something.

You can share your work easily. Copies are identical to the camera originals. You can carry images around to show them off and post them on the Internet. And because so many people can see your photos, you can easily get feedback about what works in your pictures and why.

There are fantastic digital darkrooms that require no chemicals and allow you to rework and transform your photographs in endless ways. As you are probably

aware, **Photoshop** is the undisputed giant among software applications that allow image editing.

But before we get too excited about the ascendancy of digital photography, let's note a few drawbacks. Just as photographic prints and negatives have always been subject to fading and damage, digital data is only as enduring as the electronic media that stores it. At first people used floppy disks to store their media. Then came zip drives. Today most people archive their photos on hard drives or DVDs.

Those shiny DVDs you use to store your photo library will become obsolete one day. Digital technology is always moving forward. Future breakthroughs are a certainty. Sure, it's not a bad idea to save the printouts of your favorite photos in albums or an old shoe box. But the best advice is to prepare yourself to periodically transfer the content of digital libraries from one storage format to another.

And then there's the digital equivalent of tonnage. Because there is no expense in taking photos, people tend to shoot too much. The downside to this is that sheer volume can quickly get in the way of handling and learning from images you've already shot. Many people don't cull their photo libraries. It takes time to develop good photo storage habits—organizing photos and weeding out the shots you don't want to keep. But it's worthwhile to develop a system for doing so.

WHAT MAKES A GOOD PICTURE "WORK"?

Good photographers study how the mind works to help them enhance viewer engagement. This starts with a single insight. Humans are pattern seekers. We are hardwired to use all of our senses to make meaning.

When you take a photo, you record an entire chunk of visual field, not just an element in that field. An image of your sweetheart, for example, will also include a background, other objects, or maybe even the unforeseeable cloud looming above. But when someone else looks at your sweetheart picture, what's most important to you (that secret smile of the lips) may be quite secondary to a different or more dominant pictorial element. A roller coaster in the background, for instance, with its curves and interesting forms, may distract viewers, making that smile go unnoticed or changing its meaning all together.

You can take pictures with greater impact if you understand how all the elements of your images work in unison with our amazing human brains. Here are six principles (first set forth in Gestalt theory) that will help you create better images:

• **we like seeing groups.** Objects or items in a photo that are arranged close together will be perceived as a group or unit. Proximity is the technical term for this.

Your perception will automatically attempt to fill in this incomplete drawing. This instinct is called closure. Did you see the camel?

- **we like similar shapes and forms.** Humans tend to search for regular forms. We connect objects that are similar to one another. An example is the way color will connect very different types of elements in a photograph.
- **we fill in the gaps visually.** Our perception skills compensate for incomplete elements, and our mind forces wholeness. Often we can read a word or phrase even if we see only a chunk of it. As a photographer you can use this to increase the viewer's engagement.
- **we are drawn to simple images.** The human brain searches for the greatest degree of simplicity, clarity, and regularity and then interprets its findings into a coherent element. Most of us recognize "good form."
- **we don't like busy backgrounds.** The most striking elements in a photograph become the subject, and anything surrounding them becomes "background." If the relationship between the fore- and background is not clear, the viewer will be confused.
- **we read a sequence of photos as a single story.** Our perception system does not analyze each new component as fresh, but instead draws conclusions based on what we have already seen or experienced. A series of photos is scanned as a whole. Continuity and persistence of vision are at the heart of animation and filmmaking. Chapter 5 looks deeply into this sequence-bias principle.

The two illustrations in the margins will give your pattern-recognition talents a quick workout. Make note of how satisfying it is to solve these little visual games.

THE EYE IS NOT A CAMERA

Most of us take vision for granted. Yet perceiving images, objects, color, and motion is a very complicated process.

Over the years artists and scientists have produced optical illusions, either by reducing the number of visual cues in their images or by deliberately setting up situations where the rules come into conflict. Optical illusions remind us there is an innate ambiguity in what we perceive and are a wonderful window into the process of visual perception. In theory, there could be any number of three-dimensional structures that cause a given retinal image. Our visual system usually settles for the correct interpretation of the subject in relation to its background. When we make a mistake, an illusion occurs.

Check out the four classic illusions on the following page. Each is trying to trick your eyes. Optical illusions remind you that the eye is *not* a camera. This carries over into lessons about the way we think when we take photos. We point. We click. It's almost second nature. Yet taking pictures is not second nature at all. Subtle rules shape our visual perception; the camera doesn't edit out or add in meaning the way

This is one of the most difficult decoding puzzles I ever encountered. It requires switching mental focus of foreground to background. Hint #1: It's an "eye" exam. Look for that word.

Girl or old woman?

Impossible object.

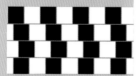

Al Gore or Bill Clinton?

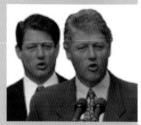

Straight horizontal lines?

There are many families of optical illusions. Shown here are four examples: **Figure Ambiguity**—it's possible to read image as both an old woman and a young one; **Impossible Objects**—you could never build the triangle-shaped object; **Facial Illusions**—that's Bill Clinton twice. Promise; **Distortion Illusions**—the horizontal lines are parallel.

our brain does. So if you want to take your photography to the next level, you need to reawaken yourself to the process of visual thinking. The psychologist William James put it this way, "Whilst part of what we perceive comes through our senses from the object before us, another part (and it may be the larger part) always comes out of our own mind."

WHAT IS VISUAL THINKING?

Visual thinking pervades all human activity. Astronomers, nurses, football coaches, carpenters, cooks—people of every kind regularly engage in thinking by visual images. It's not just the realm of artists.

Psychologists who study and test mental ability have discovered that visual thinking involves a number of visual-spatial operations:

- **pattern seeking:** We connect images based on one or more similar characteristics.
- **visual memory:** We can still "see" a photo that we took years ago.
- **kinetic imagination:** We can mentally rotate an object and see it from different vantage points, or to determine directions of implied movement.
- **visual reasoning:** We had these on those college board tests—"If A is to B, then C is to . . .")
- **dreaming:** Some of our most original visual images come during sleep.

- **fantasy:** Our imaginations, given the freedom to roam, use a mode of visual thinking that is much like dreaming.

In the 1960s, Robert McKim began to develop a course at Stanford University that was eventually called *Visual Thinking.* His book, Experiences in *Visual Thinking* develops the argument that creative thinkers must be ambidextrous.

McKim reviews the ancient symbolism for the right and left hands. The right represents discipline, objectivity, logic, knowledge, and language. The left represents openness, subjectivity, playfulness, feeling, and imagination.

My goal in this book is to massage your powers of visual thinking, or, as McKim puts it, "to gently take the symbolic left hand out of the cast in which society and education has immobilized it, to give it some exercise, and to put it to work in unity with the right." He goes on,

Computers cannot see or dream, nor can they create: computers are language-bound. Similarly, thinkers who cannot escape the structure of language, who are unaware that thinking can occur in ways having little to do with language, are often utilizing only that small part of their brain that is indeed like a computer.

By understanding the mechanics of psychology and perception, you have a far better chance of creating images that are arresting, memorable, and informative,

and that will stop a person cold in his or her tracks with an involuntary, "Wow!" To make such images you must operate as an artist (using the intuition of the left brain) and as a scientist (using analytical processes of the right brain). In other words, you must be ambidextrous.

Optical illusions remind us the laws of perception do not always rule. Humans also "see what we want to see." Our experiences dictate how we take in and interpret the world. Thus, as you try to trigger emotional and intellectual responses through your photography, you must also understand the cultural conventions that influence your audience's expectations.

The bar is always being raised when it comes to what makes a good photograph. The media continually bombards us with images of what's current and cool. By simply keeping your eyes open to TV, Web sites, magazines, and signs at the mall, you will be adjusting your visual taste and broadening visual awareness. This is one of the best ways to feed your eye as a photographer. Be open to the new and don't take any photo-taking rules too seriously—even mine. Remember that good pictures always contain a measure of mystery, surprise, and delight.

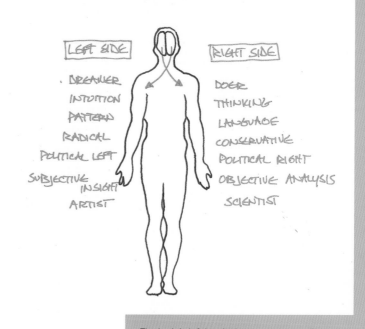

The brain's left hemisphere connects to the right side of the body. Often you'll hear someone described as being "right brained," which refers to creative skills associated with the left side of their bodies. Conversely, "left brained" suggests a person is analytical, as symbolized by the right side of their bodies.

chapter I: DIGITAL PHOTOGRAPHY

If you own your own personal computer, I bet you own a digital camera, too. These babies come in all colors and flavors. Price varies from $50 for an ultrasimple model to $1,500 or more for a state-of-the-art professional rig. There are dozens of models from which to choose from manufacturers like Canon, Kodak, Leica, Nikon, Olympus, Panasonic, Pentax, and Sony.

Be wary as you shop. Photography salespeople will pound you with an array of features and make each sound absolutely essential: large zoom range, image stabilizer, flash type, and so on. Many of today's still cameras will even shoot bursts of full motion video with sound.

I am sympathetic. The range of gear can be mind boggling. Yet as you use a digital camera in your day-to-day life, your personal patterns become clear and this truism eventually emerges—it's not the camera that takes pictures, it's *you*. Once you've zeroed in on what you enjoy most about making pictures, then which camera you own becomes secondary to what you intend to do with it.

This chapter aims to give you creative mastery over the camera you are working with today. That is my primary mission. But you may find a secondary value next time you are window-shopping or oogling the latest camera models online. That's because this chapter should you help you determine quite precisely which features are valuable for the kinds of pictures you enjoy shooting.

THE CAMERA

A device containing a lightproof chamber, an aperture fitted with a lens, a shutter through which the image passes, and a light-sensitive surface that captures the image.

The simplest of all cameras is a pin hole camera. It consists of a sealed, light-tight box or carton with a piece of photographic paper facing a small opening—the pin hole. The pin hole is covered with a piece of tape until the moment of exposure, when the photographer lifts the tape and lets a burst of light onto the light sensitive paper. There is no lens other than the tiny opening, yet the resulting image is sharp.

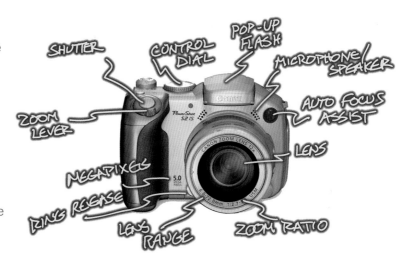

the digital camera

A digital camera is a photograph recorder that uses a light-sensitive computer chip as the capture medium.

For all its compactness and portability, even the simplest digital camera is far more complicated in its workings and usage than its equivalent film camera.

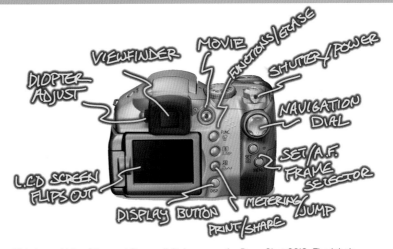

This is a middle-of-the-road Canon digital camera, the PowerShot S2IS. The labels identify many of its features. Do not underestimate the time and care it takes to become familiar with the controls and menu items in your camera. It's a good investment of effort to do a top-to-bottom, front-to-back inventory of all the functions on your camera before firing away.

still-camera anatomy

There are seven basic parts to a camera: the body, the viewing system, the capture plane, the aperture, the shutter, the lens, and storage.

The **viewing system** of the generic camera shown is the "viewfinder" or "range finder" that lets you frame up the scene. Digital cameras have either a tiny computer screen or a reflex viewing system that allows the photographer to see through the lens itself. In analog cameras, the **image capture plane** is the surface that holds the celluloid sheet with a light-sensitive chemical emulsion on it. In digital cameras the capture plane is a silicon chip that measures the light striking it. This is called the charge-coupled device (CCD) sensor.

The **aperture** is a diaphragm (modeled on the iris of the human eye) that controls how much light enters the camera. The **shutter** provides a movable shield that opens to permit light to pass. The plastic or glass **lens** creates an upside-down image on the capture plane. In the simple camera shown here, you focus by adjusting a knob on the camera's side that adjusts the width of the camera body. In all digital cameras it's a rotation of the camera's lens that adjusts the focal distance. **Storage** changed with digital movement. In film cameras you advance a roll of film after each shot and the roll is rewound and taken out of the camera and to the darkroom for developing. Digital cameras store images in a memory chip until they are downloaded onto a computer's hard drive.

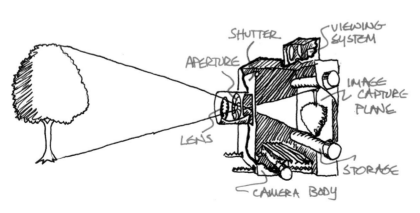

The basic terminology used for today's cameras was established quite early in photographic history. While digital cameras have moved beyond many elements of earlier technology, the model you hold in your hand remains at its core much like the classic roll-film camera shown here.

the camera system

Before we plunge into digital photography's innumerable creative options, it is useful to stand back for a thirty-thousand foot view of the multi-faceted "system." This will help you see the full scope of your photographic practice.

Here's a quick rundown of the gear that's waiting to be connected to your camera.

printers. Most of us are used to flipping though a stack of snapshots. We hold them one at a time and peer intently at the printed image. These photographs are **hard copies** made from slides or film negatives, or printed out from their digital files, on sheets of paper that often have a glossy surface.

If you are buying a digital camera for the first time, don't plan to spend lavishly on printers. Your first printer purchase should be a perfectly adequate combination printer, scanner, and copier (available for under $100).

backup and extra storage. While at first there may seem to be no cost associated with the number of photos you take, your growing personal archive eventually hits your pocketbook: You need extra electronic storage space. Having extra storage space for your pictures will make it

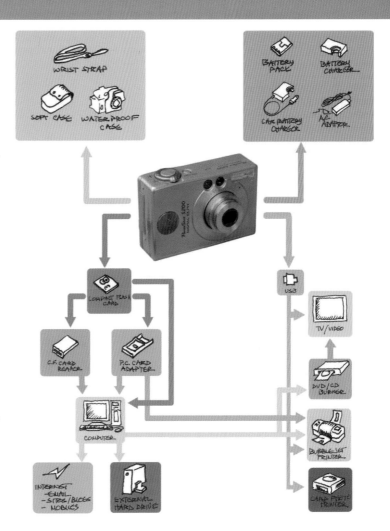

What used to be the single device of photography (just a camera) is now an integrated system of devices. This map was adapted from a manual for the Canon S200 Digital Elph, which is pictured in the middle.

easy for you to back up your images, keep them safe and available, and prevent them from using the memory required for documents and other files you have stored on your computer. See Chapter 6 for more about storage devices.

software. If you really want to get the most out of digital photography, it's worth it to begin working with full-strength, professional software applications. You'll hear this again in Chapters 2, 3, and 4.

friends. There's a part of the digital photography "system" that doesn't show up on anybody's diagram—your friends, a community of photographers who can nurture your skills and help improve your eye. Start with a pal or two with whom you can have open critiques about

your photographs. Each of you should offer feedback. Start by saying what you like in a photo, move on to what doesn't seem to work, but finish with a positive comment. Collaboration of this kind helps you polish your photography vocabularies. Getting comfortable with the terms of digital photography quickly leads to better results and more fun.

sharing sites. Check out Web sites like Flickr, Zazzle, or Shutterfly that offer forums, advice, and a place to share and critique work. Chapter 6 provides more information about such sites. Eventually you might look around for weekend or evening courses offered by local schools, museums, or photography centers. Immersing yourself in the work of others will subtly inform your eye.

resolution and megapixel hype

Resolution refers to the visual quality or sharpness of a digital image. The term megapixel references the number of sensor elements that measure light that falls on the image sensor array, which is called a CCD (charge-coupled device) chip.

Megapixels are the official measure used to gauge resolution. A megapixel is 1 million pixels. What's a pixel? The topic after next provides more information about the pixels, which I think of as the atomic structure of digital images.

Digital still cameras offer different resolution settings to take pictures. These are often labeled *high, medium,* or *low* quality. Camera manufacturers endlessly hype the idea that the quality of the image relates to the camera's megapixels.

So how many megapixels do you need? That all depends on how you use the photos.

The camera on your mobile phone or the built-in camera at the top of some portable computers generally produces resolution of 640 x 480 pixels, or about half a megapixel. These low-resolution images are great for e-mails, uploads to social networks, or even snapshot-size printouts. However, if you want to make a 5 x 7–inch print of an image, you need an image file that is medium resolution—approximately 1,600 x 1,200 pixels, or around a megapixel. If you are set on producing a high-quality 8.5 x 11–inch photograph, your source images ought to be high resolution—in the neighborhood of 3,800 x 2,600 pixels, or about 4 to 6 megapixels.

So here's the bottom line: If you have a camera with 5 megapixels or more, you are set for anything other than giant blowups or poster-size printouts.

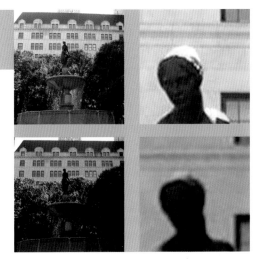

The pair of shots on top were taken with my wife's (beloved) Casio EX-7250 camera, with 7.2 megapixels. The shots below them come from my new (very beloved) iPhone, with 1.1 megapixels. The images on the left show comparable, wide-angle shots of the same building and water fountain. Both look pretty good. But if you want to blow up a tiny portion of the source as I have done with the head atop the fountain's statue, you can easily see the artifacting (a fancy word for image deterioration) that occurs with the low-resolution iPhone image. There is some deterioration with the 7.2 megapixel blowup as well, but it is not nearly as pronounced.

KINDS OF PHOTOGRAPHY

Personal photography can be categorized into six major genres. Both professional and amateur photographers often specialize in one. Over many years the craftsmanship of serious photographers has refined subsets of the six genres, so there are many different schools within each genre. Even within each school, individuals create work that is distinct and recognizable. These photographers are said to have found their voice.

Let's sort this out in a bit more detail. When used in reference to digital still cameras, the term megapixel expresses the number of sensor elements that measure light falling on the image sensor array, which is called a CCD chip (standing for charge-coupled device). An array chip with that 2048 x 1536 sensor elements can be said to have 3.1 megapixels (2048 x 1536 = 3,145,728).

There are good reasons to find your own voice. It begins by becoming aware of different genres and what each expresses best. While you cruise through the next pages, ask yourself which kind of photography you would practice if you were limited to just one. Spend an hour or two looking through your albums and file folders of photos. Look for patterns in subject matter, in composition, and in the way you approach subjects. It's possible to shoot many photos, and take in thousands more, yet never step back to look for the patterns that signal your personal tastes and style.

The sampling of images shown here is just a tiny representation of each photographic genre. Your public library or bookstore has shelves of books that contain beautiful reproductions, and a history of photography book will show you the big picture.

photojournalism

Photojournalism uses photography to record significant human and global events.

What journalists do with words, photojournalists do with images. The last couple of years have witnessed a renaissance of photojournalism. What was once the exclusive turf of professional news photographers has broadened as regular reporters have begun to use their personal cameras with the same intensity with which they have always used their notebooks. The Web sites of major newspapers around the country now report using multimedia tools that have been shot, edited, and made into slide shows by a new breed of visual journalists.

Today's digital cameras are extremely small and portable. Mobile phones have snapped images that made the front pages of our newspapers. You've got to be able to move fast. Amayzun; Carolina Correa

street

Street photography is a genre of photography that fuses a fine-arts aesthetic with the observation of daily life.

Incongruity is a hallmark of street shooting. Although it is almost impossible to observe your own neighborhood in the same way a foreigner would, the outsider attitude is what makes street photography so special.

To take street shots, you need a quick eye and the ability to make fast use of the camera. You must be able to stand back from your subject (no matter how familiar it is) and observe life from a distance.

Street photography brings us moments that are otherwise unseen. Yet at its best this genre contains formal qualities of composition, lighting contrast, and other design intangibles. Vaibhav K. Bundhoo; Peter Hastings

landscape and nature

Landscape and nature photography involves taking pictures of the natural world.

Landscape and nature photography depends on the photographer's ability to compose a striking frame and then wait out nature's own unfolding of events until the "right moment." Not discussed here—but not beyond the reach of personal media makers—is a more scientific branch of nature photography that employs cameras to capture what is invisible to the human eye by way of time-lapse or macrophotography (super close-up).

To photograph the natural world you need great patience. A tripod is also helpful. Peter Hastings; Timothy Klein; author

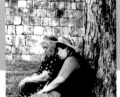

portrait

Portrait photography is the art of using a camera to interpret an individual or a group.

The human face and human form radiate endless qualities and expressions. It's no mystery why so many photographers have chosen to focus on portraiture. Their quest is not just for an "attractive" or authentic likeness, but for a photo that catches the personality, the life experience, and the very soul of the subject.

Portraiture requires the ability to make people feel comfortable and forget you and your camera are there.

There are many subgenres of photographic portraiture: candids, documentaries, formal portraits, and portraits that combine people and place. Create your own subgenre. Peter Hastings; Carolina Correa; Carolyn Jones; author

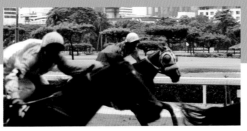

action and sports

Action and sports photographers seek to freeze a telling moment within fast-moving events and performances.

If you've ever stood on the sidelines and tried to capture a moment of athletic prowess, you know just how much skill it requires to take a great action shot. Standard equipment includes long lenses and a camera with a very fast shutter speed that can also shoot bursts of multiple images per second. (More on shutter speed later in this chapter.)

To take action and sports shots, you need an understanding of what action will be performed, where to get the best view of it, and precisely which split second best conveys the action.

Photos like these require very fast shutter speeds—a 500th of a second or faster. Ray Moore, RAR Studios; Chadri Chinalai; Todd Calvert

These three photographs transcend the communication of content and become artworks. At least they do to me. Abstract photography is only my catch-all phrase for the spectrum of photography-as-art. What flavor of such abstract approaches do you consider Art (with that capital A)? Peter Hastings; Carolina Kroon; Todd Calvert

abstract

Abstract photography is a genre of photography in which content is second to formal qualities of color, composition, and texture.

Each type of photography listed in this section can reach the level of Art (with a capital A). But just what does that uppercase A mean?

Regular photography is basically a record of a specific time or place. In contrast, many people characterize Art as a transformative experience. When you experience a work of Art, it deeply moves and changes you. The content is secondary to the emotional and intellectual impact of Art.

PIXELS

In digital photography and computer graphics, the fundamental visual element is a tiny colored square called a pixel.

The word pixel is short for "picture element." It references the smallest unit of computer graphics.

If you hold a magnifying glass up to a computer screen, you can see that photographs are composed of a **grid**, or **raster**, of tiny pixels. Each square you see represents a sample of digital data—a number—that exists within the computer in the form of zeroes and ones.

If you enlarge an image on a computer screen enough, you will also be able to see individual pixels. As you work in personal media, there may be times when you want to zoom in on an image so that you can work at this atomic scale. Mostly however, with your everyday interaction with digital images, you will not be aware of the pixels. The human eye effortlessly "resolves" the grid of tiny colored squares into an integrated whole.

Pixels may seem simple enough, but they are complicated little fellows, as these factoids suggest:

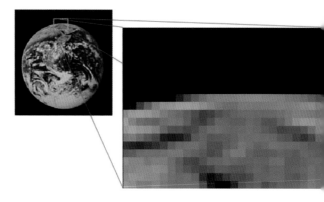

This image of Earth shows how pixels work together to form a unified whole. When enlarged, the pixels can be recognized as individual squares. Joe Maidenberg and NASA

• **PIXELS ARE CAPTURED** via cameras and scanners when a ray of light hits a computer chip with digital sensors. The electronic sensor registers only three color ingredients: red, green, and blue (RGB). Yet millions of colors can be re-created by mixing the digital code that measures the varying amounts of the three component colors.

• **PIXELS CAN BE CREATED** from scratch, using vector and bit-map software such as Adobe Photoshop and Illustrator.

• **PIXEL SIZE** can vary. A pixel can be a foot square or so small that two thousand of them can jam into a single inch.

• **PIXELS ARE CUSTOMARILY** measured by the numbers that line up in an inch. The shorthand for this measurement is ppi, which stands for "pixels per inch." The term dpi stands for "dots per inch" and is interchangeable with ppi.

- **A STANDARD DISPLAY** for the Internet is 600 x 800, meaning 600 pixels in width (side to side) and 800 pixels in height (top to bottom). This standard is bound to change as displays get larger on both desktop computers and hand-held devices like phones and digital personal assistants.

- **LOW RESOLUTION** is 72 ppi. This is the standard for the Internet.

- **MEDIUM RESOLUTION** is 300 ppi. This is the standard for print publishing.

- **HIGH RESOLUTION** is 1,200 ppi or higher. A scanner operates at this resolution.

- **PIXELS** are usually square (on computer screens), but they can be rectangular too (in video screens.)

- **REGARDLESS OF SIZE**, each pixel is assigned a single color or shade of gray. Pixels can also be assigned a degree of transparency.

binary system

A binary mathematical system has only two units as its base. This means there can be only two possible mathematical values: one or zero.

Although we perceive images (and words and sounds) as artifacts of the concrete world, in truth what is "there" before us is only long strings of computer code—zeroes and ones. Nothing more. Lucky for us, computers can process, display, and manipulate these bits of information at fantastic speeds.

bits and bytes

A bit is the smallest piece of information a computer can use. A bit is either of two binary choices: zero or one. The term is short for "binary digit."

Bits are the basic unit of information used and stored in computing. A set of 8 bits forms a byte. Think of a byte as equivalent to a word. There are exactly 256 different combinations of 1s and 0s possible within the string of 8 bits that form a byte. The byte has remained the basis for measuring the size of images even though most computers now operate with strings of 24 or even 32 bits of information.

Two layers of digital reality: an image made of pixels and the computer code within the data file. Joe Maidenberg

bit depth

Bit depth describes the number of bits used to define each pixel.

A single pixel carries a lot of information about itself. For one thing, it must describe its precise location within a field of other pixels. Each and every pixel must also carry information about its color (hue, value, and saturation). If a pixel is layered with other pixels, it may also carry information about translucency.

color bit depth refers to the number of bits used to describe the color of a given pixel. The greater the depth, the more individual shades are available. The standard for today's computer graphics is 24 bit depth.

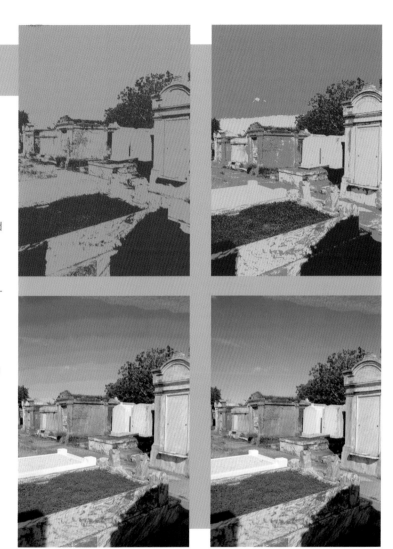

Here are four versions of the same image of a New Orleans cemetary. With a bit depth of 1 (top left) you get only two color choices. Here the 0 = green and the 1 = light blue. When the bit depth is 2 (top right) there are four combinations: 00 = green; 01 = blue; 10 = gray; 11 = off-white. Eight-bit color (bottom left) yields 256 combinations. One bite would look like this: 01100010. Note that the sky shows banding caused by lack of enough blue shades assigned. Finally, 24-bit color images read beautifully on the computer screen. Millions of colors are available. Perri Chinalai

LIGHT

Light and its reflection are what cameras record when they capture an image.

Today's digital cameras make it seem so easy to click and shoot just about anytime and anywhere. This can be a disservice. To photograph well, you need to understand the true characteristics of light. Reading through the terms below should help you become aware of the difference between what we are used to seeing and the reality of how light falls on the subject.

Because sensor chips are so sensitive to light (much more so than film), digital cameras outperform film cameras in low-light conditions. This is a good thing, for most of us have no interest in lugging around a suitcase of lighting gear. Yet shooting in available light requires a refined sensibility about lighting conditions and techniques.

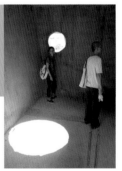

quality

The overall character of a lighting situation establishes its "quality." This is a subjective term.

Just as there are zillions of ways to discuss the quality of wine, the same is true with photographs. There are an infinite number of ways that the sun can illuminate the world around us, as sampled by the four images shown here. The more you study the different qualities of light, the more you hone in on the kinds and qualities of lighting conditions that turn you on as a photographer.

The stand of Aspens catches the muted intensity of winter daylight against the contrasting overcast landscape in the background. A single source of natural sunlight leaves almost no "fall-off"—the effect of how shadows thin out the farther they extend from their source. The color of the leaves is super illuminated by sunlight striking the side away from the camera. The direct sunlight shining into an enclosed space cuts a circle of intense white. Sunlight speaks in every voice. author; Chadri Chinalai; Perri Chinalai; Adam Dayem

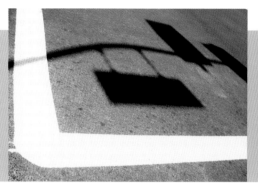

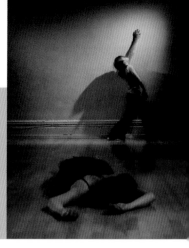

shadows

Areas of relative darkness that help define shape and location.

When taking a picture, most of us are attracted by areas of bright illumination. But it is equally important to pay attention to the dark forms within a composition. Shadows are valuable forces in directing a viewer's eye. Look for situations where you can adjust window curtains or shades, or where you can rig a form that causes patterns of shadows to fall over on a familiar subject, transforming it from ordinary to extraordinary.

The shadow of the traffic light is a reminder that direct sunlight, which comes with great intensity from a single source, can create sharp edges even at distance. The dog's snout shows an attached shadow which falls on the object that created it. It shows contours and quality of the fur. The dancer against the wall has a double cast shadow created by two different lighting sources above.

Peter Hastings; Chadri Chinalai; Carolina Kroon

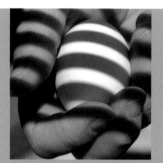
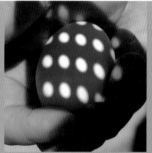
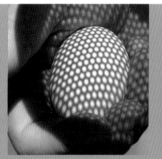
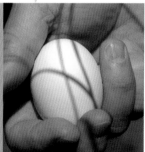

Theatrical shadows require the photographer to be an active player. There is a long tradition in stage productions of casting shadows that have their own shape identity and that also work in ways that reveal shape, texture, and highlighting on the set itself. Such pat-

terned shadows can be used in your photographic work as well. Here a pair of kitchen spatulas, a straining ladle, and some loose straw transform an egg into an object of design. The egg has become a canvas for forms created by pure light and shadow.

reflected light

Even when there is a single source of lighting, nearby objects bounce light and illuminate each other. Such bounced, indirect lighting is called reflected light.

It can be dramatic to have one portion of an object in light and the other portions in darkness. When this is the case, reflected light is a problem. But reflected light can be an asset, too. Generally, reflected light is softer than illumination from a direct, primary light source. Hence it "fills" nicely and gives form and dimension to a photograph.

Bounced light off her grandmother's sweater gives this subject a warm tone that contrasts with the direct sunlight in her hair or the bluer background tones characteristic of indirect daylight. author

refraction

When light passes through elements in the atmosphere (like clouds, smoke, fog, or pollution) particles in the air refract the light, often creating striking visual effects.

Refraction also occurs when a photographer shoots through a translucent (but not perfectly transparent) medium like water or glass. Photographs with atmospheric refraction have an "even" or "flat" look. Sound dull? Quite the contrary: Refraction effects can transform the normal.

Ice on a window refracts the shapes of the scene beyond. Early morning fog along the seashore can be thick and spooky. The different shades of gray indicate distance between palms. The mist rising off a stream catches the sunlight passing through an off-camera fence. Peter Hastings; author; author

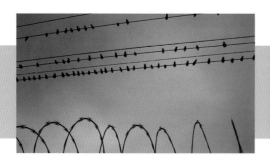

silhouettes

A strong backlight and no lighting from the front create sharp silhouettes that highlight pure shapes.

Few lighting effects are as powerful as a silhouette. Silhouettes tend to flatten objects into two dimensions, thus creating what are often called "graphic forms." The three samples here indicate the expressive range of silhouettes. More than one silhouette within a frame encourages the comparison of forms. If the silhouettes overlap, new forms are created.

The traffic signal and light (right) are pure silhouettes against a white background, which makes this easily self-matting. More on that in Chapter 2. The birds and barbed wire (left) invite comparisons that engage viewers. The grapes (center) are not true silhouettes, yet they group themselves into new forms as is typical in the genre. Ryan Junell; Todd Calvert; Peter Hastings

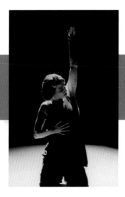

dramatic agency

Lighting effects that accentuate a particular part of the photograph.

The term dramatic agency may be a bit of a mouthful, but it is more than likely a daily presence in your life. TV shows and movies, store displays, and architectural spaces are all places that use artificial lighting to create a sense of drama.

Brides have a knack for catching the spotlight (left). A purple gel on the stage lights (middle) makes the shot festive and brings you into the mood of the dancers. A top light (right) is always dramatic. Chadri Chinalai; John Krupsky; Carolina Kroon

POINT OF VIEW

Point of view refers both to a physical and mental relationship between a photographer and subject.

Often abbreviated to its initials, POV has two levels of meaning. On a practical level it is about seeking out unexpected and engaging angles and locations for positioning the camera. But POV is also about the photographer's inner vision. For example, a POV can be ironic or menacing or so familiar it's an intentional cliché.

bipod bias

The human tendency to stand and shoot photographs from eye level.

Because humans stand on two legs, most photographs are taken from eye level (four and a half to six feet above the ground). This viewpoint is so common, we almost come to expect it.

There can be a jolt of delight for the viewer when an inventive photographer lies down or perches in an unusual position. Some photography mavens hold that if a subject is shot from a lower than normal viewpoint, the subject appears "powerful/dominant." Inversely, a shot taken from above can reduce the psychological stature of subjects and make them appear less powerful. But beware of clichés. Conventions that are fresh one day become stale the next. In any event, finding a dynamic camera position requires both imagination and dexterity.

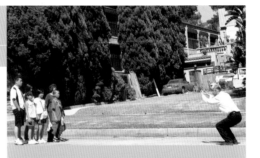
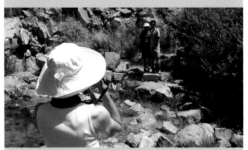

Most photos are taken from a height of four and a half to six feet above the ground—even across wide spaces! Mike Schmid; Perri Chinalai

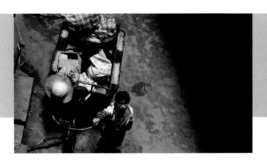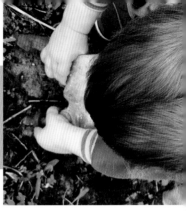

camera's position

The precise location and orientation of the camera at the moment the photographer takes the picture.

Of course there are an infinite number of positions for taking any picture. Even moving the camera a few inches will cause noticeable differences in how the subject appears in terms of framing and the relationship between the subject and background. Critics use the odd term *occult* to distinguish unusual (and therefore striking) camera positions. A weird POV can be a good POV.

Study the spatial relationships between photographer and subject. The first photo was taken from a position far above the subject. With the second image, the photographer is shooting through a silhouetted foreground that makes an occult frame for the subject, located in the distance, dead center. The third image was shot directly over the red-headed child. Chadri Chinalai; Todd Calvert; Brenda Anderson

photographer's intent

The goals and intentions behind taking a certain shot.

Sometimes snapping a photo is just a simple impulse. You have the camera out and ready. You are waiting for the right moment, and when it comes, you start clicking. But as you become more adept in photography, your mental involvement deepens. The more you can identify your intentions—whether they are centered on emotion or content—the better you orchestrate the full creative tool set.

In Chadri Chinalai's first image (above left), it's hard to say who is prouder, the dog or the owner behind the lens. The intent of Chinalai's second shot (above right), is a playful collaboration between photographer and subject. Chadri Chinalai; Chadri Chinalai

LENS CHOICE

Lens choice refers to the decision a photographer makes about how much of a scene he or she wishes to capture.

A camera's lens defines an *optical* relationship between photographer and subject. Lenses are measured by their focal length, which is a measure (in millimeters) from the center of the lens to the principal focal point where the camera "captures" the image inside the camera. Focal point is often referred to as the angle of view.

Most digital cameras come equipped with a **zoom lens.** You can stand in the same spot and take a wide shot or a telephoto shot.

The disadvantage of a zoom lens is that there's no single one that can match the range of focal lengths found in the six types of prime lenses shown below.

normal lens

A normal lens approximates the angle seen by the human eye.

With digital cameras a normal lens has a focal length of 35mm. This is roughly the same angle of view as a 50mm lens on an analog camera. (The difference is the size of the film versus the size of the light-sensitive chip in a digital camera.)

wide-angle

A wide-angle lens captures a broader field of vision than we normally see.

The wide angle lens allows more space in which the photographer can record relationships between subject and background. This commonly found lens is good for shooting buildings and landscapes. It's not so good for portraits because it often distorts the edges of the image. The example shown was taken with a 24mm wide-angle lens.

The photos on this spread were all taken with the same camera at the same fixed distance from the lovely subject, Madeline. We used a Nikon D200 single lens reflex camera and a number of prime lenses. Special thanks to John Hall who lent both lenses and daughter

The default lens for the camera in most mobile phones is halfway between the normal lens and a wide-angle one.

Anything wider will begin to warp the image. This shows up first in horizontal lines that begin to bend. Distortion is greater at the sides than in the middle.

telephoto

A telephoto is a long lens that makes distant objects appear larger in the viewfinder and in photographs.

Because telephoto lenses contain many sets of glass prisms, the lens itself can become so large and heavy that you need a tripod or a monopod to steady and support the rig. You'll see the latter among press photographers covering a football game. The telephoto tends to compress images so that the foreground and background "flatten."

fish eye

A fish eye lens exaggerates the center of the image. It takes in a field of vision far, far wider than is familiar to the human eye.

The sample picture was taken with an 11mm fish eye. It's not easy to find subjects that lend themselves to the built-in distortion that a fish eye causes. Yet there is no dispute that this lens creates striking images.

macro

A macro lens is a specialized lens that lets a photographer magnify what the human eye would see if it could get extremely close to a subject.

Many digital cameras have a built-in macro lens feature. This lens is also known as a close-up lens or diaper. Once you begin shooting such extreme close-ups a whole new world opens up. Things that are ordinary become extraordinary.

zoom lens

Most digital cameras come with a built-in zoom lens, which can be adjusted to a choice of focal lengths between its widest angle setting and its most telephoto setting.

The more accurate name for a zoom lens is "vary-focal." The stand-alone versions that you can buy for a camera that takes interchangeable lenses can be huge, like the ones you see dwarfing the cameras of professional sports photographers. Zooms contain a set of glass prisms that can be adjusted so that, through physical realignment of optical elements, the lens works at all focal lengths.

A common effect of long lenses is to limit the depth of field. If you look carefully you can see that the tip of nose is soft.

When a fish eye (super wide angle) lens is placed close to the subject, the distortion passes into a reality that is quite creative. As a portrait, this shot catches something of the subject's natural energy and playfulness.

With a macro lense, depth of field is limited. This can yield striking results.

EXPOSURE

Exposure is the amount of illumination that falls on the camera's light-sensitive plane while recording an image.

It's easy to get confused about how to achieve the right exposure. Does the f-stop setting make the biggest difference, or is it how long light enters the camera? What's the perfect exposure when the subject is backlit? Should you adjust the exposure depending on whether a shot is bound for print or computer screen?

All photographic exposures are achieved by the mix of three camera settings: shutter speed, aperture opening, and (to a lesser degree) ISO.

"correct" exposure

The "correct" or ideal exposure is a subjective judgment about what degree of lightness or darkness looks "right."

The correct exposure can be a matter of personal taste, or it can be a judgment of how something looks in the context of something else. The set of five images above attempts to indicate how complex and subjective exposure can be.

overexposure is the term used when images are "burned-out" with too many whites or highlights. Overexposure is caused by an excess of light being let into the camera.

underexposure is the term used when images are "too dark." Shadows reveal less detail. Underexposure is caused by a lack of light entering the camera.

Which is the "right" exposure? I like the middle one, because no detail is visible in the white towel that forms the background. But the second one from the right looks good too.

[30]

bracketing

Bracketing is a shooting technique whereby the same photo is shot using a range of exposure settings.

Because getting a perfect exposure is so difficult, you want to know about bracketing, a shooting technique that professional photographers use all the time. The basic approach is simple enough. You don't take just one image, but instead you fire off a series of exposures of the same setup. The goal is to hedge your bet. Between individual exposures you adjust the mix of shutter speed, aperture setting, and ISO rating knowing that you'll find out what turns out to be the "best" exposure only when you compare the variations side by side.

By the way, it's almost impossible to gauge whether or not you have the correct exposure just by looking at the camera's LCD screen or at the meter that may appear in the viewfinder. So bracketing is a good practice that will help you get the best photographic results.

1	1/2	1/4	1/8	1/15	1/30	1/60	1/125	1/250	1/500	1/1000
			f32	f22	f16	f11	f8	f5.6	f4	f2.8

As the chart above shows, there can be as many as eight possible combinations of f-stop and shutter speeds that will *theoretically* achieve a "correct" exposure. If the aperture is more open (a lower f-stop setting) then the shutter needs to be faster (at a smaller fraction of a second). ISO settings will also affect correct exposure, but we'll consider that as a separate variable.

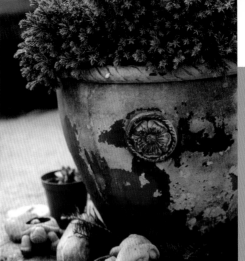

contrast ratio

The range between the lightest (whitest) part of a photograph and the darkest (blackest) part is the contrast ratio.

Photographs generally look best when there is a full range of luminosity: The lightest areas approach white and the darkest areas approach black. The middle image of the examples shown demonstrates such range.

A striking photograph, however, can be one in which the overall tonality is constant. **Low-contrast** exposures are often sought after for images that will provide a background for text. A bright yellow text would stand out well from the example image on the left. **High contrast** describes a photograph that exhibits very little midrange grays.

The first two images display a subtle difference in contrast ratios. All color has been taken out of the image on the right and contrast has been "pushed" until there is no tone except pure white and pure black. This high contrast version, made in Photoshop, is called a *Kodalith*. Some digital cameras have a high-contrast setting. Carolina Kroon

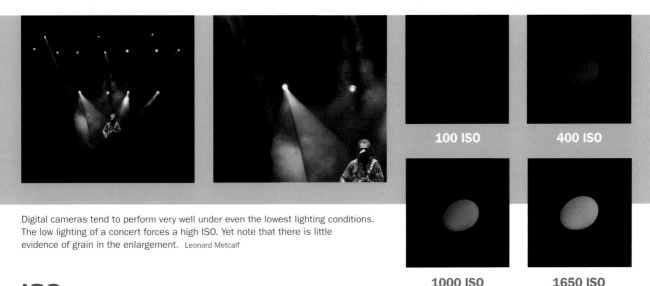

100 ISO **400 ISO**

1000 ISO **1650 ISO**

Digital cameras tend to perform very well under even the lowest lighting conditions. The low lighting of a concert forces a high ISO. Yet note that there is little evidence of grain in the enlargement. Leonard Metcalf

ISO

ISO is an index that measures (and adjusts) the overall sensitivity of a camera's capture chip to the light that comes in through the lens and shutter.

ISO (which stands for International Standards Organization) refers to the industry norm for indicating the light sensitivity of a camera's capture chip. A rating of 100 ISO is considered "normal." This is the default setting on digital cameras. You can adjust the ISO setting higher or lower. If you were shooting a nighttime shot, for instance, you'd want as much light sensitivity as possible and you'd choose a high ISO setting. Shooting at noon on the day after a snowfall, you'd probably need to lower your camera's ISO setting.

graininess is a related topic. Grain refers to subtle, minute artifacts that result when digital photos are taken in extremely low light. The grain can be seen in slight variations of what should be a solid tone, or in white specks that stand out awkwardly. The latter is sometimes called **visual noise.**

With my 10 megapixel Nikon camera, I can "push" the ISO setting from 100 to 1650 in order to get a decent exposure without gaining any noticeable noise. If there is enough light for me to see, then I can capture a digital photo. These four shots of an egg were taken in semidark. I kept the same f-stop and shutter speed and changed only the ISO setting.

FRAMING

Framing refers to a photographer's decision about what exactly to let into the picture—and what to exclude. Framing takes place in the camera viewfinder.

Many people don't realize that different cameras take pictures in different shapes and therefore the framing depends on the dimensions of the capture field. The term **aspect ratio** specifies the precise proportions, width to height, of an image's frame. For example, many cell phone cameras use a square frame with an aspect ration of 1:1. For a number of decades there was but a single configuration for movies and television frames. That's no longer the case. High-definition televisions have very wide screen ratios and are starting to influence the frame dimensions of digital still cameras. Further, the more we watch high-definition TV, the more our aesthetic sensibilities change and we begin to prefer a wider, narrower horizontal configuration of images.

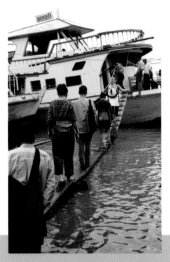

"standard" photographic frame

The framing dimensions of most digital cameras is 4 units wide by 3 units high. This aspect ratio is expressed as both 4:3 and/or 1.33:1.

The standard frame size is a hand-me-down from the world of 35mm photography. Depending on how the photographer holds the camera, the long side can be horizontal (4:3, bottom) or vertical (3:4, shown at top). Because Internet users favor scrolling down over scrolling across, vertically composed images turn out to be more flexible than their horizontal counterparts.

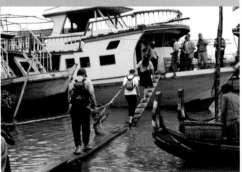

The vertical composition works best for me in capturing a sense of the precarious bridge onto the boat. Note that many people don't like to mix vertical and horizontal aspect ratios in a slide show. Perri Chinalai

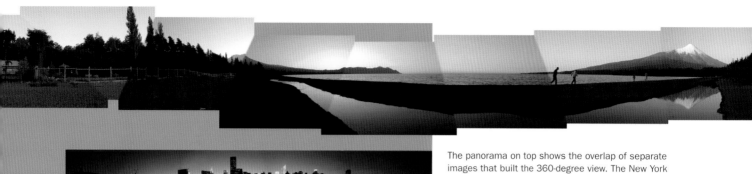

The panorama on top shows the overlap of separate images that built the 360-degree view. The New York waterfront was also composed from separate JPEGS. (JPEGS are the most common file format used in digital photography—see end of chapter.) There are specially built digital and analog cameras that capture superwide negatives with an aspect ratio as wide as 5:1.

Carolina Kroon; Robert Amsler

panoramic frame

Panoramas are those photographs that have an exceptionally wide field of view—far wider that the human eye. They often cover 180 degrees or more.

I recall using instant, disposable cameras with superwide lenses that delivered great panoramas. However, with the decline of film-based photography, it seems we've lost such light-weight panoramic cameras. A pity.

Using special software, a series of digital photographs can be "stitched" together to create a single panoramic photograph, as shown. One important characteristic of a panoramic photo is the great detail (and no optical distortion) across the entire image.

in-camera framing

There is an art to composing a shot to achieve pleasing framing at the moment the photographer snaps the photo, as opposed to later in the digital darkroom.

Develop your ability to look around the edges of the frame, not just at what is going on in the middle of the frame. Images in their unedited form (no recropping) are said to maintain their **source framing.**

An entire photographic aesthetic developed around the art of framing something carefully in its actual moment of capture. For years, many well-known photographers refused to crop their pictures in the darkroom. These die-hard types considered themselves superior to other photographers because they had the chops to compose a "perfect" shot in the camera. For me, this distinction has diminished relevance today.

Digital photography makes it really easy to crop an image when it's a digital file. But this shouldn't make you lazy about how you line up your camera's frame. The images here demonstrate an awareness of the frame. You know that the photographer was purposeful in constructing these shots. Todd Calvert; Carolina Kroon; Peter Hastings

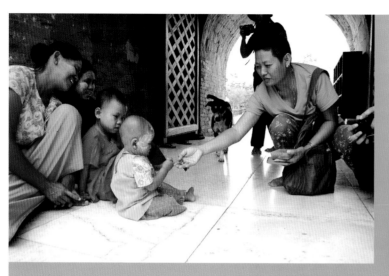

cropping

Cropping is reframing that alters the dimensions of a photograph and, in so doing, alters the viewer's focal point and the image's meaning.

You can crop your images for any number of reasons—to emphasize one portion of an image, edit something out, zoom in on a part you'd like to emphasize, or make a picture fit in a given space. The example that follows demonstrates the power of cropping: One wide-angle shot becomes four smaller, well-observed images.

Photographers and filmmakers use the term **coverage** to describe how they try to document an entire scene with a combination of wide shots and close-ups. After the shoot and back at their studios, they choose which images and which crops work best.

The source image at top left was shot wide enough to allow for lots of recropping options. The four configurations draw attention to different parts of the picture, helping to tell a story and highlight emotions. Cropping is also useful in eliminating distracting elements such as the dog or the figure holding the camera. Perri Chinalai

COMPOSITION

The arrangement of elements within a frame defines its composition.

"Make this beautiful." There is a little voice inside a photographer's head that whispers those words as he or she lines up a shot. Making it beautiful translates into finding the right frame for the subject matter. This need not be a purely intuitive process, dependent on a moment's "inspiration." Instead, that little voice can be replaced with a useful set of conceptual tools, which follow.

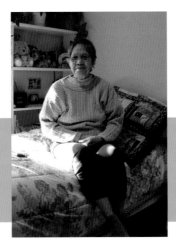

rule of thirds

The rule of thirds emphasizes placement of subject at one of four intersection points of a three-unit grid.

Here's one way to remember this bit of dogma: If the primary element in a photograph is located *dead center,* then the picture will be deadly boring. To make use of the rule of thirds when in the field, you can easily subdivide the viewfinder into thirds along both the vertical and horizontal axes. Proponents of this aesthetic rule argue that by positioning key elements at one or more of the four "power points" (intersections), you will create a composition with dynamic tension and visual energy.

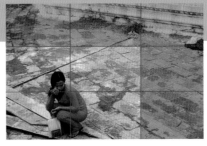

Which version of the two photos of the woman on the bed holds your interest more? The one on the right uses the rule of thirds. The grid superimposed on the photograph of the squatting woman in red shows the grid and intersection points for the rule of thirds. The bottom one works best, I think, because the girl is looking into the body of the image, not off screen. Perri Chinalai

size contrast and foreshortening

Size contrast and foreshortening are ways a photographer can use the frame to emphasize unusual relationships between objects.

It is often interesting to compose a frame in ways that mess with the scale of the subjects.

size contrast is represented in the photo of the Taj Mahal. The human form is an effective standard of measurement to use when playing with size in your photos.

foreshortening can be a powerful distortion. The ear of corn is held closer to the lens, making it appear oddly large.

Sometimes a scene before you will have built-in elements that contrast size of objects. You see the contrast and click where you stand. It's more typical, however, for the photographer to move around as he or she searches for the perfect angle that reveals a juxtaposition between foreground and background. Simos Xenitellis; Chadri Chinalai

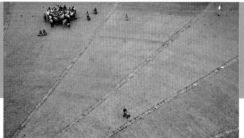

repeating patterns

A photographer can use a camera to isolate and reveal repeating visual motifs.

Here's an aesthetic tip that doesn't show up nearly as often as it should: find repeating patterns. This is a simple tactic that catches the eye and holds it. And it seems to work with all photographic genres.

Repeating patterns are often found in distance shots, like those above. Peter Forster; Peter Hastings; author

FOCUS AND DEPTH OF FIELD

Focus is the crispness of a subject in a photograph. Depth of field is the range of distance from the camera lens within which subjects remain in focus.

Focus is one of the most powerful elements of design. Back when photography was a new medium, people were surprised that part of an image would be sharp while the other parts were out of focus. The naked eye focuses so fast and so effortlessly that we are unaware of any eye movement at all. Photography's optical engineering cannot match the virtuosity of the eye and brain. As a result, all photographs exhibit a quality called depth of field. In a photograph with a lot of depth of field, the foreground, middle, and background are all in focus. In a photograph with little depth of field, only the foreground, middle, or background is in focus.

Four factors control depth of field:

- **lens choice.** A wide-angle lens gives a greater depth of field than a telephoto lens
- **aperture.** An open lens (lower f-stop such as 2.8) gives a greater depth of field than a closed lens (higher f-stop such as 16 or 22)
- **distance from camera.** A longer distance between camera and subject gives a greater depth of field.
- **lighting levels.** More light gives a greater depth of field than low light.

soft focus

An image is described as "soft" when the main subject is out of focus. This is rarely a good thing.

Viewers can instinctively tell the difference between a photograph that is mistakenly blurry and one that is intentionally blurry. A slightly soft focus—for example some of the blossoms in a shot like that shown—adds a layer of delicacy and beauty to the picture.

We instinctively see the fuzzy image of the blossoms as hopelessly out of focus, and we want it to look more like the bottom image, even though some of its blossoms are soft. Carolina Kroon

auto focus

Most digital cameras have "auto focus" mechanisms that use an electronic sensor to achieve sharp focus.

Here's how the auto focus feature works: An electronic pulse beams out from a small lens on the front of the camera. The pulse bounces off of the main subject, measures the distance, and quickly adjusts the focus setting.

Auto focus is really terrific if you wear glasses. But auto focus can create problems, too. For example, there are some situations in which you want a particular element in your shot to come in sharp, yet the camera chooses a different element to focus on. Most cameras offer a standard "work-around" that allows you to focus on the subject and hold down the shutter release halfway, locking the focus so you can reframe the shot.

In the example above, the auto focus device sensed the pane of glass between the shooter and egg. Therefore, the subject is blurred in the top photo, which must be junked.

selective focus

Selective focus uses limited depth of field to bring attention to one particular element within a frame.

By controlling what appears sharp or soft, you lead the viewer's eyes to precisely where you want it. At the same time, selective focus allows the viewer to perceive the larger context, but in a way that doesn't interrupt or distract him or her from the main subject. Single lens reflex (SLR) cameras have a button that flips a mirror inside the camera and allows the photographer to preview depth of field directly through the lens.

These shots demonstrate the expressive value of depth of field. author; author; Robert Amsler; Simon Thomas

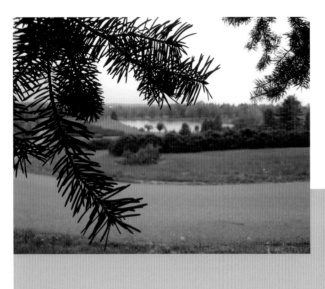
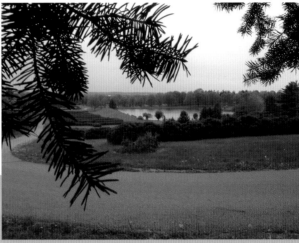

deep focus

Deep focus uses a maximum depth of field to make the entire photograph appear crisply in focus.

This pair of photos demonstrates the subtle differences between extended and limited depths of field. Both shots were taken from almost exactly the same location. But in the one on the left, the pine needles are in sharp focus while the horizon is soft. In the shot on the right, the horizon line is just as sharp as the foreground.

Take a close look at the shot on the left. The lake and trees are not in focus. The shot at right is focused from foreground through to infinity. The optics of a wide-angle lens, especially when used with bright lighting, will eliminate the depth of field, making sharp both foreground and background. Jared Cherup

BLUR

A photo subject that appears smeared and out of focus because the subject, or the camera, was moving at the moment of exposure.

Generally, we all strive for crisp images that are achieved when a subject is static or the exposure is extremely fast. If an object is moving particularly fast, it may appear blurred even at a short shutter speed.

Yet blur can be a beautiful thing. Photography's ability to freeze time and not freeze time lets us see things in new ways. Try an intentional capturing of blur, which you will discover is a hugely creative variable.

shutter speed

The length of time, in hundredths of a second, that a shutter is open

The longer a shutter is open, the more time there is for a moving subject to blur. Conversely, the shorter the shutter speed (say a hundredth of a second), the crisper the image. In the examples here we see the differing shapes of the water as it moves through the same space in different chunks of time.

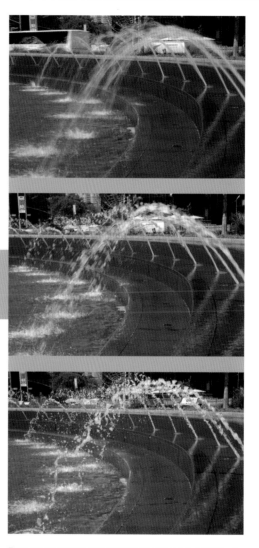

From top to bottom the shutter speeds were 1/10th of a second, 1/60th of a second, 1/350th of a second.

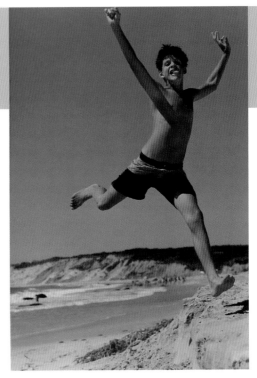

speed of the subject

How fast a person or thing is moving in front of the camera partially determines whether the image will be legible to the viewer.

Photography can suggest how fast something is going (a race car blurs more than a tricycle), or it can freeze something that is moving so that we see it anew.

If you pan your camera to follow your subject as you shoot, the background will look blurred and the subject crisp. If the subject is moving toward you, the amount of blur will be less than if the subject were moving parallel to the camera. If you choose a slower shutter speed and hold the camera still as the subject passes through the frame, the streaked subject indicates its velocity. The very fastest shutter speeds can reveal positions and relationships that were previously invisible to the human eye.

These three photos distinguish how subject speed can yield very different effects. Peter Hastings; Jamie Kruse; author

intentional blur

Blur used to achieve a range of effects.

Don't think of blur as a bad thing. It can be a very powerful aesthetic force.

Viewers, by convention, interpret blur as either an indication of an object's speed or a wobbly camera. But, of course, there's more creative range than that. It's great fun to see what images you can "paint" by intentionally moving your camera while shooting with a slow shutter speed.

These samples catch the power of intentional blur. In the first image (left),the slight blur of the boy suggests the thrill of discovering dance. The second image paints abstract shapes with the green light. The third abstracts the colors of a sunset landscape. The last creates an interesting contrast between the static human subject and the moving fish. Here blur deepens mood. author; Perri Chinalai; Chadri Chinalai; Perri Chinalai

camera shake

Unsteadiness at the moment of exposure creates blur and can ruin a shot.

Unintentionally created blur is a problem every photographer has experienced. If you choose a shutter speed longer (slower) than a hundredth of a second, you need to be careful about moving the camera while shooting and therefore creating a blur. At speeds of 1/4 of a second or longer, either place your camera on a solid surface or, better, use a tripod. Camera shake is more likely to occur with a lightweight camera than a heavier one.

When I download my pictures, there are always unusable ones because I failed to hold the camera steady enough. Camera shake can be quite subtle and may look like a soft focus. I hate it when I do this.

COLOR VS. BLACK AND WHITE

A choice you have about how you want your final photo to look. Most digital cameras will capture the image in color. Some will record in gray tones.

In the late 1950s and early 1960s, when ordinary Americans began to recognize that photography could be an *art form,* suddenly all those color snapshots taken with Kodachrome (the first commercial color film) became "lowbrow" while black-and-white photos became "highbrow."

Some of this bias remains today. But beneath any lingering snobbery is the plain fact that black-and-white photography can be powerful and memorable and has its own distinct aesthetic. By the way, **monochromatic** is the more accurate term for the reduction of the full color spectrum into a prescribed set of hues.

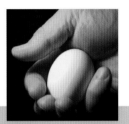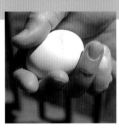
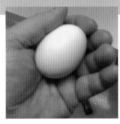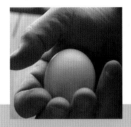

These four shots were taken using the same white balance setting of daylight. I turned off the automatic white balance function. Sources are indirect daylight (top left); incandescent (top right); fluorescent (bottom left); and direct sun (bottom right).

white balance

White balance (also known as color balance) is an adjustment in the camera that compensates for different types of lighting.

The human eye sees things in relative terms. White is white is white, right? Well not so much, actually. Your camera will prove to you, if it hasn't already done so, that the same white object takes on many different tonalities depending on the source that's illuminating it. All digital cameras have a function that lets you make adjustments, regardless of the light source, so that you can get a neutral "white" color. In some cameras color adjustment can be done through an automatic white balance setting. In others you must choose a camera setting that corresponds to one of the five most common lighting situations: daylight (also called sunny), shadows (or indirect sunlight), incandescent (also called indoor), fluorescent, or flash.

Both images here are classified as black and white, yet the one on the right has a touch of cool tone. Carolina Kroon; Chadri Chinalai

black and white

Photographs that have no hue. The image is represented in shades of gray, or grayscale.

The blackest of blacks and the whitest of whites are positioned at either end of the grayscale. In the middle is a rich mix of grays.

A hue can be added to a gray, if color is mixed in with the black. There can be bluish gray tones, called "cool" tones, and there are brownish ones, called "warm" tones. The two photographs above demonstrate the tonalities in black and white.

sepia

Sepia is a coloring of photographs that uses brown tints.

Sepia is often associated with archival photographs from the first decades of photography. The nature of early chemicals used in developing prints also caused colors to shift toward earth tones, giving a characteristic brownish color to archival photos.

There's a definite aesthetic charm in choosing to use warm color values in contemporary photography. Many digital cameras have menu settings for shooting in the sepia mode.

The shot of that oh-so-cutie was taken by a professional portrait photographer around 1944. I know the date because that one-year-old is me. The second example, also a family photo taken circa 1917, is a vignette with feathered edges and represents a design choice distinct to photographs of that period. The shot of the building is contemporary. Carolina Correa; unknown; unknown

monochromatic

A photograph that features one predominant color or part of the color spectrum is referred to as monochromatic.

Our preference for simplicity may be what causes us to enjoy photography that displays a limited part of the color palette. Photographers used to carry glass filters tinted with a shade of color. They'd mount these in front of the lens to achieve heightened color effects. Today people tend to colorize in Photoshop and other image-editing applications.

A photograph can be termed monochromatic even if it contains traces of hues other than the picture's dominating colors. Note how the person blends into the second shot. Simon Thomas; Peter Hastings

solarization

Solarization is a photographic effect in which the colors of a photograph are reversed to their opposite (negative) values.

Have you seen cool-looking images like those below and wondered how they were done? Solarization is a darkroom technique so popular that some digital cameras have a function to alter "normal" RGB color settings and create psychedelic, dramatic color treatments. Striking images result as unfamiliar hues are inserted within familiar shapes.

Some digital cameras have a menu setting for solarization. The technique evolved in analog photography wherein an undeveloped piece of color film was exposed briefly to natural light before it was put into chemical development baths. This caused the original color to either partly or wholly reverse—often in quite beautiful ways.
Dan Leithauser, Lighthouse PhotoArt; author; author; Carolina Correa

[48]

LIGHTING SETUPS

A lighting setup is a configuration of various illumination sources arranged to provide the photographer with a custom-crafted composition.

How good a photo looks is often the direct outcome of how the subject has been lit.

In the photographic studio, the photographer need not stalk dazzling illumination. He or she can make that happen. Lighting is an art form in its own right, of course. There are complete courses—indeed, full programs of study—that focus exclusively on lighting techniques.

triangulation

Triangulation is an arrangement of three lighting sources that reveals a subject's dimensionality.

The simplest approach to lighting is known as triangulation. The arrangement of just three lights around a subject provides the right combination of **key, fill,** and **backlight** to capture an object's contours using the full spectrum of light values—dark shadows to bright highlights.

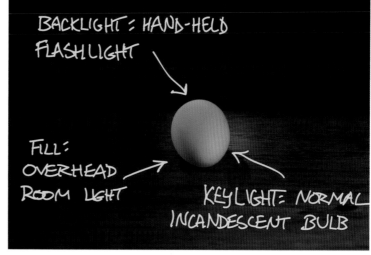

It's fun to improvise lighting setups by working with whatever is available. If you were to zoom out on this picture, you'd see my hand holding a flashlight just out of frame. The flashlight was an easy and available solution for illuminating the top and rear edges of the egg. Key light and fill lights alone wouldn't let me show the full shape of the egg in the way I wanted.

studio lighting techniques

Inside darkened studios, photographers use different types of artificial lights to achieve precise lighting effects.

The five-light setup is a classic approach for interviews or solo performances. The **key light** provides the basic light source that the viewer can easily distinguish. **Fill** gives general and "soft" illumination. The **kicker** illuminates the outside or silhouette edge of subject. The **back** or **rim light** casts light onto the back of the subject, helping to separate the subject from the background. **Background lighting** is anything that illuminates the setting in which the subject is positioned.

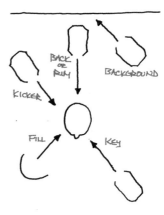

A bird's eye view sketch of a photo studio setup. The subject is at center and a wall is at one side. Five lights are around the subject, positioned much closer than they would be in reality.

flash unit

The flash is a device (often built into a camera) that produces an instantaneous burst of light that illuminates a dark scene and allows for a usable exposure.

That blinding moment of illumination—typically about one three-thousandths of a second—is extremely bright, with a color mix similar to natural daylight.

Flash photography has disadvantages. The biggest drawback is that flash lighting tends to flatten out the subject, because the shadows that provide dimension are eliminated by the head-on lighting. A common work-around is to partially block the flash with your finger. This softens and diffuses the light. With an independent flash unit that mounts on your camera or can be positioned off to the side, you can bounce illumination onto the subject from a side angle.

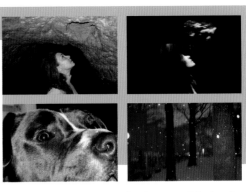

The top pair of photos were shot in a cave. A flash unit illuminates the background and flattens the woman looking up. There is some blur from camera movement in the second shot, yet the cave's natural lighting source makes a stronger photo. The dog's photo also displays the characteristic flattening of contours that comes with a flash. The twilight snowscape is a good example of employing flash in a creative way. The flash accentuates the falling snowflakes. Todd Calvert; Todd Calvert; Chadri Chinalai; Peter Hastings

lighting gear

The specially designed illumination fixtures, stands, and related accessories used in artificial lighting for photography.

There is an astounding array of lighting fixtures that provide illumination when there is little or no natural light from the sun. The illustrations provided sample the range. Gear includes not just the actual light sources but stands, screens, colored gels, and storage cases.

You don't need to have professional status or a formal studio to exercise control over the lighting in your photography. Nor do you need a closet of gear and lots of space for setting up that gear. Look online or in good photography stores for the latest generation of highly portable and relatively inexpensive lighting pieces.

These six drawings (left to right) identify a few of the lighting fixtures you might want to consider. *Photoflood bulbs* are very bright and come in clear or frosted. You will want to screw these bulbs into a *metal scoop fixture*, shown here with a handy spring clamp. A *soft light* creates a bright but diffuse illumination and is good for portraits or general fill. *Spotlights* are very bright and can be focused. The drawing shows "barn doors" that are adjusted to shield areas that you want to place in shadow. The *pick stand* holds spotlights and collapses for easy transportation and storage.

reflectors

A reflector is a surface used to bounce light into the shadows of a subject.

If you learned to use just one lighting technique, it should be the great bounce trick.

We like shadows, right? They create visual interest and show three-dimensionality. Yet shadows can be a pain when they hide the details. The most powerful and flexible lighting tool—and also the cheapest and most accessible—can be a simple piece of white paper that bounces light into shadowed portions of a subject.

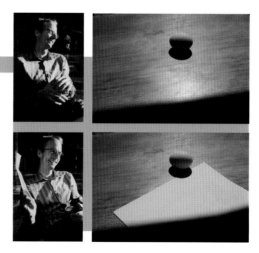

Both sets of photos show how bounced light can provide depth and detail to an object that has a strong key light source. Carolina Kroon; author

APPLICATIONS
AND FILE FORMATS

Almost all digital cameras come with a CD-ROM that carries the manufacturer's proprietary software for downloading photos onto your computer. This will get you off to a good start in organizing, storing, and sorting your photographs. As your enjoyment of digital photography expands, you'll start wishing the program could do more. Photo library applications provide handling and distribution services that offer you many other options. For example, they help you:

- work with very large numbers of images.
- automatically preserve "source" images.
- access the EXIF data (info encoded onto each photograph as it is shot).
- use file-naming protocols that include annotations, key words, and quality ratings for individual images.
- organize your collection via "albums," "buckets," or "libraries."
- track different "rolls" of images by the dates on which they were made.
- place duplicate photos in multiple libraries.
- search picture archives.
- distribute images via e-mail and the Web.
- publish bound copies of photographic books/albums.

Two photo library applications deserve special attention: Apple's **iPhoto** (designed for Macintosh computers) and **Window's Picture Manager** (which comes with many PC computers). Both are good products and representative of this software category. But there are many other choices. In alphabetical order, here are some of the more popular photo library programs for PCs and Macs: AcDsee, Aperture, ID Manager, iMatch, iView Media Pro, and Picasa.

Apple's iPhoto '08

Apple's iPhoto comes free when you buy a Macintosh computer. It is part of the iLife suite of integrated software that includes iPhoto, iTunes, iMovie, iWeb, and GarageBand. Good stuff!

iPhoto helps you organize in an intuitive way, using Events, and the application has a unifed search function that works well. You can hide photos without deleting them to get rid of clutter.

Apple's .Mac service (billed as "Your life. On the internet.") lets you easily showcase your photos in a Web Gallery where visitors can view and download your images.

Apple iPhoto. *The Source List* provides a listing of the entire library of imported photos and video clips and also lists slide shows and other items you create. *The Information Panel* shows data for individual images: size, date, keywords, rating. Note that Show Photo Info produces data about a shot's image, file, camera, and exposure. *The Toolbar* has sections for editing and organizing (left) and sharing (center and right). *The Viewing Area* switches views depending on tasks like organizing, editing images, making a slide, or building an iWeb site. *The Size Slider* adjusts the thumbnails from tiny to larger. *The Picture Shortcuts Pane* provides express lanes to folders that contain your photos and other graphics.

Windows' Picture Manager

Microsoft Office Picture Manager enables you to archive your photographs. It also provides the essential tools for photo correction and image editing such as cropping, color adjustment, brightness and contrast, rotating, and other basic features.

jpg or jpeg (Joint Photographic Experts Group)

Pronounced "jay-peg," JPEG is without a doubt the most common image format. JPEGS are compressed, but you can adjust the compression quality when you save them. The higher the compression ratio, the lower the image quality.

tif or tiff (Tag Image File Format)

TIFFS have the least compression ratio, so they are popular among graphic designers and printers. Because this format will store more information (and preserve layers), TIFFS make larger files than JPEGS.

Windows Picture Manager. *The Preview Pane* is where the images are displayed. You can change how they appear by selecting options on the Views toolbar: Thumbnail, Filmstrip, and Single Picture. *The Edit Pictures and Task Pane* leads to editing tools that enable you to make standard corrections to your pictures: brightness and contrast, color, crop, rotate and flip, red eye removal, and resize. *The Toolbar* is positioned in a standard interface location. It contains the standard Save, Print, E-mail, Cut, Copy, Paste, and Delete commands. *Auto Correct* sits in the Formatting toolbar zone and will automatically perform corrections to your pictures. Try it before you trust it.

raw

One additional file format bears mentioning. RAW image files contain the unprocessed data from the image sensor chip in a camera or scanner. They are called "raw" because they are literally raw—not yet processed into bitmaps for viewing. These are huge files and cannot be seen in Photoshop, Preview, or other standard display programs without a converter application. RAW files are primarily used by archivists, publishers who need the most flexibility in sizing and cropping images, and people who will be making very large prints from large megapixel files.

PORTRAITURE

Your goal with this project is to explore what your camera can do and what it can't. Making a beautiful portrait is a secondary objective. In fact, the worse your pictures are, the more likely you are to learn from them. After completing this hands-on adventure, you will you know every function on your camera. You will also have expanded your shooting repertoire.

You need two pals for this creative probe. Begin with a friend—someone you know and like and who likes you enough to be your photo slave. The second pal is your camera. Plan on shooing at a location where there are a variety of lighting possibilities.

As you sweet-talk someone into being your subject, be sure to give them the following warnings: You will need at least a full hour of his or her time. He or she should be prepared to hold poses for extended periods of time. Suggest bringing a book or magazine to read while you are busy preparing different setups and fiddling with your camera. This will be a work session, not a gabfest.

There are seven specific challenges. Each explores a particular facet of digital photography that yields big benefits.

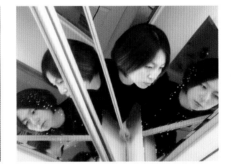

Sean-Michael Aaron; Jeff Ertz; Alan Yong Suk Lee; Jeff Ertz

1. OCCULT POINT OF VIEW

Shoot your subject using the most extreme points of view you can find. At least one image should show your subject's full body. You might experiment shooting your subject via a mirrored surface. Try to find a fresh and original viewpoint and note that giving direction to your subject is in itself something you need to experiment with. There's more to it than you might expect!

2. DEPTH OF FIELD

Take shots of your subject that incorporate both the maximum depth of field (where everything is in focus) and the minimum depth of field possible. For the latter, you might ask your subject to stretch out on the floor while you attempt to shoot some parts of the body in focus and some out of focus. Note the differences caused by shooting with the telephoto as opposed to the wide-angle settings on your zoom lens.

3. SILHOUETTE

Without a lighting kit that includes two or three fixtures and a reflecting surface, it is pretty difficult to experiment with the key, fill, rim, and other lighting approaches described in this chapter. However, you should be able to shoot a silhouette by placing your subject against a very bright background. Bracket your exposures with the aim of recording a figure that is totally filled in and shows no contours other than the outside edges.

4. FRAMING AND COMPOSITION

Try an extreme close-up, a medium frame, and a long shot. While composing at least one of the shots, set up your subject so that you are looking through or past something in the foreground (a screen, mesh, a finger, a hair, etc.). Explore the rule of thirds by shooting one image with the subject in the center. Then shoot a similar image with the subject located at a couple of the four intersecting points created when you divide the viewfinder into three equal horizontal and vertical lines.

5. BLUR

Test your camera's shutter speed by trying to make the most blurry picture possible. Have your subject rapidly swing his or her arms while you shoot with the "fastest" exposure. Then have him or her repeat the gesture, but shoot on the "slowest" shutter speed. To complete this camera test, have your subject repeat the motion a final time, and see what motion blur you get from the camera's automatic setting. Blur is a very creative design element. See if you can paint with a light by intentionally swinging the camera as you press the trigger.

6. LAG

Test the shutter lag in your camera by asking your subject to jump in place. Can you capture an image of your friend at the height of his or her jump? The jumping test will reveal your camera's speed and help you figure out how best to catch decisive moments. Note that camera lag is much less a factor with the current generation of digital cameras than it was with earlier generations.

7. FORESHORTENING AND SIZE CONTRAST

Experiment with compositions that place your subject in different visual relationships with other objects in the camera's frame. For example, position the camera so that your subject's head is tiny compared to another part of his or her body. Vary this idea by having fun with a prop.

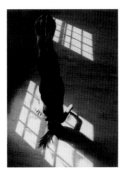

Katie Elmore; Lydia Antonini; Ken Gordon

chapter 2: IMAGE EDITING

When all photographs were taken with film, image manipulation took place in the darkroom. Illuminated only by red safelights that didn't affect the emulsions of printing paper, photographers worked with enlargers as they burned and dodged the light passing through a celluloid negative onto light-sensitive photographic paper. There was indisputably a craft to making the Perfect Print. Darkroom techniques included cropping and enlarging. Sometimes an enterprising photographer would combine elements of one image with those of another. Sometimes special effects were undertaken via chemical baths.

Today the lightproof room has been replaced by the well-lit computer screen. A digital image file—the equivalent of a photographic negative—can be worked and reworked with a dazzling set of digital tools. Dodging and burning becomes child's play. Photographs can easily be sliced and recombined. They can be recolored, cropped, superimposed, solarized, and screened—all the equivalent of traditional darkroom magic.

But the new magic goes way, way, way beyond what was possible in a traditional darkroom. The creative landscape of image processing far exceeds that of chemical processing. It's a wide-open vista where everyone—professional and hobbyist alike—can break new ground.

There is one undisputed champion among image editing applications. That, of course, is Adobe Photoshop.

PHOTOSHOPPING AS A VERB

Photoshop extends the fun of personal media making. Once you get an idea of what is possible, your relationship with your camera changes. Your imagination will be fired when you are out in the field shooting, because you will begin anticipating the creative things you can do back at your computer.

Photoshop is complex and there is a daunting learning curve. Maybe the best measure of just how much there is to learn is the number of books that have been written about Photoshop. Entire

bookcases in large urban bookstores are devoted to Photoshop. If you search at Amazon.com, you'll find over 11,000 titles. One Photoshop volume has eight hundred pages!

Few if any professional designers or photographers claim to know everything about Photoshop. It is just too vast. This chapter aims to orient you to the creative possibilities. Think of Photoshop as a verb—something you can do—not simply something you must learn. As you begin this chapter, it's a good idea to first take a quick tour of the chapter, noting which visual effects fit with the kind of photographs you take. Then circle back, giving the parts that interest you most a second read.

PHOTOSHOP VS. PHOTOSHOP ELEMENTS

Photoshop CS3 retails for $650, and Photoshop Elements runs around $90—although you can get both versions cheaper through discounters. You should probably go with the full-strength Photoshop. Here's why.

The Adobe Web site characterizes Elements as "ideal for casual photographers." That is true. The value of the stripped-down product is its focus on explicit, step-by-step assistance. Photoshop Elements helps you to organize images, make casual edits, build photo-based products, and share work via the Web.

If you are enjoying this book, then you are *not* just a casual photographer. Bit by bit you will find yourself wanting to extend your skills in altering and amplifying the images you take. As you put photographs to work—at Web sites and in documents of all kinds—Photoshop will become a valued and trusted friend. The time it takes to become familiar with the application will eventually pay handsome dividends.

By all means take advantage of Adobe's offer of a free trial of Photoshop before you open your wallet. There are also other image-editing programs to explore. See the section "Applications and File Formats" at the end of this chapter.

COMPOSITING IMAGES

Compositing images involves combining two or more visual elements to create a new image.

Our sense of what is real has been conditioned by traditional photographs, which for years have been used to record events or scenes. We've come to assume that a photo will be an accurate record of a place and a moment in time. Image editing blasts apart this convention. Digital technology allows photographers to recombine real elements into alternative forms, sometimes referred to as hyperreal because they have the full detail of what our eyes see in real life yet are artifacts of digital construction.

There are two generic forms of composited imagery: collage and blendo. These terms are not found in general usage, but they are worth knowing because they distinguish very different creative approaches to image editing.

collage

Collage includes any graphic composition that contains a variety of materials (photographs, newspaper, cloth, glitter, tape, and so on) and maintains the appearance of having been purposefully assembled.

Collage comes from a French word that means "to glue." When you look at collaged compositions like those that came from the Dada art movement in Europe just after World War I, there is an immediate awareness that the image has been synthesized. It doesn't seem real in the sense that it could have been photographed at a single moment in place and time.

This collage pays homage to President Lincoln and his Gettysburg Address. The heart of the piece is its third level, the archive image of Lincoln (opposite page). Note how the subtle shifts of color draw us into Lincoln's haunting eyes. The five layers are pulled apart on page 75. Repository: Library of Congress Prints and Photographs Division; compositing by Carolina Correa

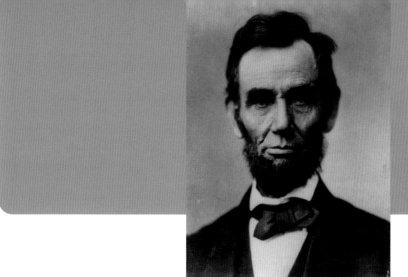

In addition to a patchwork quality, collage compositions appear layered. The image of President Lincoln, opposite, includes five different layers. Collage lends itself well to two common creative tasks: placing a subject in an unfamiliar background and combining objects that are not normally associated with each other.

blendo

Blendo refers to graphic compositions in which parts of different images have been seamlessly combined so that they appear to be an original, unprocessed image.

The term *blendo* comes from the world of cinematic special effects, where digital wizards stitch together different source images into a unified whole. The origins of this technique go back to the early days of Hollywood movies, when techniques were developed that would insert an actor into a background. Today with Photoshop and similar programs, nonprofessionals can blend unrelated source photos into a realistic whole. You can composite a photo of your mom into a city she's never visited, and no one will be able to tell the difference.

The intent with blendo is to produce an image that could have been photographed in a real space and at a real time. If done well, there should be no hint of the "doctoring" that has been performed.

This same portrait of President Lincoln is blended onto the body of a contemporary figure who is wearing a hoodie and iPod. The compositing artist has given Abe a haircut, sunglasses, and a partial shave. The color version (time-consuming to produce) firmly anchors us in the present time. You can see here how today's digital tools yield a world where it is impossible to tell the difference between a bogus photo and an unprocessed or documentary one. Repository: Library of Congress Prints and Photographs Division; compositing by Carolina Correa

RESOLUTION AND RESIZING

Resolution is the degree of definition or clarity with which a digital image is captured, displayed, or reproduced.

The term *resolution* is often used as a measure of the quality of an image. When you shoot a photo or scan an image, its original copy is called the **source.** To resize an image requires knowledge of its resolution.

There is no way to tell the size of a photograph when you first open a file in Photoshop. What you see on the screen can be misleading. For an accurate measure of source image size, you must navigate from the main menu (click>Image>Image Size) to produce the dialogue box shown here.

The amount of digital detail for a given photograph is recorded as pixels per inch. When Photoshop imports files directly from a camera, those files are often at a relatively high resolution, such as 200 dots per inch (dpi) or more. Scanners (think of them as superhigh-resolution cameras) can scan flat objects at over 1000 dpi or more. Often Photoshop shows the image size at 72 dpi, yet at huge dimensions like 36 inches x 24 inches. So don't panic if you see 72 dpi and think your image must be low resolution.

Here is an important operational note: It's good practice to save the **original** or **source** image before you start resizing it. While you can always reduce the size of a photo (either its resolution or its actual dimensions), once that reduction has been done and saved, you cannot add back what's been deleted.

The top section of Photoshop's Image Size pop-up window tells you how many bytes of digital info the image contains. The source image of young Abe Lincoln came from the Library of Congress. It is huge in its original form—almost 59 megabytes with, as shown, a document size of 56 inches wide and 70 inches tall at the 72 dpi resolution. If you change the resolution to 300 dpi, the size of the image is 13.5 inches wide and 16.8 inches high. Repository: Library of Congress Prints and Photographs Division

artifacting

Artifacting is the term used to describe distortions and discolorations that can appear in a digital image.

Don't confuse *artifact* with anything artistic. With very few exceptions, an artifact is a bad thing. Other phrases uttered in horror when the display of an image demands more resolution than is available: *jaggies, stair-stepping, messed-up,* and *real bad looking*.

screen resolution

The defacto standard for Web and multimedia design is 72 dpi. This is the sharpest resolution for an image displayed on a computer monitor.

Resolution is a slippery concept. As an operational guideline, it's important to know that a given photograph can look the same whether it is at 72, 300, or 1200 dpi resolution. The difference comes when zooming or resizing that image.

The shot of Amber with Frisbee (left) is an 8-bit, low-resolution photo. It looks okay if it is small. But when the image is enlarged (center), you notice a blocky, blurred-looking area on the dog's cheek. Basically the computer has run out of colors to shade that shadowed area, so it has selected to make those pixels the same color. The result is a blotchy patch—an artifact.

Why did it run out of colors? Well, although 256 colors in 8-bit pictures might seem like a lot, the fact is that the human eye can discern many times that. In this example the computer wasted all its colors on the grass, as confirmed in the bitmap color table (right) for this specific photograph. Joe Maidenberg

The JPEG source file is quite big for the elephant's eye. It is 60 inches by 40 inches at 72 dpi. Still, on a computer screen if you zoom in for an extreme close-up, the pixels can be clearly seen. Chadri Chinalai

The elephant's eye photo file was printed with a small HP three-in-one printer. The color print filled a standard piece of 8.5 x 11–inch computer paper, which was scanned. The printout was then scanned a second time after zooming in as tight as the scanner would permit (right). The close-up shows the tiny dots used in printing. They look quite different than the pixels seen in the previous example. Chadri Chinalai

print resolution

The resolution required for a printed image is generally cited at 300 dpi. Note that dpi (dots per inch) and ppi (pixels per inch) are one and the same.

In layman's terms, it takes many more and smaller dots to form the illusion of a continuous tone when you print an image than when you view it on a computer monitor. Problems with resolution usually occur when you go to print an image you've pulled off the Web. Switching image size from 72 dpi to 300 dpi means you are left with much smaller dimensions that you want.

display size

The view, or display size, of an image on the computer screen can be enlarged or reduced without changing its file characteristics.

When doing image-editing work, you will constantly find yourself zooming in and out. Photoshop and many other graphics applications allow you to view an image at an extreme range of magnifications—from .29 percent to 1600 percent. Viewing size affects the display of the image, but not its fundamental dimensions.

This fish graphic is very small. At 100 percent size (left), it is 2.5 inches wide—191 pixels—and has a file size of 54.3 K. At 300 percent enlargement artifacting is evident when you look at a detail of the enlarged image. With a zoom-in that increases size by 1200 percent, each pixel is clearly visible within this cropped sample of the fish's eye (right). Believe it or not, you will find situations such as logo design when it's important to work at the pixel level.

monitor resolution

**Different resolution configurations can be displayed
on the same computer monitor.**

Once a computer has been purchased and set up, few people
will ever need or want to adjust the resolution of its screen.
But it's good to be aware you have this option.

You will probably insist on working at the highest resolu-
tion that your monitor can provide, because that is the way
to see the most real estate and maximize the size of the
area you can work within.

My 12-inch Apple Powerbook G4 can display at 640 x
480 pixels (upper left), 800 x 600 pixels (upper right),
or 1020 x 768 pixels (lower left). I prefer the last one
because I can see more screen real estate, even if
items are significantly smaller.

My 30-inch Apple Cinema Display (such a luxury—
but so helpful in doing a book!) offers fourteen different
resolutions, from 640 X 480 pixels up to 2560 X1600
pixels (lower right). All of these screen captures show
the entire monitor and the same version of our fish
friend. I can always zoom in if I need a larger view of
part of the frame.

SELECTING PARTS OF PICTURES

Selection is a term used to describe a primary editing function: to cut out, isolate, or define a part of an image.

The main selection tools in Photoshop are the **Magic Wand, Lasso,** and **Marquee.** These tools do not change any of the information in a photograph. But they do enable a range of creative activities, which are sampled below.

Photoshop's Marquee (left), Lasso (middle), and Magic Wand (right) tools. These are screen grabs from Photoshop CS3 for Mac. The toolbar on your version of Photoshop may look a little different.

isolating objects

When you isolate an object, you cleanly extract it out of its source image background.

The challenge in isolating objects is finding the precise edge to the object so that you can decide which pixels are "in" and which are "out." Making such distinctions can be extremely challenging.

Imagine you want to extract the orange flower from its background at the center of the photo below. By zooming in on the image and using one of the selection tools, you can work pretty quickly in isolating the bright orange petals. Yet none of the tools will easily discern the green leaves and stem from the green foliage behind it. You must zoom into the pixel level.

With care and patience even a challenge like the source picture (top inset) can yield a clean selection (above). While most often you will find yourself wanting to isolate objects from backgrounds, the opposite can be true. There are times when you will need to capture a background to use with other foreground images. picture by author; aces cutting out by Carolina Correa

masking

Masking is a technique of covering over a part or parts of an image, while the rest remains visible and editable.

Ordinary household masking tape is the inspiration for this term. You are probably familiar with the process of putting tape over the glass in a window you want to paint. The masking tape protects what's under it, and after the job is done you can remove the tape. The difference between ordinary selections and masking is that masking is a **nondestructive** selection. Instead of literally eliminating pixels as you cut something from its background, you are simply covering over the part of the image you don't want.

The big deal here is that with masking you are making an editable selection. You can always come back to the source and tweak the mask you have created.

The source image (left) shows a pair of scissors on a blue cloth, with the "white ants" indicating the area not to be masked. The Layers menu shows the red, green, blue, and composite RGB colors, plus a high contrast, black-and-white version. The mask is applied (right) as the scissors (with accompanying black-and-white mask seen in the Levels sub window) are placed over the new image confetti background. Sara Greenberger Rafferty

sharpening

Sharpening involves altering the apparent sharpness of an image by increasing or decreasing the contrast between adjacent pixels.

Here's how sharpening works: Pixels that are *almost* black and white are *made* black and white—increasing the contrast on the edges. This can help or hurt images. Sometimes sharpening can increase the visual noise, producing unwanted small specs. Be wary: The sharpening tool can make images look great in the monitor (with more of a contrast and sharp) but awful in prints (too much contrast and sharp).

Sara Greenberger Rafferty

softening

Softening is the technique of making an image less sharp.

There are many circumstances in which it can be very effective to purposefully "soften" or blur a portion of an image. In portrait photography, for example, softening the background pushes the subject forward. This is especially useful if there is a distracting element in the background.

Perri Chinalai

GLOBAL MANIPULATIONS

Global manipulation refers to editing changes that have been made in order to complete image files (and not just a part of it).

Image editing usually involves working with part of an image. That said, there are also some very useful ways that Photoshop and similar applications help you process large bunches of pixels.

cropping

Cropping involves slicing off a portion of any or all of the sides of an image. It is usually done to focus attention or to delete a distracting element.

There are two reasons why people tend to crop their images more often in digital photography. First, most cameras have lenses that capture a wide frame, not a narrow one. Second, the resolution has become so good that you can enlarge a portion of an image and still have a sharp picture.

The best reason to crop your pictures is creative control. It is often better to shoot wide, knowing that you will be able to carefully adjust the overall composition of your picture by cropping it on your computer screen, where you can experiment with different configurations of the source image.

The source image (above) is wide and has little impact. Consider the differently cropped versions, left to right. The surfer alone lacks a sense of place. The faint form of the pier works better when the sand is cut out. The last three are much alike, with the surfer placed in different parts of the frame. Which do you like best?

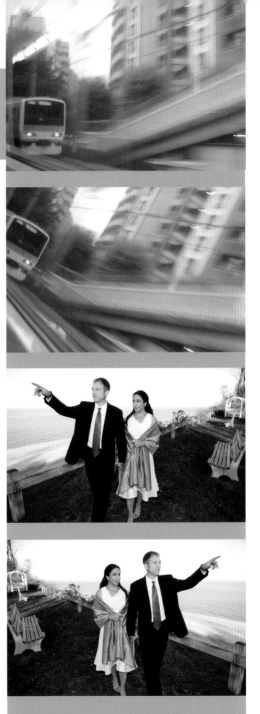

Images can be rotated in two ways. The example with bird shapes shows how the entire picture frame can be placed clocked one way or another. The subway image twists the image within a standard, horizontal frame.

Flipping requires a subjective impulse. The source image of the couple (top) feels more comfortable to me when the guy is pointing to the right of the screen (bottom).

Perri Chinalai; Perri Chinalai; Perri Chinalai; Adam Dayem; Adam Dayem; Robert Amsler, Robert Amsler.

rotating and flipping

Rotating involves pivoting an image around its center. Flipping involves inverting the image either horizontally or vertically.

There are interesting creative possibilities when you select a point of rotation other than the center. Similarly, it can be effective to twist an image slightly off the vertical and horizontal axes. All image-handling applications (including those built into a camera) allow rotating in units of 90 degrees left or right, or a full 180 degrees.

COLOR AND BRIGHTNESS

Pixels can be assigned any one of millions of colors. Image-editing software provides control in identifying, selecting, and changing colors and brightness.

For many years computer screens had color, but desktop publishing was largely a black- and-white proposition. A new era of glorious color has certainly arrived. Before we get into the nitty-gritty of color on the computer, however, let's pause to review the language used to talk about color.

color theory

Color theory refers to how computers can create a spectrum of colors using one of three methods.

With **additive color,** more commonly called **RGB,** shades of red, green, and blue are mixed in extremely precise amounts to yield sixteen million pixel hues for computer display and all the colors possible in photographic printing.

With **subtractive colors,** called **CMYK,** reflected shades of cyan, magenta, yellow, and black are "subtracted" from pure white light. Subtractive color may seem strange, yet it is much like the process our eyes experience as we walk around. A red apple, for example, absorbs green and blue, but its surface reflects red. CMYK are termed **process colors** and are used in the printing industry.

What we call black-and-white photography is, in fact, mostly made up of **gray scale.** Virtually all of today's computers can generate at least 256 gradations of gray. Photoshop can convert the RGB colors into grayscale mode.

RGB at top left. CMYK at top right. The K in CMYK is substituted for what would be CMYB, with the B for black. B also stands for blue, hence the switcheroo. This gray scale swatch shows 15 values of gray—about all the human eye can distinguish side-by-side.

hue, value, and saturation

Hue, value, and saturation are three terms used to describe color.

When you refer to color, most times you mean **hue.** That's red, blue, purple, green, orange, brown, and so on. Black, white, and gray are all colors without a hue.

The range of lightness and darkness in an image is its **value** or **tone.** More accurately, value and tone are the amount of black or white in a specific color swatch. Describing a color's value is a relative judgment that often has to do with the contrast between a color and its background or neighboring colors.

The ratio of a color's raw hue to the amount of white it contains is its **saturation.** In conversation, saturation generally means the purity or density of a hue. Saturation is also called chroma, intensity, dilution, or amount of pigment, and it may further be described as faded or rich.

When correcting color, your eye is the only accurate instrument in judging when the tweaking is just right.

Charoon Chinalai

overall cast

The overall cast is the distinct color bias in a photograph.

Sometimes images you shoot will bear an overall tonality you want to adjust. For instance, shooting under fluorescent lights often produces a bothersome greenish tinge. Image-editing applications have tools to help you make adjustments to a file's overall cast of hue.

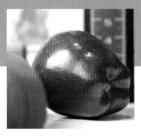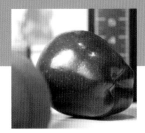

toning and duotones

Toning a photograph refers to making it a single color. Duotoning transforms a photo into two color choices.

Digital toning involves transforming a full-range color image into one with one or two hues. Images that have only one color (in addition to the background) are **monotones.**

Images made up of combinations of two colors are **duotones.** This term carries a name that evolved in traditional printing, where two ink colors (plus the default tone of the paper stock) could be used to create a photographic image with a striking use of colors.

The full-color source image (left) shows an apple with a tomato partially visible in the foreground. A monotone treatment has only one color, which here is black (middle). Of course there is always the second color of the background, which is white in this example but could be a different color if the paper stock was tinted. The third version (right) is made up of two colors—yellow and blue. Sara Greenberger Rafferty

histograms

Histograms are graphic representations of an image's contrast and brightness.

There are two forms of histograms. A color histogram is a representation of the distribution of colors in an image. An image histogram is a representation of pixel values (light and dark) within an image. This is the kind that you see in Photoshop and other image editors. The image histogram plots number of pixels (vertical axis) with a particular brightness (horizontal axis).

The histogram is a way to display data about the tonal distribution within a photo. It allows you to adjust the value scale (lights and darks) using levels or curves tools. Histograms are less useful, I think, than judgments made by the naked eye. Sara Greenberger Rafferty

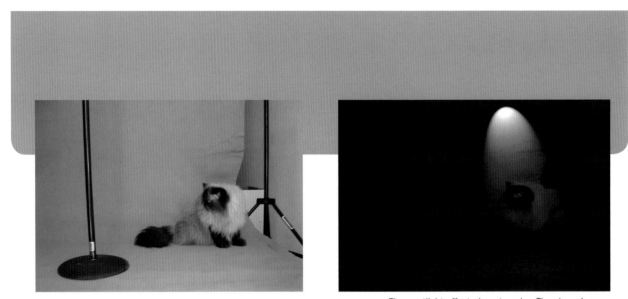

lighting effects

Adjustable filters that emulate the characteristic look of different studio lighting setups.

Nested within Photoshop's filters are some lighting effects you reach through this chain: Click>Filter>Render>Lighting Effects. Controls give a choice of different types of lighting units (spotlight, directional, omni) plus various adjustments that come with them, like intensity and width of the light's throw.

The spotlight effect almost works. The viewer's eye is pulled to the cat, and there is a characteristic cast of a spotlight. But if you look closely, it quickly becomes apparent that the real illumination is not light falling on the cat's head and shoulders, because otherwise there would be cast shadows.

Sara Greenberger Rafferty

LAYERS

A layer is a discrete, self-contained unit of an image file that shares the same dimensions as corresponding units of the same image. Layers become the primary tool for creating nuanced, complex images.

Each layer can be individually viewed and edited. Such isolation is valuable because you can return at a later time to make changes to one layer without affecting the other layers. When editing is completed, the layers are merged and exported as a single new image file—commonly as a JPG. Photoshop has its own proprietary file format that comes with the tag **.psd** (**PhotoShop Document**). This file format preserves the layers, even when the PSD is imported into other applications.

The stacking order of layers is important because layers are viewed from top to bottom in an intuitive manner. It's as if you were looking down through layers that could be partly opaque, partly clear, and partly transparent. Layers closer to the top block the pixels in the same position on lower layers. In Photoshop and similar programs, layers are easily added, duplicated, masked, arranged, blended, locked, and rearranged.

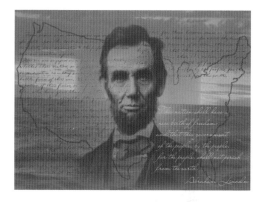

Transparent Orange Layer

Text- Quote from Gettysburg Address

Traced map of USA

Sunrise picture

Gettysburg Address image

Here is a closer look at the Lincoln collage that started this chapter. Examined one at a time, the five layers are so different. Yet they come together well in the composite version. Photoshop's Layers palette suggests how much control you get over each. Layers can be locked, turned on and off, and merged in many ways. Repository: Library of Congress Prints and Photographs Division; composited by Carolina Correa

fills and gradients

Fills are computer-generated fields of solid color or patterns. Gradients are fields that modulate smoothly from one hue to another.

Fills are easy to understand: the computer places a color or pre-set pattern inside a closed shape.

Gradients are fills of a very cool type. In painting or drawing by hand, it is extremely difficult to create a smooth and even transition between values or hues. Computers do this quite effortlessly. Gradients can be laid out in many ways and they can involve multiple colors.

The scissors image sits above a two-tone gradient (left) and a pattern field (right). Photoshop's toolbar contains controls that let you easily create a surprisingly wide variety of gradients or sweeps, as they are also sometimes called. There are also texture fields that fill in behind a selected shape. Sara Greenberger Rafferty

transparency

How much you can see through an image is its degree of transparency. The opposite of transparency is opacity.

Transparency is an important design element in image editing, although many find it confusing. It can be helpful to remember that any given pixel is made up of four components. Three of them have to do with color (separate channels of red, green, and blue). The forth component is the **degree of transparency**, and its corresponding data is referred to as the alpha channel.

Photoshop allows you to adjust the transparency of all levels except the background level, which sits below all other layers and always remains fully opaque. In the layered image (left) a portion of the two source images (middle and right) are fused. The composite image cleverly mimics the natural transparency of water. Perri Chinalai

EDGE TREATMENTS

Edge treatments can either liberate an image from its own boxlike boundaries or reinforce and expand upon the rectangular frame that bounds all digital photos.

Picture edges should be motivated. That means there should be some logic that connects the choice of an edge or frame with the content and meaning of the image.

As you look through the choices for edge treatments, ask yourself which one of them supports and extends the mood, meaning, and intent of the specific image you are framing.

border

A border sets off an image, separating it from the background. It is usually rectangular.

Borders connote a professional quality that can boost a photo from snapshot to Art. Borders are perhaps the least distracting of edge treatments. They buffer an image from its surrounding background. When framing a picture for display, a border is sometimes called a **matte.**

To add a border via Photoshop, Click>Image> ImageCanvas. A box appears with settings for a border's width and color (left). Simple as it may be, an aesthetic punch remains strong for photos that have been given the classic white border (right). Perri Chinalai; Perri Chinalai

frames

Frames are edge choices that portray representational versions of traditional, three-dimensional frames like the ones you would choose at an art framing shop.

Photoshop contains different sorts of frames. The cat above has been given a realistic version of a three-dimensional frame with beveled edges. The New Orleans shot demonstrates a contemporary snow effect and a set of nostalgic, scrapbook corners.

Photoshop's library of frames is accessed by this path: Click>Windows>Actions>expand arrow in upper right corner of dialogue box>choose the frame you want to build. Note that you must click the Play Selection button at the very bottom of the Actions dialogue box in order to apply the frame itself. Sara Greenberger Rafferty; Perri Chinalai; Perri Chinalai

feathering

Feathering involves gradually blending the edge of a selection into its surrounding background.

In the example right, the cat image is feathered into the background of confetti. The term vignetting is often used in combination with the feathering effect. Vignettes are often oval in shape and can work well on solid backgrounds.

The cat's framing is feathered into an oval shape. Note that the outside edges of a photograph can also be feathered. Sara Greenberger Rafferty

freeform cropping

Freeform cropping involves creating custom, nonregular image edges, typically including some boundaries that are neither horizontal or vertical.

There is no rule that rectangles or ovals are the only ways to form edges around an image. Freeform cropping can yield a jazzy, asymmetrical frame with energy and emphasis. But you need to have a good reason to use such a treatment or it will be completely distracting.

What would normally be a very static image (rectangles inside rectangles) is made more dynamic with this dynamic cropping. Sara Greenberger Rafferty

drop shadows

A drop shadow is a visual effect that places a translucent, soft-edged shape beneath a selected object.

Drop shadows give the impression that an object supposedly casting a shadow is raised above the surface behind it. All image-editing programs, word processing programs, and illustration programs generate drop shadows.

You can have more control over drop shadows than you might expect. Many applications allow you to alter a drop shadow's position, transparency, color, and degree of edge softness. Our innate perceptual abilities immediately recognize drop shadows and their implied lighting sources. This is why they work so well in creating the illusion of dimensionality in a flat image.

Sara Greenberger Rafferty

DOCTORING

The term doctoring doesn't appear in Photoshop's Help menu. But it perfectly describes four of Photoshop's coolest functions: cloning, blending, transforming, and red-eye repair.

Doctoring photos is fun. And when one evaluates all the different sorts of editing that you can do in Photoshop, there are few places where five minutes of tweaking will provide greater impact. The four forms of doctoring can make the difference between an image you enjoy yourself and one you want to duplicate and circulate among your friends.

transforming

Transforming includes techniques for manipulating the right underlying grid (also known as raster) that holds bit-mapped pixels in place.

Transforming is partly controlled and directed by an application's operator (you) and partly by a particular algorithm (mathematical formula) generated by the computer and applied to the image's raster.

Photoshop has lots of way to distort an image. If you select an image and then Click>Edit>Transform, you will find options including Skew, Distort, Perspective, and Warp. Photoshop's filters offer lots of other transforming possibilities as well.

A friend took this photo of my wife and me with our brand-new iPhones. The Transform functions can change the shape of the entire frame via Skew (middle left) or Warp (middle right). The last frame capture (right) shows how a Liquefy filter can be used to doctor parts of a bitmap image. Vanessa Pappas; image transformations by author

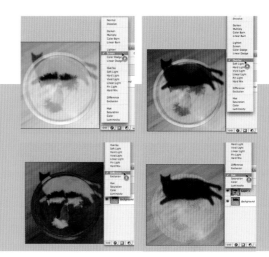

The top image shows two different layers—a Groucho Marx disguise on a plate and a soft-focused cat on a wooden floor. The next four screen captures sample how the two sources are blended in turn via Screen, Overlay, Difference, and Hue settings within Photoshop. Sara Greenberger Rafferty

blending

Blending involves digitally combining two or more layers in a PSD file according to different Photoshop settings.

> Working with a blending mode is a lot like painting over an image or a portion of that image. The Mode pop-up window (located in the Options bar) has twenty-four separate effects with names like Soft Light, Luminosity, Multiply, Color Dodge, and more.

cloning

Cloning is a technique for duplicating pixels within an image.

> Cloning is done most often for repairs. In the example to the right, the two figures on either side of the girl were covered over with cloned grafts of the water in the background.

The two figures surrounding the girl in red were covered over by repeated swatches of the water. The tools for such magic are the Clone/Stamp Tool, the Spot Healing Brush, and the Healing Brush. Sara Greenberger Rafferty

This is a twisted example, of course. This shot of my kids when they were little was retrofitted with demonic red eye and all manner of horrid blemishes. It's fun to poke fun at touch-ups, but the service is an important one and the skills are surprisingly easy to learn.
Sara Greenberger Rafferty did the dirty work.

red-eye repair

Red-eye happens when a camera's flash bounces off the subject's retina and is caught in the exposure that follows the flash by a few microseconds.

Here's how red eye happens. In the dark, the human iris opens wide, thus revealing a "mirror" (the retina) that reflects the incoming light.

There are few things more disturbing than the photo of a loved one whose eyes beam with the satanic glare of "red eye." The techniques used for cosmetic fixes combine a number of cloning and blending techniques. Together, they are valuable in touching up recent shots and in repairing old photographs. Image editing makes it easy to eliminate dust spots, repair rips, whiten teeth, erase blemishes, and eradicate other problems brought on by time and mishandling.

FILTERS

Photoshop contains more than ninety filters that you can apply to an image with a single click. These filters effect striking, global changes to the character of a source image.

Filters have been dismissed as gimmicks. But they are far better than that. Photoshop's filters and the plug-in filters created by others constitute a rare and genuine expansion to the language of visual design. As digital imagery finds its place in our global information sphere, it's possible that specific filter effects will take on far greater significance than they have now.

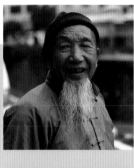 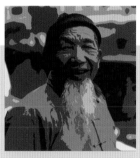 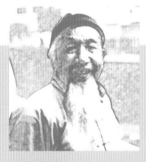 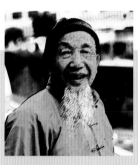

 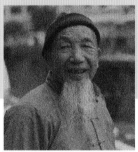

Photoshop has many groupings in its Filter Gallery: Artistic, Brush Strokes, Distort, Sketch, Stylize, Texture, and more. The selection here is but a taste of the dozens and dozens of available filters. Third-party *plug-ins* offer dozens of ways to process digital photographs. Plug-ins are application extensions. Think of them as stand-alone algorithms that offer yet more ways to transform a photograph file's pixels.

Chadri Chinalai; Filters added by Perri Chinalai

COMPRESSION

Media forms like video and music, which store very large data files, require that you be able to compress the digital information.

Compression is not just for large data files like videos or pieces of music. It is often required even for single-image files. Here's why. Large-size images can be a big, big problem. They clog up the Internet and hog storage space. They make computers run slow and crash. And they can be a nightmare to download.

Programmers and computer scientists have spent decades refining systems that can identify and eliminate "undetected" or "redundant" pieces of information within picture, video, and audio files. The trick, of course, is whether or not the eye or ear can discern such compression.

measuring data

Digital terminology includes specific units that measure quantities of data.

It takes awhile to develop a sense of the measurements of digital data. You may want to return from time to time to the chart shown.

Bit	a binary "letter," i.e., a 1 or 0
Byte	a binary "word," equal to 8 bits
Kilobyte (K)	1,000 bytes (about a page of text)
Megabyte (M)	1,000K (a short novel)
Gigabyte (G)	1,000M (Beethoven's Fifth Symphony, CD quality)
Terabyte (T)	1,000G (all the books in a mid-size library)

compression schemes

Codecs—short for compression and decompression–are compression schemes used to reduce the size of binary files for storage, processing, and transmission.

Three factors combine to establish an image's size: pixel count, color bit depth, and compression scheme.

The pixel count is fairly obvious. The larger the dimensions of an image, the more pixels it has. More pixels equal more size. The only thing you need to watch for is that tricky equation from geometry, where if you halve the number of pixels in the horizontal and the vertical, you've actually quartered the size of the image . . . right?

Color bit depth is also a huge factor in the file size of an image. Bit depth measures the number of bits of information in each pixel. Twenty-four bits is today's operating standard for information contained by each and every pixel—the string of twenty-four zeroes and ones contains information about a pixel's location, color, and transparency. The same basic image with only 8 bits of color will be one-third the size of its 24-bit cousin. (The version with less bit depth will display fewer hues, of course). Sometimes professionals work at 36-bit color depth. This extends the number of elements that can be specified for each digital unit. The resulting file sizes are humongous, just as you'd expect.

Codecs, a somewhat awkward term, is used to describe compression systems that use common sense and mathematical insights to construct complex algorithms used to reduce the size of the file needed to represent a picture.

For example, because the background of the earth photograph is consistently black (portraying deep space), then a compression algorithm can use a formula to corral all the pixels that are black into one small chunk of digital code—not endless repetitions of 24-bit info about each and every black pixel. This, of course, takes up far less room than writing out and saving each black pixel.

Compression schemes can be **lossless** or **lossy**. The former abbreviate binary code without discarding any info so that when an image is decompressed it is identical to the original. Lossy schemes, such as JPEGs, employ ways to average or discard the least significant data. Compressed formats include JPEG, GIF, and PNG. Uncompressed formats include PICT, BMP, and TIFF.

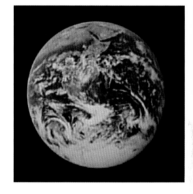

How big is this image? 8.5 x 11 inches? 604 x 480 pixels? 937 kilobytes? All three are actually correct. How you measure digital size can be done in all three modes: by the outside dimensions of the image; by the number of pixels in the image, or by the measure of digital data in an image file. NASA

APPLICATIONS AND FILE FORMATS

image-editing applications

Although full-strength Photoshop is highly recommended, there's one good reason to begin with a simpler and less expensive application. And that's to get started *now*. Please remember that while this chapter is built around the specific function within Photoshop, you'll find parallel functions in the alternative applications.

Picassa is a free software program from Google. Other popular applications include Paint Shop Pro, Corel Photo-Paint, The Print Shop, Image Doctor, Printmaster, Microsoft's Digital Image Suite, Roxio's PhotoSuite, Kid Pix Deluxe, PhotoStudio Expressions, and more.

Basic considerations include cost (what investment can you afford now), hardware requirements (you don't want to be forced into getting new gear), usability (try it yourself), and functionality (will it do what you need it to do?).

Adobe's Photoshop CS3

When you open all the windows contained in Photoshop's interface, your screen seems like it might burst with menus.

The version of Photoshop sampled here is part of the Creative Suite (CS) that the Adobe Corporation sells as

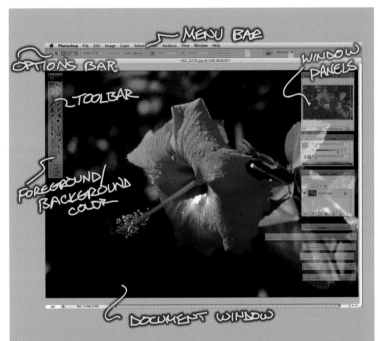

Adobe's Photoshop CS3. The *Document Window* holds the image you are working with. The image file itself can be different aspect ratios and sizes. Altogether there are twenty-one *Window Panels* in Photoshop CS3. Some are called panes and some are called palettes. Each expands to reveal and give access to different functions. Panels can be moved around and collapsed or expanded. Sometimes they are grouped with tabs that are active. The *Menu Bar* is the main interface. Everything is presented via pop-down windows. The *Options Bar* changes depending on which Tool has been chosen. The *Toolbar* has over sixty different tools grouped under the twenty-five icons. *Foreground/ Background Color* is only one of the tools, but it is an especially important one.

a package of computer graphics applications. Actually, it's not quite that easy. Adobe sells no less than six versions of its Creative Suite 3. The simplest is called Design Standard and includes four applications plus some smaller linking applications. The Master Collection has a dozen major applications. Check the Adobe site to see if one of these works for you or if you want to purchase the applications one at a time.

Hewlett Packard's Image Zone

Various personal computer, digital camera, and printer/scanner manufacturers offer applications that have basic photo-editing features. Hewlett Packard's Image Zone is a widely used example. Although not as full featured as Photoshop or other dedicated image-editing applications, Image Zone has lots of functionality and utility.

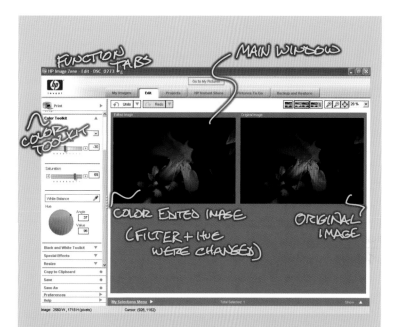

Hewlett Packard's Image Zone. The *Main Window* is where the work gets done. The Editing Tool Palette is located along the left side and shows the *Color Toolkit* in this captured frame. Use it to adjust contrast, sharpness, and color as well as to perform many other functions. The *Projects Tab* has some very useful templates: Panoramas, CD Labels, Calendars, Brochures, Album Pages, Cards, or Flyers. HP Instant Share allows others to view and print your photographs over the Internet. There's also an "up-scale" opportunity to order prints. Pictures to Go adds images to mobile media—cell phones, PDAs, cards, and portable USB drives.

Google's Picasa

Free image-editing programs are available online. One of the most popular is Google's Picasa, which works only on PCs operating with Windows. The application offers "basic fixes" that crop, straighten, adjust color and contrast, and eliminate red eye, There are also a dozen visual effects, a function for writing captions, histograms, and EXIF camera data. Picasa has a slide show program that makes movies. It also has a picture collage function, which is sampled in this screen grab.

Google's Picassa. *Folders List* is on the left of the *Library Tools*, seen above. You can change how this looks and works. *Photo Tray* and *Output Options* offer a full range of functions. Sampled in this screen grab is one called *Collage*. *Light Box* is where the work takes place. The term references an analog viewing device that has a bright, even set of fluorescent lights beneath a white opaque surface. It is an ideal tool for viewing color slides of the bygone era. Picasa has a really clear "Getting Started Guide" with a PDF you can print out.

. pdf (PhotoShop Document)

You should always use Adobe's propri-
etary PSD format when you are work-
ing with layers, paths, and channels.
After a work in progress yields a final
version, the PSD can be "Saved As"
a JPEG or TIFF file, which will flatten
it into a single layer. Preserve native
PSD versions of a file if you think you
might *ever* return to it for additional
editing and versioning.

Paint.net

Paint.net is an open source and
totally free program for Windows PCs
that offers more editing capabilities
than Picasa and operates in much the
same way as Photoshop—with layers,
filters, and special effects.

.gif (Graphic Interface Format)

This highly condensed file format
is especially useful in compressing
images for the Internet. GIFs do not
work well with photographs because
they often are made from a range of
shades and colors. GIFS are great
with graphics that feature solid colors
and sharpened edges.

Paint Net. The *Main Menu, Tool Bar,* and *Tool Attributes* are clustered at the
top and work much like the corresponding user interface of Adobe applica-
tions. *Canvas* is the main work area, which is nice and big. The *Tool Palette*
and *Layers Pane* are what you'd expect. *Color Wheel* is smartly designed: It's
large and its functions are easy to access.

PHOTOSHOP MAKEOVERS

This project is a way to explore Photoshop's filters and other visual effects. The end product becomes a set of **multiples**—versions of the same image intended to be viewed as a group.

This kind of image processing is fun. It can be easy, too—just a single click to apply a filter. Often the best results come when you combine different effects through building layers and by reprocessing an image many times in different ways. Multiple treatments can transform an everyday source image into realms of imagery that no one has ever seen before.

As a general goal, aim to make fifteen variations of the same source image. This will provide an opportunity for you to explore the amazing variety of filters and related effects. Explore freely and range widely. A final goal of this little exploration will be to select four altered images and create a composition, all mounted in the same frame. Our minds thrive on comparisons. Each image in the frame will be stronger because of the others.

The pull-down menu for Photoshop's filter gallery (left) was applied to a source image (right). A frame grab (middle) shows the Filter Gallery as it previews the Neon Glow filter. Note the slider controls let you subtly fine-tune the effect. Kohn Liu

1. HEAD SHOT

Shoot a head-and-shoulders photo of yourself or a friend. Make sure there is some illumination on both sides of the face. Pose the subject against a solid textured background, but one without distracting objects. Consider cropping your source photo into a square format. Sets of squares work very well in the multiples configurations.

2. OPEN PHOTOSHOP FILTER GALLERY

Import your image into Photoshop and label it "makeover source." If there are distracting background elements, clone these out of the picture or soften the background. Check out the pull-down menu that accompanies the main menu's Filter option. By opening the Filter Gallery, you arrive at a dialogue box that makes it easy to preview the dozens of filters.

3. MAKEOVER ROUND 1

Proceed in checking out different effects. Snoop around the Filter Gallery. As you preview the visual impact of different filters, make notes and mark those you like best. Each time you save a new version of your image, it is very important

that you give it a file name that will help identify the specific filter you've applied. Furthermore, each filter will have different sliders and other input controls that give you control over specific elements of the filter. Make notes to yourself.

4. EVALUATION AND ROUND 2

Look at your results. Which are most aesthetically successful? Which versions create an emotional response? Do any resonate with a particular quality or characteristic that you recognize in yourself or the person in the photograph?

5. REPEAT, CULL, AND DISPLAY

Repeat steps three to four to create at least four variations that might work well as an ensemble. Your goal now is to generate a single page printout that displays four (or more) images and is suitable for framing. You can build such a composite image in Photoshop, Illustrator, MS Word, or another layout program. To make the images pop, try placing the images over a dark gray background, as suggested in the series of examples. You can also turn your entire Makeover file into a slide show (see Chapter 5).

My graduate students at The New School produced these makeovers. I appreciate their willingness to share these personal probes.

Kohn Liu; Desiree Baldwin;

Nathalie Joachim;

Benjamin Ing

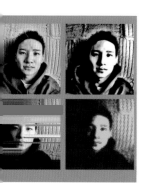

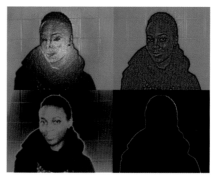

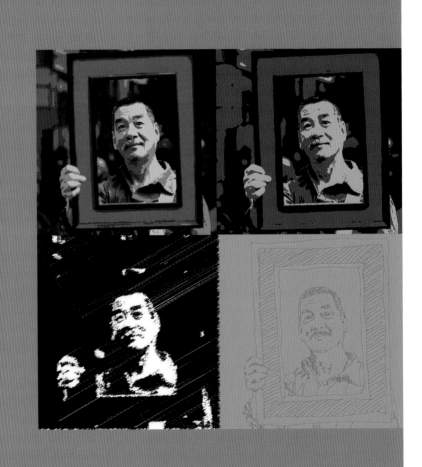

the PAGE

Selecting typefaces and laying out a page—once the rarified tasks of a handful of professionals—are now undertaken routinely millions of times a day by people in all walks of life.

Each one of them is acting as a graphic designer, although only a few would even identify in the slightest way with that term. In fact, many who regularly communicate by printed page and computer screen have little awareness that their design choices matter.

Of course those choices do matter. Even a touch of design savvy will make a report read smarter, an invitation beckon with more charm, an e-mail land more memorably, a Facebook entry exude a touch of cool.

In the next couple of chapters you will have an opportunity to slow down a bit and inspect—one at a time—the different elements of design that you are already working with on a seat-of-the-pants basis. I think you will be surprised how such a review will enhance your enjoyment of media making. You will come to appreciate that when the elements of design are used in a coordinated way, the impact shows up fast.

THE ASCENDENCY OF DESIGN

In the early part of the twentieth century, the term *graphic design* referred to **print-making** techniques such as etchings, lithography, and block prints. Printing technology, which had started 400 years earlier, had worked out conventions for using type and hand-rendered images. At the turn of the last century it was printers, not designers, who directed the assembly of **books**, **newspapers,** and **flyers.**

As new kinds of printing techniques developed in the twentieth century, graphic design was born through the expanding visual vocabularies of **magazines, posters, advertising,** and **packaging. Logos** and **signage**, evolving in tandem with the idea of consistent **branding,** hit full stride in the early 1950s as the field of corporate design grew. At this juncture design professions jumped from artistic to commercial.

In the 1960s new forms of **motion graphics** (based on animation and optical

printing techniques) emerged within the feature-film industry. And by the 1970s television networks (especially cable networks) were inventing what became known as **broadcast design**—fancy show openers, stay-tuned bumpers, and five- to ten-second station IDs.

The biggest evolution of design has come with **desktop publishing.** Since the 1990s, the use of personal computers and personal printers has allowed just about everyone to create forms of communication that previously had been the work of professionals. The basic unit is still the page. Yet the page now has an electronic form—the computer screen. The aesthetic vocabulary continues to evolve as new visual and interactive elements expand our patterns of usage. The next two chapters explore the domain of the page and screen design. This is the frontier of modern graphics and, as you will see, the very language of design is exploding in new directions.

SKIMABILITY, FIRST READ, AND CHUNKING

We are all victims of information overload. It was bad enough before the Internet came along. Now the problem has reached pandemic proportions. No one—but no one—can keep up with the ceaseless flow of information. Three odd terms—*skimability, first read,* and *chunking*—offer hope as we try to resolve this serious dilemma. Design teacher and curator Ellen Lupton throws out a very contemporary challenge to those who prepare anything to be read:

> **Although many books define the purpose of typography as enhancing the readability of the written word, one of design's most humane functions is, in actuality, to help readers avoid *reading*.**

How can we reduce the need to read? Every document, from a party invitation to a photo album, has an inherent logic of its own. If you can stand back and see that logic, then you can help others grab the basic information they are after at a glance—literally at a glance.

Skimability is the art of structuring information so that the eye can easily "flow" through everything presented on a computer screen or in a document. Here's a valuable insight—and one you can verify through your own experience: When encountering a page (or screen) of information for the first time, the human eye habitually follows a Z pattern, starting from top left. Good layouts attempt to channel this process and seduce the reader's eyeballs to scan in a particular path. **First read** refers to the initial skimming of a layout. It takes less than a second, but forcefully prepares the reader for the experience ahead.

In a page layout, there are many different elements that lead the eye. Of course type selection is very important.

Trees

Nests

Stairs

But there is also the hidden structure, or grid, that determines the placement of the text, the positioning of images, the use of heads and subheads, and more. In everything you design you will want to add visual cues that let your audience skim for key points, facts, opinions, and ideas. This means that you have to figure out in advance what you really want to say. What's the most important message? Is there a photo to connect with a specific idea? What is the lead story in a newsletter? What are the key transitions in a slide show? What calls-to-action do you want to provoke when someone visits your blog or reads your pamphlet? What are you hoping your readers will take away?

The need for speed is particularly critical with the Internet, where users expect to be able to find things quickly and efficiently. Make no mistake. The designer's job has become more important, not less. The reader or site visitor who comes upon your work expects you to lead them, to move them along quickly, and to make sure there is a clear take-away.

Design gives you power to express and emphasize the meaning of what you put on your page or screen. Composing a layout that really works requires you to bake the meaning into the design and not just rely on single images and words to convey your message.

The three sketches in the left margin show very basic architecture that reflects the hierarchy of information: trees, nests, and stairs. These layout patterns show off order of importance within a complex set of elements and illustrate basic relationships between elements.

In a wonderful volume titled *Universal Principles of Design*, authors William Lidwell, Kritina Holden, and Jill Butler observe that according to research findings, people's short-term memory consists of just four memories, plus or minus one. This is the take-away capacity of a reader looking at your page or screen. So when you prioritize the information you want to convey, there's not much point in going beyond the first three to five items.

What if you have more than five things to say? **Chunking,** or breaking information into subgroups, speeds recognition and makes it easier to process more complex information. The way you treat the chunks will give a sense of order and conciseness in your page layout.

The sketch at right illustrates the power of chunking. At a glance you can see how three groups are much easier to take in than nineteen equal items.

SIMPLICITY RULES!

Another one of my favorite design gurus is John Maeda, a former professor in MIT's Media Lab and now the president of the Rhode Island School of Design (RISD). and a world-renowned graphic designer. He has written a short book with ten laws for simplifying information. These are very practical and hands-on insights that

together show us how to use less but get more.

WHAT'S THE ROI ON AESTHETICS?

Meaning is one thing. But what about beauty?

ROI is a business term. It stands for "return on investment." If you are a banker or venture capitalist, you are looking for big returns of 20 percent or more for the moolah you've put into a business. It's easy to calibrate ROI when dollars are involved.

But how do you measure ROI on good design? Is there value added when you make something look good? How would you measure the emotional impact of a photograph? Is it worth finessing a posting to your blog or the poster you make for a charity dinner?

Traditional aesthetics refers to an understanding and appreciation of beauty *plus* the ability to evaluate beauty consistently as a matter of everyday living. Growing up you've formed your own point of view about what looks good and what seems right. Your aesthetic taste may not be absolutely consistent yet, based on your cumulative life experience, I'm sure

Ten laws of simplicity

1. reduce: The simplest way to achieve simplicity is through thoughtful reduction.

2. organize: Organization makes a system of many appear fewer.

3. time: Savings in time feels like simplicity

4. learn: Knowledge makes everything simpler.

5. differences: Simplicity and complexity need each other.

6. context: What lies in the periphery of simplicity is definitely not peripheral.

7. emotion: More emotions are better than fewer.

8. trust: In simplicity we trust.

9. failure: Some things can never be made simple.

10. the one: Simplicity is about subtracting the obvious and adding the meaningful.

Condensed listing of John Maeda's *The Laws of Simplicity,* used with permission of the NUT Press.

you can say of good design, "I know what I like when I see it."

Where does taste come from? Taste is partly cultural, acquired without awareness as we grow up. Think of what people thought were good hairstyles in the 1960s or nice-looking eyeglasses in the 1970s. Yet aesthetic preferences are individual, too. People will always make different personal choices about color and style. Moreover, our preferences are constantly evolving.

My mentor in media studies, John Culkin, once quipped, "People get good taste by tasting good things." Enjoy these next chapters and the opportunity to taste a wide sampling of graphic design.

This parade of ampersands is a reminder of how wonderfully varied type fonts can be and how they are expressive of different emotions, design eras, and visual styling.

chapter 3: TYPE AND LAYOUT

Many people spend their entire lives looking at the printed page without ever pausing to figure out how and why the type looks good, conveys a mood or message, or is (or is not) legible. In this chapter we'll take that pause to look at the nature of letterforms and how they combine in individual words and running text. We'll also study the elements that go into any written document, be they personal correspondence, newsletters, Web pages, or books.

There is a big reason and a small one for why this is worth doing. The small one has to do with filling in holes in your knowledge base. This book has already made the assumption that you're a person who enjoys making personal media on your own and that you notice how type and layout work. But there are probably some gaps in your knowledge. Let's fill them.

The larger reason has to do with expanding your range of creative options. By standing back to inspect all the different parts of page design, you will get some new ideas for combining different choices into a fresh and effective whole. The

choice of a particular font style affects the choice of heads and subheads. The width of your text column will in part determine the type size you should use and whether lines of text should be justified or ragged right. The elements of graphic design influence each other, and this chapter looks at the elements and how they add up to more than the sum of their parts.

BECOME A STYLE MAVEN

Why do we instantly recognize a CD cover as "so 80s" or pause to examine a magazine ad that feels so completely fresh and inventive?

Every era has a distinct style—a mix of visual emphasis, graphic style, fashion sensibility, and popular taste. Together these elements form a dominant visual aesthetic that permeates the culture from top to bottom. In their book *Graphic Style: from Victorian to Digital*, Steven Heller and Seymour Chwast present compelling arguments for why there is a dominant visual aesthetic for each era. They feature this quote from the British critic, Sir Mica Black:

Style is the signal of a civilization. Historians can date any artifact by its style, be it Egyptian, Grecian, Gothic, Renaissance, Colonial, American or Art Nouveau. It is impossible for man to produce objects without reflecting the society of which he is a part and the moment of history when the product concept developed in his mind. . . . In this sense everything produced by man has style.

The pitch here is for you to become a constant observer and collector of the emerging styles that our culture regularly churns out (with some help from the advertising and fashion worlds). An ongoing fascination with what is going on in the mediascape can nourish that part of you where ideas for new projects and ways to express yourself are born.

The velocity of new design movements is accelerating. Authors Heller and Chwast observe that in just the past fifteen years our culture has chewed its way through New Wave, Punk, Deconstruction, Émigré, Fontism, Controlled Chaos, Rave, and the New Simplicity. Turn on the TV or flip through a glossy magazine: What are the latest looks that you can recognize?

Scour your visual world for things that strike you as being "new" or "radical" or "edgy." Keep a file of things you've ripped out of newspapers or magazines that represent current trends. Use the screen capture utility to grab hot visuals from blogs or sites. If you need help getting started as a style maven, ask your most clothing-conscious friend what he or she thinks is the best new fashion trend. As a personal media maker, you too will want to be a student of the constantly evolving here and now.

Here are seven broadly recognized eras of graphic style, set in type fonts typical of those eras.

TEXT

Text is the visual representation of spoken language.

We tend to think of the text blocks as so standard as to be indistinguishable. Yet lots of careful consideration goes into the selection of typeface, spacing between lines, length of lines, and positioning of running text.

legibility

The first imperative of text is legibility—that it can be read or deciphered.

The accompanying illustration makes the point that fancy text is not necessarily quick or easy to read. How long did it take you to decode the word?

Can you make your way through the distracting flourishes of these nine uppercase letters?
Jamie Kruse

aliasing and anti-aliasing

Aliasing and anti-aliasing are ways to fool the eye into seeing smooth edges in images composed of jagged pixels.

Letterforms and other sharp-edged graphics can look awful if the pixels that compose them are only black and white. Anti-aliasing employs gray-toned pixels within bitmap images to create the illusion that edges are smooth.

"Jaggies" or "staircasing" occurs when the resolution of a bitmapped image or font is insufficient. Here the letter has been enlarged so much that the square pixels become visible.

The image on the top has anti-aliasing gray pixels. On the bottom, the letters have no anti-aliasing to smooth the edges.

text blocks

Groups of sentences and paragraphs are called text blocks. These are the primary building blocks of pages.

Monolithic columns of unbroken text are not only hard to read, but nobody really wants to read them. There are zillions of ways to divide them up with variety, style, and wit: ruled lines and borders; background fills; "dropped out" type (white text on a dark background); bold words at the head of paragraphs; lists; images; indents that vary column width.

These thumbnails sample the prototype, double-page layouts for this book. The design emphasizes chunked text. Layout design by Karla Baker

highlighting

Highlighting involves displaying text in ways that stand out on a computer screen or page.

Always try to help your reader move quickly.

Envision a document as a stream the reader must cross. Highlighted words are well placed stones that let your reader move quickly. You can highlight parts of a text passage by using font styles (underlining, italics, bold, small caps, and so on), color (in front or background), and a mix of font families.

The sample paragraph uses all of these in one place.

"Compared to the law, *medicine,* or **architecture**, whose formal discourses date back to antiquity, GRAPHIC DESIGN is a newcomer to the professional scene, appearing in the early twentieth century. As a medium closely connected to popular culture, graphic design has had tough time defining itself as an autonomous academic discourse. One could say that for graphic design, the barbarians have always been at the gate. We are the barbarians, the bastard children of *fine arts*."

Ellen Lupton, "D.I.Y. Design it Yourself"

Ellen Lupton, Princeton Architectural Press; quote from *D.I.Y Design It Yourself* (2006)

LETTERS

A letter is a unit of an alphabet that represents one or more speech sounds.

There are twenty-six letters in the Roman alphabet, the one English uses. In combining letters into words and para-graphs, languages require additional marks and symbols. And then there are numbers too. If you add all the punctua-tion marks, there are about one hundred elements we use regularly in written communication. Many computer key-boards, for example, have forty-six keys, and each one has two different letter or symbol forms.

calligraphy

Calligraphy is artistic handwriting or hand lettering.

Before typewriters and computer keyboards ossified our fingers, penmanship was generally appreciated as a form of art. You can gain valuable design ideas if you study the elegant drawings that visually represent gestures made by calligraphers' hands.

Calligraphy lives on today: Chinese characters painted on the ceiling of what was once a factory and is now an art gallery; Petroglyphs that Native Americans etched on rocks can still be found throughout the Southwest; contemporary Japanese calligraphy is revered as artwork in its own right; grafitti taggers reinventing calligraphy in a modern form. Perri Chinalai; iStockphoto; Shigeko Ushijima; Jamie Kruse.

alphabets

Alphabets are sets of letters or other characters that accompany one or more languages.

The Latin alphabet is just one of many and is used, of course, within a range of European languages, from Norwegian to Italian. Almost all human cultures have created alphabets of one kind or another. When you think about it, written communication is a mind-blowing accomplishment, and the variety is even more astonishing.

The Cyrillic alphabet is used in Russia; letters from the Burmese alphabet. The Egyptians had an alphabet that was just decoded in the nineteenth century, when the Rosetta Stone was found. Modern Greek letters and Hebrew.
Google; Perri Chinalai; iStockphoto; iStockphoto; iStockphoto

letterforms

A letterform is the shape of a letter in an alphabet.

In English there are two kinds of letterforms: cursive and roman. Cursive letters are based on the forward-slanting manner with which the human hand most easily forms letters. Roman letters are based on the vertical, upright manner in which letterforms were carved into stone in classical Rome and Greece.

As a visual artifact, the U.S. Constitution is a reminder that the level of penmanship has plummeted down in the decades since the typewriter made its way into our lives. iStockphoto

As cursive becomes less common, handwritten adaptions of Roman lettering seems to have increased.
iStockphoto

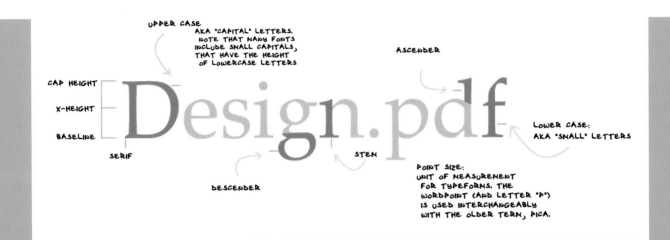

anatomy of a letter

There are specific names for different parts of letterforms.

It will serve you well to become familiar with the vocabulary that has developed for discussing type. It will also sharpen your eye when evaluating whether a chunk of type will scan easily. Learning these terms is like a lesson in anatomy.

This diagram is based on ones by Ellen Lupton in her book, *Thinking with Type.* Used with permission of Ellen and Princeton Architectural Press (2004).

computer letterforms

Computer letterforms are made up of grids of pixels and designed to be legible and look good on computer screens large or small.

Computer displays use two different technologies. **Vector/ "post script" type** is used for font sizes 10 points or higher because they scale so easily and are routinely anti-aliased (therefore appear with "smooth" curves). **Bitmap type** is used on computer screens for font sizes 9 points and below. Bitmaps are easier to read in tiny scale. Small type is especially important for mobile phones and other handheld devices. The two most popular bitmap fonts are Verdana and Georgia.

The cell phone screen (above) shows a bitmap type, Verdana. The same font is shown (below) in its vector version in different sizes.

Verdana at 14 point

Verdana at 10 point

Verdana at 8 point

type as image

Letterforms can also be used as a container for images or patterns.

Children start to read at age six or seven, with letter and word recognition beginning even earlier. The shapes of letters are coded very deeply into the human brain. So deep that we are able to both "read" a word while simultaneously "reading" the images that formed them.

With Photoshop or Illustrator you can create the outline of a letterform and then fill it with solids, patterns, gradients, or images. Jamie Kruse

TYPOGRAPHY

Typography is the art of choosing type and configuring it for the printed page or computer screen.

Movable (and reusable) type was invented in 1456 by a German man named Johannes Gutenberg. For hundreds of generations before that, scribes labored to hand copy texts. Gutenberg's invention—a mechanical means to reproduce writing—has evolved to make scribes of us all. The power of movable type now resides at the fingertips of everyone with access to a computer.

Herr Gutenberg worked in a double column format, with no attention to paragraph indents. However he did adopt the use of large wraparound letters to start new sections. By the mid-fifteenth century transcribers had developed many of the design devices identified in this chapter. Shutterstock

fonts

A font is a systematically designed collection of the twenty-six letters (in both upper and lower case) and numerals 0 through 9, plus glyphs, punctuation marks, and other symbols.

But there's even more. If you open the Insert pull-down menu in Microsoft Word and then click Symbols or other choices, you will get a pop-up menu with many more characters. You can live your life without ever having visited all the type elements available on your computer—but don't miss out. They are so much fun to explore.

But here's a warning as you explore the font pull-down menu. Resist font eclecticism. Variety, in this case, doesn't spice up a document as much as it makes it really difficult to read. Unless the circumstances are very special, your job in choosing type is to aim for simplicity and clarity.

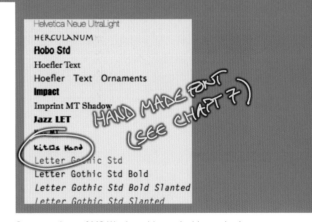

Some versions of MS Word provide a valuable service by displaying a computer's library of fonts in the distinctive style of each font. This makes it easy to preview what a font will look like on the page. The circled item, Kit's Hand, is a font I made from my own handwriting. I can type it as easily as I can type any other font. Chapter 7 will show you how to design fonts in your hand.

classifications

Fonts are described as serif, sans serif, and display fonts.

This universe of different looks, sizes, and weights of letterforms has been separated into three generic classifications. It is surprising how useful these are in sorting out what seems at first to be an impossible range of choices.

Serif fonts. These characters have thick and thin strokes and are flared at the ends of the lines. Serif fonts have evolved over the last 200 years to help the human eye read long lines of printed text.

Sans-serif fonts. This classification includes fonts with squared-off ends and a consistent line thickness. It is generally accepted that san-serif fonts, with their rounded shapes, should be used for text that will appear on a computer screen, because they are easier to read on a monitor composed of pixels.

Display fonts. Display fonts are used for headings and headlines. They attract attention and evoke an emotional response. This is by far the biggest of the classifications. They're fun to design, and, since legibility is not a primary concern, a lot of variety is possible. Most display fonts won't be legible if they're used for long passages of text.

Baskerville
Garamond
Times

Many consider serif fonts to be the best body type for use in books, where there are extended text passages and the length of a line is relatively long. The flares at the tops and bottoms of letterforms help connect them horizontally, making reading faster.

Antique Olive
Futura
Helvetica

San-serif fonts carry a contemporary feel even though they were introduced on a large scale in the 1950s.

Voluta Script
Marker Felt Thin
JAZZ POSTER

It's fun to collect display fonts. Many sites give them away or sell them. New display fonts are constantly being designed in efforts to capture the particular style of the day. Display fonts are thus fashion statements in their own right.

glyphs

Glyphs are small figures that convey information nonverbally. Some serve as the equivalent of letters.

Spend a few minutes at your keyboard locating all of the miscellaneous font-like, non-letter elements that live there. You'll find an eclectic collection. Some font characters like %, &, or $ function as abbreviations for words. Others have a grammatical function, like ! or ? or (). Some have specific technical usage. A puzzling number have unknown origins and usages.

Strictly speaking, the term *glyph* refers to font characters that function as symbols. But it can also be a catch-all term for all the nonletter elements of a font.

` 1 2 3 4 5 6 7 8 9 0 - = (normal)

~ ! @ # $ % ^ & * () _ + (shift)

` ¡ ™ £ ¢ ∞ § ¶ • ª º – ≠ (option)

` / € ‹ › fi fl ‡ ° · ' — ± (shift & options)

? Ä Å Ç º † ¶ § ¢ ¶ ® ™ © « ∆ ≈ √ æ fi € œ — » Æ

(random selection of items from file/symbols menu in MS Word)

To produce the first four rows of glyphs, I simply tapped from left to right the thirteen keys that appear in the numbers row of my keyboard. The first time across the numbers, I hit the keys. The second time across, I pressed the shift key: The third pass, I held down the option key. Fourth pass, I held down both the shift and option keys.

The line of nonletter elements (bottom row) is a sampling of the symbol characters you can find by opening up the Symbols menu found in MS Word (Click> Insert>Symbols).

font styles

Font styles are a prescribed set of treatments that word-processing applications can apply to a pieces of text.

Don't confuse font "styles" with font "families." Font families have to do with the overall design of the font. Font styles refers to a specific number of standard ways that any font can be versioned by a word processing program: italics, bold face, underline, and the like.

Microsoft Word 2007 and other popular word-processing applications like Corel's WordPerfect, StarOffice, and Apple's iWork let you switch font styles with a highlight and a click.

Mediapedia (bold)

Mediapedia (italics)

Mediapedia (underline)

Mediapedia (shadow)

Mediapedia ^{mediapedia} (superscript follows)

Mediapedia _{mediapedia} (subscript follows)

MEDIAPEDIA (all caps—capital letters)

MEDIAPEDIA (small caps)

The eight versions of the word *Mediapedia* are all in 14 point Times font. The bracketed information to the right gives the name of the particular style.

font families

The creators of a new font often design different versions of their alphabet. Such font families share a concept but present options suited to different uses.

Font families usually include normal, light, bold, and condensed versions. These variations may be used on the same page or even the same paragraph, depending on what a document needs to communicate. More exotic aunts and uncles include: italics, narrow, subhead, small text, semibold, slanted, and extended.

AaBaCcDdEeFfGgHhIiJjKkLlMmNnOoPpQqRrSsTtUuVvWwXxYyZz
1234567890!@#$%^&*()_+ (normal)

AaBaCcDdEeFfGgHhIiJjKkLlMmNnOoPpQqRrSqTtUuVvWwXxYyZz
1234567890!@#$%^&*()_+ (light)

AaBaCcDdEeFfGgHhIiJjKkLlMmNnOoPpQqRrSqTtUuVvWwXxYyZz
1234567890!@#$%^&*()_+ (ultra light)

**AaBaCcDdEeFfGgHhIiJjKkLlMmNnOoPpQqRrSqTtUuVvWwXxYyZz
1234567890!@#$%^&*()_+** (bold condensed)

**AaBaCcDdEeFfGgHhIiJjKkLlMmNnOoPpQqRrSqTtUuVvWwXxYyZz
1234567890!@#$%^&*()_+** (black condensed)

The alphabets above are all in 8 point Helvetica Neue. Each variation was completely redesigned from scratch. Helvetica Neue is a recent version of the classic Bauhaus font, Helvetica, designed in 1957 by Max Miedinger.

kerning and leading

Kerning and leading are subtle but important adjustments to the spaces between individual characters and between lines of text.

Originally, type on a printed page was created by composed "cold type," tiny metal letters placed in rows. Printers could make adjustments by hand to the spacing between characters and words (called kerning) and between lines (called leading).

Today metal type is used only in shops that print invitations or produce artist books or limited editions. Type is universally set by personal computers through a rich array of desktop publishing programs.

Applications like MS Word have preserved, extended, and fine-tuned the art of typography. Most people work with the line spacing settings that are based on the settings of manual typewriters (single, double, and triple spacing). But fewer know about kerning and leading, part of the typographer's art.

Try this out if you have MS Word on your computer.

1. Type in the sentence above.
2. Highlight the sentence.
3. Go to Format>Font>Character Spacing.
4. In the dialog box, mess around with Character Spacing—which will adjust the spacing between letters. Make a phrase and "condense" it to 1.4 points. Then expand the same sample by 2.0 points. Your results should look like this:

The quick brown fox jumped over the lazy dog but, if you think about it closely, now is the time for all good men to come to the aid of the party.

The silly sentence above jams together two sentences often used in classes that teach typing skills. Here it is used as an example to show leading—in this case a very wide spacing between lines of text.

The quick brown fox ...
(normal)

The quick brown fox ...
(condensed)

The quick brown fox . . .
(extended)

The amount of condensing and expanding between letterforms is adjustable in MS Word or when using Adobe Illustrator, which is an excellent tool for creative adjustments of type.

handmade letters

A custom touch can be incorporated into computer graphics through individual handwriting, stencils, stamps, and other sources.

Don't overlook the obvious. Some of the richest font sources are those you create yourself. Your own handwriting can add a distinctive touch to a layout created by desktop publishing.

Hand lettering (left) is distinctive because no two humans print letters or write in precisely the same way. Rubber stamps (middle left) have undergone a revival in the paper crafts movement, so look for nifty collections of letter and symbol stamps for a fresh approach that you can incorporate into your digital work. Stencils/templates (middle right) are cardboard or plastic cutouts used to trace individual letters onto paper. If you study graffiti artists, you will see many different forms of hand-drafted display type (right).

dingbats and wingdings

Most computers come with a selection of decorative typographical characters such as Zapf Dingbats and Wingdings.

What are these things used for? They have an interesting origin. The term *dingbat* supposedly originated through onomatopoeia. In old-style metal-type print shops, extra space around text or illustrations would be filled by "ding"-ing an ornament into the space then "bat"-ing it tight to be ready for inking. These little shapes and symbols are also called *glyphs* or *graphemes* and are useful in logo design, as bullets, for graphics cues, and simply as pretty ornaments.

The first three lines of symbols sampled here are made by typing the first ten letters of the alphabet with the Wingdings, Wingdings2, and Wingdings3 fonts. The fourth line is written in Zapf Dingbats.

STRUCTURE

In the context of page design, structure refers to placing objects in relation to one another in order to create a recognizable pattern.

The following set of terms about structure are closely related to **composition.** There's a difference, though. Structure is something you start with. It is an external construct that offers you a coherent way to arrange the chunks of information on your page. Composition is something that emerges from the materials at hand. There are compositional strategies you can look for, but these are always specific to the content you are working with.

The little sketches that run through the next two sections provide an intuitive way to distinguish between structure and composition. Although the drawings are the author's, he wants to acknowledge his debt to Norwegian designer Christian Leborg. In *Visual Grammar* (Princeton Architectual Press, 2007) Leborg writes, "Visual language has no formal syntax or semantics, but the visual objects themselves can be classified."

Formal structure, is the even distribution of elements along implied axes.

In **graduation,** a pattern emerges when the lines that provide structure change in an even way.

In a **spiral structure,** structure lines spiral out from a shared center point.

With **informal structure,** there is no regularity in the arrangement of objects. It is also known as random structure.

Concrete structure is in place when structure lines are visible.

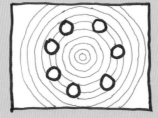

In a **radiation structure,** a repetitive pattern leads to a center point.

When **concentric structure** is in place, structure lines (usually hidden) circle the same shared center point.

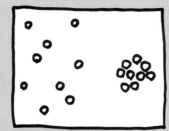

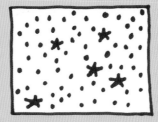

Tight and **loose** are comparative terms for structures that display characteristic wide versus narrow placement of visual elements.

Pronounced "moe-teef," a **motif** is an object, phrase, or image that appears throughout a layout.

COMPOSITION

Composition is an intentional arrangement of elements in a frame.

Composition is a word that describes the relationships between parts as they form a patterned whole. That whole—the composition—is more powerful than its parts. Composition can be about order and consistency. It is often invisible, but it also has the power to make a statement. Each of the thirteen terms that follow shows compositional choices that convey a message just as clearly as words or images can.

Composition is best when mixed with surprise and delight. Good composition zigs when you are expecting a zag.

Paula Scher is an acclaimed graphic designer and principal partner at the New York offices of Pentagram Design, a graphic design firm with offices around the world. Scher creates posters for the Public Theater, an institution dedicated to new forms of theater. They also run the Shakespeare Festival that plays each summer in New York's Central Park.

Scher's work shown here illustrates classic principles of composition. Poster making is an art form that can be practiced by anyone. A poster is just an announcement. There is usually one predominant item of importance and then three or four required elements of information such as place, time, and cost. Posters have a clear hierarchy of ideas, so they are easily chunked.

In a book, it's useful to break the elements of composition into categories. But in the real world, many design elements exist at one time, within a single document. This is certainly true of Scher's work. Although I have pigeonholed posters in order to give concrete examples of terms, it's easy to see that any given example could work in multiple categories. Every one of the posters below contains lessons in color, typography, texture, photography, illustration, focus, and more.

Paula Scher

Pentagram

balance

Balance is a quality that has to do with visual weight. A composition that is balanced is sometimes said to have optical equilibrium.

A single object, like the phone in the *"Dog Opera"* poster, can be in balance, especially if centered in the frame. The second poster is clearly out of balance and weighted heavily to the left side.

Leborg, in *Visual Grammar*, says, "Balance can be created between objects that have the same form but different positions, or between objects that have contrasting forms. Without this interaction between elements, a composition is static and not dynamic."

Courtesy of Paula Scher/Pentagram and The Public Theater

symmetry and asymmetry

Symmetrical objects have identical arrangements on both sides of an axis. **Asymmetrical** compositions display dissimilar structures on either side of a dividing line.

The first poster has symmetry to the left and right of the vertical axis. The second poster is asymmetrical. Note how the huge quotation marks provide a counterweight to the portrait.

In her book, *D.I.Y. Design It Yourself,* Ellen Lupton observes that symmetry "lends stability" while asymmetry "is organic and achieves tension." Lupton believes that "asymmetrical design attracts and holds your audience's attention longer because the visual relationships are not optically predictable."

Courtesy of Paula Scher/Pentagram and The Public Theater

size

Size is only apparent when one object references another.

Seen alone and without any context or frame, there is no way to know how big or small the object an image refers to is supposed to be. The mask in the first poster stands out because it is tiny within the frame. The second poster uses just the opposite compositional device. In it is a simple drawing that has been blown up large.

Courtesy of Paula Scher/Pentagram and The Public Theater

contrast

The strategy of contrast is achieved when compositional objects are compared and appraised in respect to their differences.

The human eye quickly perceives contrast: one element standing out from others. In a broad sense, contrast is the opposite of harmony. In the first poster, the clean white font contrasts the grays of the background. In the second example there is contrast of color, texture, and legibility.

Leborg says, "[Contrast] is among the most potent tools a designer can use to create impact and emphasis. . . . When you juxtapose an element with its opposite, the inherent qualities of that element stand out more dramatically, thereby increasing the overall dynamic of the design."

Courtesy of Paula Scher/Pentagram and The Public Theater

positive and negative

The strategy of positive and negative is in play when a composition includes an object that is reversed with its polarities: white to black and black to white.

Scher's poster for Henry VI literally uses a positive and negative image of a rose. It also reverses color fields and mirrors top to bottom. The second poster uses two positive-to-negative elements: across the background and also within the letterforms.

Courtesy of Paula Scher/Penta-gram and The Public Theater

figure and ground

Viewers should be able to easily determine the main subject in a composition—its figure. The surrounding space is always called the "ground."

Designers often intentionally play with figure/ground relationships. In the little drawing, for example, it would be impossible to know whether the red Xs or the blue squares were intended to be the foreground or background.

In the green poster the background is actually a map of Central Park in New York City. An arrow and red circle locate the physical home of the Shakespeare Theater, while the text, serving as the figure, tells us the performance is free and headlines the two plays being presented. The second poster places type on a tinted, monochrome photograph. The background references the bold meaning of the play, and the reader has to participate in filling in the letters —especially in the top line, CAUTION!

Courtesy of Paula Scher/Penta-gram and The Public Theater

direction

Compositions are often built upon spatial directions: up and down, ascending or descending, and north, south, east, and west.

Layouts can direct the eyes in certain directions and even create a palpable sense of movement. In the first poster Scher uses strong vectors to direct the eye from upper left to middle right to bottom left. The second poster shows a stairway for the reader to travel down.

Courtesy of Paula Scher/Pentagram and The Public Theater

position

An object or group of objects can define a location within a given composition. Positions include, for example, the bottom, an edge, or the center.

In the little drawing the position of the circle in the upper right of the frame could be described and located by a specific reference: six units from the left and two units from the top. The six circles are positioned bottom left. In the yellow poster the words have been carefully positioned as a visual shout. In the second poster the play's title is flush right and vertical.

Courtesy of Paula Scher/Pentagram and The Public Theater

groupings

Groupings are the gathering or disbursement of elements within a composition.

Scher depends on our built-in capacity to group elements when she designs posters such as these two that feature jam-packed typography. Her skillful use of size, color, positioning, ruled lines, and backgrounds helps us make order.

Courtesy of Paula Scher/Pentagram and The Public Theater

mirroring

In composition, mirroring refers to a pair of objects (even the same object) that is "flipped" around a central axis (which can be vertical, horizontal, or diagonal).

The first poster is a classic riff on the way a mirror inverts the image it reflects. The red and blue figures are not identical, yet they are close enough to engage the eye in comparison. The second poster mirrors through its slightly displaced version of the same photograph. The mirroring suggests the impact of a punch to the head.

Courtesy of Paula Scher/Pentagram and The Public Theater

repetition

Repetition in graphics involves duplicating the same visual element within the composition. Repetitious forms can be made via size, color, or texture.

Portions of the type create a pattern and serve as the background in the first poster for a play called *The Story*. In the second poster, stacked duplicates of a woman's head provide the repeating element.

Courtesy of Paula Scher/Pentagram and The Public Theater

white space

White space includes any unoccupied or empty areas within a given frame.

In Scher's poster for *Him*, the white space is green. The emptiness of the background sets up the Elvis hairdo. The *As You Like It* poster employs two forms of white space—the empty tan background and the white edges surrounding the cut-out body parts. The white of the cutouts shows us that the composition is a collage of picture elements lifted from another source.

Courtesy of Paula Scher/Pentagram and The Public Theater

visual frequency and rhythm

Frequency within a composition references the number of times a visual element appears in a work. Rhythm is found when there is a discernable pattern within duplicated forms.

The human eye responds to patterns just like the ear responds to rhythm, repetition, and variation. Leborg observes, "When the distance between repeated objects is identical, the repetition has an equal **frequency.** When the distance between the objects varies between several given frequencies, the repetition has **rhythm.**"

Courtesy of Paula Scher/Pentagram and The Public Theater

LAYOUT

Layout is the arrangement of text, images, and other graphic elements onto a page.

Whether it is a printed page or the page on a computer screen, each layout you create combines a range of visual elements: lines of type and units of text, images and their captions, page numbers, and headings that locate a page within a larger document or site.

Form should follow function. Toward that end, layout should simplify the way information appears on a page and help viewers find the information they want.

Where to start? Professional designers put text and illustrations into page layout applications like Quark or InDesign. Then they begin to play around with the tools on their computer. For those of us with less experience, it is often helpful to feel our way into the many design choices by making simple sketches.

thumbnails

Thumbnails are miniature sketches that preview a layout by representing the position of text, headlines, images, captions, and more.

While there has probably never been a trial layout as small as a person's thumbnail, that is indeed where the term comes from.

Start planning your layout by taking into account everything your reader will see in a single view. Books, magazines, and pamphlets, for example, are often planned out as two-page spreads. When designing for the computer screen, a thumbnail sketch should indicate how much is viewable without scrolling down.

This thumbnail drawing was created by Jan White for his book, *Editing by Design*. Although extremely simple, the thumbnail shows lots of detail about the layout. For instance, you can see bold heads used with caption text.
Jan V. White, *Editing by Design*, 1st Edition.

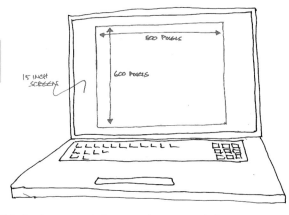

page and screen formats

There are two dominant formats for desktop printing: 8.5 x 11 inches (letter size) and 11 x 17 inches (ledger size). There is no similar standard for computer display.

It's far trickier to design a layout for a computer screen than for a printed page. There are small, vertical screens and large, wide-screen screens. What makes it worse is that even monitors that are the same sizes are notoriously different from one another in how much raster grid they display.

Printed documents have much more stable and predictable formats. Yet there can be challenges here, too.

This drawing represents the currently recommended default dimensions for a computer monitor, which is 800 x 600 pixels. Not long ago the default size was 640 x 480 pixels. Today most laptops have a 15- or 17-inch screen. But there is no standard as yet for the small screens of handheld devices.

folds and scrolling

The amount of the document or screen that's first visible in a normal-size browser is referred to as "above the fold."

Above the fold is the first thing you read, or what you see first. Even though there may be more information accessible through scrolling, you should consider above the fold as your primary design space.

The middle example shows a thin rule used to indicate where a fold should fall in a handout. Broadsheet newspapers are usually folded in half, and traditionally editors plan to put the most important information in an article above the fold (left). An online layout's "fold" depends on the height of the browser window (right), as shown by a screen capture of the *New York Times* Web site.

Jamie Kruse; Carolina Correa

margins, indents, headers, and alignment

These are all key terms that refer to the positioning of elements within a print or screen page.

The design impact of margins, indents, headers, and alignment must be carefully evaluated. Your eye is the ultimate gauge for what works best when setting values for the following.

- **margins:** the areas of a page or screen outside the main text body.
- **indent:** a space that sets a block of text to the right of the existing margin.
- **inset:** a paragraph or column of text set within a text block.
- **alignment:** the proper positioning of text or graphic elements in relation to one another.
- **head:** a word or short phrase that identifies a block of text.

The bigger drawing (right) calls out the margins, paragraph spacing, and heads. The second drawing (left) shows alignment: flush left, flush right, centered, and justified. This is also called "positioning." Take special care with justified type, because there can be huge gaping spaces between words when there are too few words for the column width. The third sketch (middle) samples a "runaround"—text that wraps around objects or other elements in the page.

grid systems and style sheets

A design grid is a hidden system of column guidelines that determines placement of text and graphics. A style sheet codifies and visualizes the rules for a layout.

Whenever you are laying out a document that runs beyond four or five pages, both a grid and a style sheet become essential.

There are even more moving parts in Web design than there are in print design. Grids are important in figuring out columns and sidebars. Flowcharts are essential in figuring out links and the architecture of site information. Both Web sites and complex print projects often require a style sheet that specifies and demonstrates choice of font, color, and more.

An informal grid (top left) sets up both a two-column (blue) and three-column (red) layout. The thumbnail (top middle) gives a sense of the visual weight of both column options. The top right grid and the layout below it are from Lupton's *Thinking with Type*. The grid is for a book layout. The layout is for a Web site's layout. Ellen Lupton, *Thinking with Type* (2004), and Princeton Architectural Press

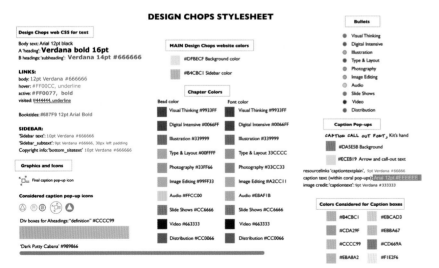

DESIGN CHOPS STYLESHEET

Design Chops web CSS for text

Body text: Arial 12pt black
A 'heading': **Verdana bold 16pt**
B headings: 'subheading': Verdana 14pt #666666

LINKS:
body: 12pt Verdana #666666
hover: #FF00CC, underline
active: #FF0077, bold
visited: #444444, underline

Booktitles: #687F9 12pt Arial Bold

SIDEBAR:
'Sidebar text': 10pt Verdana #666666
'Sidebar_subtext': 9pt Verdana #666666, 30px left padding
Copyright info: 'bottom_sitetext' 10pt Verdana #666666

Graphics and Icons

Final caption pop-up icon

Considered caption pop-up icons

Div boxes for A-headings: "definition" #CCCC99

'Dark Putty Cabana' #989866

MAIN Design Chops website colors

#DFBECF Background color

#B4CBC1 Sidebar color

Chapter Colors

Bead color / Font color

	Bead color	Font color
Visual Thinking	#9933FF	#9933FF
Digital Intensive	#0066FF	#0066FF
Illustration	#339999	#339999
Type & Layout	#00FFFF	33CCCC
Photography	#33FF66	#33CC33
Image Editing	#99FF33	#A2CC11
Audio	#FFCC00	#EBAF1B
Slide Shows	#CC6666	#CC6666
Video	#663333	#663333
Distribution	#CC0066	#CC0066

Bullets

- Visual Thinking
- Digital Intensive
- Illustration
- Type & Layout
- Photography
- Image Editing
- Audio
- Slide Shows
- Video
- Distribution

Caption Pop-ups

CAPTION CALL OUT FONT, Kit's hand

#DA5E5B Background

#ECEB19 Arrow and call-out text

resourcelinks 'captiontextplain', 9pt Verdana #666666
caption text (within coral pop-ups) Arial 12pt #EEEEEE
image credit: 'captiontext': 9pt Verdana #333333

Colors Considered for Caption boxes

#B4CBC1	#EBCAD3
#CDA29F	#EBBA67
#CCCC99	#CD669A
#EBA8A2	#F1E2F6

This a style sheet for the teaching Web site called Mediachops.com, which was the development bed for mediapedia.net. Web designer, Jamie Kruse, helped fashion the site and build it out. Jamie Kruse

captions and call outs

Captions and call outs are bits of text that explain an image.

Useful text often accompanies photographs, drawings, charts, cartoons, diagrams, or any decorative visual elements. **Captions** are explanatory comments that accompanying an image. In a book captions often include credits that cite the source of a photograph or illustration. **Call outs** are superimposed onto an image and provide more information. These include notes, arrows, and other information on illustrations or photographs. You can use both Photoshop and Illustrator to make call outs.

a Upfront Foster
b Rumkeg di Vicenzo
c Doubloons McNamara
d Topside Frankenheimer
e Legs O'Neal
f Hair Lips Grossman
g Black Sheep de Noël
h Pilchard McGee

Let's admire this lovely sense of humor. Here are two types of call outs, both shown in White's pirate example. *Editing By Design,* Jan V. White, 1st Edition.

APPLICATIONS
AND FILE FORMATS

Screen Captures

Screen captures allow a computer to record whatever is on its monitor. The whole screen can be captured or just a selected part. So become good friends with the screen grabbing utility. On PCs it's called **Snipping Tool** within the Windows Vista operating system. On Macs it's called **Grab.** For heavy lifting of screen captures, there are stand-alone applications you can buy. One of the best is **Snapz X Pro,** which was used often in making this book.

Adobe InDesign

For heavy-duty layout you need a computer program designed precisely for the job. There is widespread agreement among graphic designers working in various media that Adobe's InDesign is now the industry standard, replacing Adobe Pagemaker and challenging QuarkXPress.

If you want to do a book, for example, InDesign offers powerful features for creating richer, more complex documents including extensive integration with other Adobe applications, reliable printing, full-featured tables, and professional typographical controls.

Other page layout applications are QuarkXPress, Scribus (free), Microsoft Publisher, and Apple Pages.

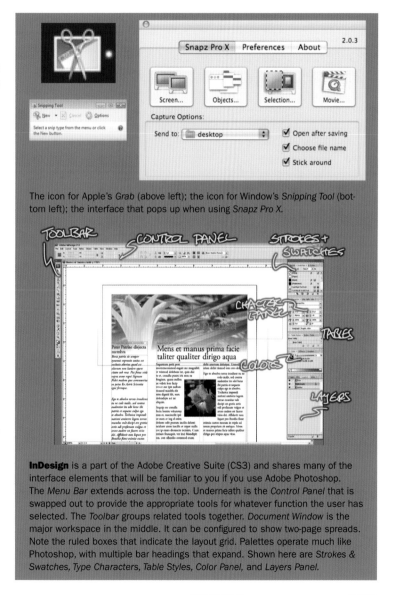

The icon for Apple's *Grab* (above left); the icon for Window's *Snipping Tool* (bottom left); the interface that pops up when using *Snapz Pro X.*

InDesign is a part of the Adobe Creative Suite (CS3) and shares many of the interface elements that will be familiar to you if you use Adobe Photoshop. The *Menu Bar* extends across the top. Underneath is the *Control Panel* that is swapped out to provide the appropriate tools for whatever function the user has selected. The *Toolbar* groups related tools together. *Document Window* is the major workspace in the middle. It can be configured to show two-page spreads. Note the ruled boxes that indicate the layout grid. Palettes operate much like Photoshop, with multiple bar headings that expand. Shown here are *Strokes & Swatches, Type Characters, Table Styles, Color Panel,* and *Layers Panel.*

Microsoft Word

Microsoft Word is the preeminent word processing program on the planet. It works on both PC and Mac platforms and its files are read by every program that exists. The very good news for personal media makers is that Word will take you surprisingly far into the realm of type and layout.

Microsoft Word is the first powerful design tool that most people encounter. Yet many of us will use it for years without exploring its robust capacity to handle type and layout. The program has been upgraded every year for nearly twenty-five years. As Word has gotten bigger, many people have learned to play with and enjoy its type, layout, and illustration tools.

Microsoft Word. The sample document attempts to highlight the layout capabilities of Word. *Inserting image files* is easy: just drag and drop. When you highlight an image file, a set of new tools appears in the *Formatting Palette* under the Image sub-menu (not shown). *Word Art* is a design world unto itself. The Jamaica Blues logotype is an example of what you can make with a single click. *Drawing* has its own toolbar for creating simple shapes and drawing on the screen. *Clip Art* is found under Insert in the Main Menu. Colors galore are available in MS Word and all word processors. A document's entire background can be given a color.

.doc (Document)

This tag identifies a file as being native to MS Word.

.rtf (Rich Text Format)

RTF is a document file format designed to be easily exchangeable among various operating systems and software programs. Since it is primarily a text file, it also works well with various programming languages.

.pdf (Portable Document Format)

PDF is a file format created and owned by Adobe Systems. It embeds text, images, and formatting of text, making documents appear exactly the same across platforms. See Chapter 6 for details on Adobe Acrobat and Adobe Reader.

.indd (InDesign Document)

INDD identifies a file as being native to Adobe InDesign.

.qxt (QuarkXpress)

QXT identifies a file as being native to QuarkXpress.

A GARISH SCREEN SAVER

Back in the day of cathode ray tubes (CRTs), when the same image was held on a computer screen for long periods of time, a ghost of that image could be permanently burned into the display. Screen saver programs were invented to avoid such disaster.

Today's LCD screens don't have the burn-in problem, but people have come to love the photograph, animation, or slide show that pops on after a few minutes of inactivity.

This exercise is a radical warm-up. Radical because you are going to use MS Word as an unlikely graphic design tool. Warm-up because messing around with MS Word

is going to prepare you for the next chapter. Your task is to overload a single frame with words, objects, drawings, Word Art, animation, photographs, and clip art. Your intent is not to reflect your superb visual taste but, instead, to fabricate something that is garish, over the top, overdone. Be really outrageous. Flaunt hideous colors and clashing typography. Mix fonts. Find truly silly clip art.

1. TEXT ABUSE

Open a blank Word document. Type the phrase SCREEN SAVER DU JOUR and center it. Copy and Paste two more versions of the phrase. Set each copy in a different display font. Make the size 20 points or larger. In the example shown I went with drop shadow, a background color, and a text color.

2. LOGOTYPE MASSACRE

Lets take your first name and turn it into a logotype. Duplicate your name three times. Each will be treated in a distinct way and part of the assignment is to figure out how your version of MS Word will complete these three tasks. First, **box it up.** Select a font and put a box around it. Second, **drop it out.** Highlight your name and give it a fill color. When the background color is in place, make the type color white. This creates the "drop out" effect. It looks like the letters have been punched out, and the paper color is showing through. Third, **put your name inside an object:** MS Word contains a library of shapes. Find this collection, drag a shape to the document and then place your name inside it. The object I went with was the thought balloon.

3. WORD ART SHOWBOATING

Navigate Word's main menu until you find WordArt. A dialog box appears. Write in the letters of your last name, using yet another font and large size. The example shows 36 point Braggadocio. Note the WordArt palette lets you kern the font. I used "loose" to spread apart the letters.

4. BACKGROUND MAYHEM

Word will let you choose a background color, texture, pattern or picture. I went with gradient. Remember you are pursuing the garish in this exercise. Find a background that really clashes with the elements you have collected so far.

5. DRAWING DISASTERS

You can get into lots of trouble messing with the Drawing toolbar. Try free form doodles. Auto Shapes are fun. Explore different lines and fills.

6. CLIP ART CHEESE

Finish off this garish screen saver with a few examples of clip art. MS Word has plenty of oddities you can look through. Resize and reposition to your heart's content.

7. REPEAT, BUT TASTEFULLY

Along with its hideous outcome, this project should have gotten you familiar with the graphic design toolset that comes in MS Word. It's surprisingly robust. Now that you know your way around, try creating a screen saver that you would actually want to see when your desktop times out. Make a tasteful slate—a one-page graphic you can also use at the head of slide shows or on a Web page. Render your name in a font that suits your personality and style. Make the name into a logo by applying appropriate graphic treatments. Find some decorative elements or border. Select a background that works with everything else. If you get something you really like, e-mail a copy to Mediapedia.net where I will collect a gallery of beauties.

chapter 4: ILLUSTRATION

Why is it that people don't like to draw? As kids we all draw effortlessly. Making marks is a deep and gratifying impulse. But long before adulthood, most of us decide that if we can't draw with the same facility that we write our names, we should never pick up a sketchpad. We may not expect ourselves to perform like professional athletes when we exercise, but we do feel we should draw like professional artists when we pick up a pencil to draw.

Even my graduate students tend to become downright *antsy* when, in our first class, I start handing out sticks of charcoal and large sheets of newsprint. The activity of drawing seems insultingly stupid, too rinky-dink, and an overall waste of time. But I start with drawing—and stick with it—for five very sound reasons:

1. The ideas and skills used in drawing are fundamental to all forms of personal media.
2. Drawing is a reminder that we need to rediscover old skills as we push to build new ones.
3. Drawing for even a few weeks reawakens the meaning of "practice." Progress is usually rapid and extremely satisfying.
4. Illustration is often more about revision than it is about that first blast of inspiration.
5. And this plain truth: Drawing is a survival skill. I don't mean finished masterpieces. Rather, I mean quick sketches that solve problems and communicate quickly in ways that words can't.

Let me hit a little harder on the idea of practice. We all tend to think that if we read about something or sit through a lecture about it, then we know that something. For many subjects, this is true enough. However there are some areas in which knowledge can only come through active doing— *through practice*. For example, you could read endlessly about playing the piano but would still be unable to bang out a tune the first time you sat down at a keyboard. You get the point. Accomplishment is achieved through practice.

SO DEAL WITH IT: YOU'RE NO MICHELANGELO

Digital illustration, the subject of this chapter, is a challenge to learn. I think I can break down the process in ways that will be fun and will encourage you to plunge in. But first, you need to realize that how you draw is not really the issue.

Your drawing skills need only meet one standard: You should be effective in representing your ideas. To prove this point, I asked a number of friends to sketch a dog. What you see here is what came back. Some of the drawings are by designers who practice a lot. Others come from friends who seldom draw. But all have charm and punch. All provide a window on the essence of "dog." All show that the person wielding the pen or pencil has a unique way of seeing the world. As a group, these little sketches prove that difference itself is of value and that you don't need to be a Renaissance master to make some terrific marks.

So get ready to draw with pencil and cursor. Personal media making will require you to do so, whether laying out a Web site's site flowchart, storyboarding a slide show sequence, roughing out the design for a logo, sketching a page layout, or making a lighting diagram. And I bet you will surprise yourself by how well your practiced eye can direct a rusty hand.

If you want to sharpen your eye and get some drawing tips, please visit the Drawing Studio Session within the parallel Chapter 4 at mediapedia. net. You'll find a PDF based on the drawing instruction in Bert Dodson's terrific book, *Keys to Drawing.* Top row, l-r: Heather Ben-Zvi; Evan Baily; Sandra Chamberlin; Peter Baumann; Deborah Bond-Upson; bottom row, l-r: Leo Catapano; Harriet Power; Stephen White; and Emmy Podunovich.

BITMAPS VS. VECTORS

Bitmaps and vectors are the two fundamentally different ways that computers create, store, and manipulate images.

In the practical world of computer graphics, bitmap and vector images bump happily along with each other. You could work for years without needing to differentiate between the two. But that's not to say you should remain in the dark.

Adobe Photoshop manipulates photographic images. Adobe Illustrator makes graphic images. They are sister applications that dominate the worlds of still images. Whereas many sisters grow apart as they grow old, these have grown closer. With each new version of Adobe's Creative Suite, the interfaces of both applications become more and more alike.

Photoshop and Illustrator may be sisters, but they are quite different. Photoshop works with pixels and bitmaps. Illustrator works with something called vectors.

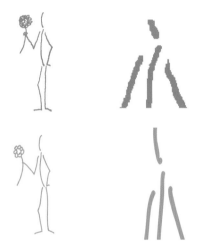

bitmap graphics

Bitmap graphics are images made up of a grid of pixels.

Visualize the computer image as a mosaic, made up of millions of square blocks, or pixels. A bitmap is the image "seen from above." The bitmap format (which is sometimes called a **raster** format) lends itself to continuous tone, photo-realistic images.

The human eye reads the evenly distributed pixels of a bitmap's surface as if it were a coherent, smooth image. A standard size for a computer image is 640 x 480 pixels. This area contains roughly 300,000 pixels laid out in rows.

With bitmaps, size matters. If you try to expand them too much, the image breaks down and artifacting occurs. Bitmaps are thus **resolution dependent.**

I created a bitmap stick figure (top left) using a drawing tablet and working in a 4 x 6–inch space. My hand is a bit shaky using the Pencil tool. I created the vector stick figure (bottom left) in Illustrator. using the Brush tool with settings that smoothed out my drawing. (Both drawings on the top and bottom left have been scaled down to fit into the book's layout). In terms of resolution, the two figures on the left top and bottom look pretty much the same.

The close-ups (right, both rows) compare the stick figures' shoulders. Both these shots are enlarged 1200 percent, meaning they are twelve times bigger than the originals. The vector drawing (bottom right) shows the brushstroke in perfect clarity. The detail of the raster drawing (top right) shows individual pixels.

vector graphics

Vector graphics are images that are composed by mathematical formulas.

Don't think of vectors as being relatively simple shapes, like letterforms (which are almost always created with vectors.) Vector graphics can be extremely complicated and produce images with hand-drawn qualities. The vector format is best suited for solid colors, lines, curves, charts, logos, and fonts. In vector graphics, a mathematical formula provides instructions to the entire grid. Fortunately, you don't need to know how vectors work in order to put them to work.

While "math" may be an accurate description of the computer code that generates Illustrator images, the reference makes it hard to get a concrete grasp of how vectors work. It's easier if you think of vectors as being a few specific **points** that are connected by **paths.** As you will see, points and paths become the very tangible engine by which you will create within Illustrator.

There are two advantages of vectors over bitmaps. First, a vector image allows any geometric shape, even a complex series of curves and lines, to be described in very little space. Vector graphics are **highly compact** and don't hog computer hard drives. The illustration here provides an example.

The second huge advantage of vectors over bitmaps can be understood at a glance: Vectors allow you to resize without any loss of quality. This ability to keep an image sharp no matter how big or small it is called **resolution independence.**

VECTOR

"Create a shape with a center at (x,y), with radius r, and color C"

BITMAP

whitepixel. whitepixel. whitepixel. whitepixel. whitepixel. whitepixel. whitepixel. whitepixel. whitepixel. whitepixel. whitepixel. whitepixel. whitepixel. bluepixel. bluepixel. bluepixel. bluepixel. bluepixel. whitepixel. whitepixel. whitepixel. whitepixel. whitepixel. whitepixel. whitepixel. whitepixel. whitepixel. whitepixel. bluepixel. bluepixel. bluepixel. bluepixel. bluepixel. whitepixel. whitepixel. whitepixel. whitepixel. whitepixel. etc.

At a glance you can see that the amount of data required for a vector is far less than the data required for a bitmap. The vector formula is written out in words. Its mathematical version would be even shorter. The bitmap data would consist of binary information about whether each and every pixel was to be blue or white. As with words, the code would fill pages. Joe Maidenberg

KINDS OF ILLUSTRATIONS

All non-photographic visuals.

In computer graphics, the term "illustration" covers a wide range of graphic objects, from large pieces of cover art to graphs and charts, to tiny logos. To help you think about how illustration might fit into the kinds of projects you do within personal media, here are eight different types of digital illustration to consider.

symbols and icons

A symbol is an image that represents something by association, not resemblance. An icon is a simplified image that represents something based on resemblance.

Symbols can visualize abstract ideas. They can also represent tangible things. Symbols are commonly found on maps and in public environments and many are designed to visually communicate concepts that span multiple cultures.

Symbols connect to the thing they refer to indirectly, obliquely, or through association and not by resemblance. Icons are more simple and direct and are frequently used to replace words.

Adobe Illustrator has a Symbol Library that is pretty lame. It doesn't recognize the distinctions between icons and true symbols. Why be so fussy? Because acute awareness feeds creativity.

The first symbol (top left) stands for atomic energy and is slightly representational of an atom surrounded by electrons. The universal sign for "help" (top center) originated with the Red Cross and signaled medical assistance in wartime. In the United States, interstate highways have evolved a symbolic shield (top right) into which the number of the route is placed.

There is no reason to stick with dull icons. The standard controls for movies and audio can be revitalized with the addition of a little color (middle row). Other well-known icons include a reel that holds a strip of film, the globally recognized signage for bathrooms, and a speaker with sound waves for volume control. (top row) Illustrator Symbol Library; (middle row) Heather Ben-Zvi; (bottom row) Illustrator Symbol Library

logos

A logo is a graphic element that serves as a visual identity for an organization, company, or individual.

Large organizations and companies pay top designers to create their logos. But you can make one for yourself for free and have some fun in the process. Adobe Illustrator is the instrument of choice.

A good logo should do the following: (a) be easy to recognize and remember; (b) scale from large to small across print and screen; (c) print as black and white, even if the logo is normally seen in color; (d) connect to a core quality or attribute of what it represents; and (e) be flexible for use in many contexts.

These are custom logos. The one at the top mimics official government signage. The one at the left has a tribal, ancient resonance. At the right, a circular logo encapsulates a set of initials. Stephen B. Nguyen; Stephen B. Nguyen; Jamie Kruse, courtesy of Stefano Bonaretti

technical drawings and diagrams

Technical drawings and diagrams are precise illustrations developed for the purpose of guiding construction.

Illustrator is often used to create "working drawings" of objects that are then fabricated in production shops of all kinds—from welded metal to crafts to architecture. **Shop Drawings,** as technical drawings are often called, require great clarity and often have size specifications added.

Both of these technical drawings are extremely precise, as technical drawings and diagrams need to be. The night soil schematic (left) includes a green inset that suggests the overall object at full size. The diagram of a school locker has been marked up by hand. Jamie Kruse/Smudge Studio; Ian Cooper

charts and graphs

Charts and graphs are quantitative illustrations that reveal relationships between different elements that must be explicitly identified.

The clean and accurate structure of vector illustrations makes them ideal for visualizing data and complex qualitative relationships.

A vector drawing application like Illustrator allows you to make custom graphs that blow away the default graphics of MS Word, PowerPoint, or Excel. iStockphoto; iStockphoto

spot art

Original illustrations used to fill space in publications and screen layouts are called spot art.

The term spot art originated at *The New Yorker* magazine for the wonderful variety of handmade illustrations (sometimes representational, sometimes abstract) used for decades to provide visual interest on pages dominated by columns of type. Spot art does not have any direct, content-specific relationship to the text it adorns. Its purpose is to give readers a visual break and an emotional jolt.

These three examples show that when computer drawings are relieved of a need to carry information, they can move toward the abstract. Spot art is a great opportunity to show your creative chops. Stephen B. Nguyen; Stephen B. Nguyen; iStockphoto

display art

Display art includes an original illustration commissioned to accompany a specific story or theme.

When most people think of illustration, they envision display art: ambitious digital imagery used on covers of books or magazines or featured in blogs and Web sites. Display art is front and center with greeting cards of both print and electronic flavors. Of the many forms and functions of computer-based illustration, undertaking a piece of display art is the most challenging, the most high profile, and the most satisfying.

Display art often conveys editorial content. When well conceived, it can be much more than a pretty picture. It can establish characters, places, and moods. Stephen B. Nguyen; Stephen B. Nguyen; Heather Ben-Zvi

clip art

Clip art includes illustrations made available for anyone to use.

The term clip art originated in the era of photo-offset printing. Designers would cut out interesting images and literally paste them into layouts, which were then photographically prepared for offset printing. Of course copyright was a big issue then—as it is now. A number of enterprising companies began collecting copyright-free images and putting them into books that graphic designers could purchase and use to their hearts' content.

Corbis is a privately held company owned by Microsoft's Bill Gates. It offers a collection of more than one hundred million images, including the famed Bettmann Archives. Corbis owns Snapvillage, a consumer photo-sharing Web site.

Dover Publications offers a huge library of books containing designs from various eras. The company also sells CD-ROMs, but as of this writing does not have an online marketplace.

Getty Images has a live feed of images from current events in addition to contemporary stock photography, illustrations, and archival images. Getty also offers stock video footage and stock music.

iStockphoto is a relatively low-cost collection of royalty-free images (once you purchase the license to use them). It is more user-to-user oriented than Corbis or Getty and represents a large group of similar sites including Photos.com, Archive Photos, and Photofest.

DRAWING CONVENTIONS

There are "rules" that allow two dimensional images to substitute for a three dimensional world.

Humans have two eyes, spread slightly apart. Our brains combine and interpret both the left and right images as three-dimensional space. The rest of our senses confirm this. As a media maker, it's important to remind yourself once in awhile about what is subconsciously happening between our eyes and our brains. For with this understanding comes insights about how to create work that will manipulate human perceptions (in good ways, of course).

First, review the design elements by which Western eyes read two dimensional space. When your job is to conjure up and manipulate an image, you need a precise vocabulary in order to tap into the nearly automatic way people see.

Second, review the hidden structures within perspective drawings. Perspective is a technique of representing a plane— the spatial relation of objects as they might appear to the eye. There are layout rules that are not well understood, even by those who draw regularly.

point

A point is a position in space.

There is a point at the end of each line or at the juncture where two lines intersect. Norwegian designer Christian Leborg observes that when you try to draw a point, you do not end up with a true point but, instead, with a surface marked with a dot.

This and the following drawings are inspired by Christian Leborg's small volume, *Visual Grammar*. This book provides a nuanced and elegant text about the elements of two-dimensional and three-dimensional space. Courtesy Christian Leborg/*Visual Grammar*, Princeton Architectural Press

line

A line is a long narrow mark or band. A straight line is the shortest distance between two points.

When you draw an actual line on a specific surface, the resulting mark can have a variety of attributes. Lines come in many forms. They have **position** and **direction** (straight, squiggly, horizontal, and so on), **variation** and **weight** (thick and thin), **qualities** (jagged, decorative, busy), and **kinds** (fuzzy, cross-hatched, smudged, dotted). As obvious and familiar as they may be, designers use these terms all the time.

A line, like a point, is more a concept than an artifact. The first drawing (top left) shows how a line is made up of points. There are an infinite number of them.

The collection of smaller drawings presents a gallery of lines. Different kinds of lines have the power to be amazingly expressive. The **straight line** is diagonal to the implied horizon. The **jagged line** has sharp angles and is easily distinguishable from the **squiggly line**, although they are traveling the same basic route. The **decorative line** repeats a pattern and has rhythm. The final **varied line** changes are weight (thickness) and degree of definition (smoothness) and even get a bit of color.

And then there are the circles: a **fuzzy** one, a **dotted** one, and a **smudged** one. All the terms highlighted here are more associative than descriptive. It is very hard to teach computers how to characterize the quality of lines in a way that humans do so effortlessly.

plane

The surface of a flat plane is defined by two lines known as the x- and y-axes.

If a surface has a bend, it is three-dimensional. More on that shortly. Right now let's study a flat plane.

The **x-axis** is one of two directional coordinates in a system that defines a plane. By convention the x-axis is the horizontal one. The **y-axis** is the vertical coordinate direction in a two-dimensional space.

A flat plane is represented by two axes in the drawing at left. This form is most often seen and used for charts. The middle drawing represents a plane seen from above and to the side. The third drawing reminds us that the surface of a plane need not be flat.

boundries

All two-dimensional images have outside edges that form boundaries.

Sometimes boundaries are called **borders**. Sometimes they are called **frames.**

Boundaries are evident at a glance. They define an object's physical state. Yet there is creative power in knowing how to fool the eye in the way that optical illusions do.

This page from a 1911 baby book has borders inside borders. Note how the image of the child is vignetted. The layering of information via boundries provides a clear visual hierarchy. Unknown photographer

z axis

The z-axis represents depth relative to the x- and y-axes.

The three-dimensional coordinate system requires a dimension that extends 90 degrees away from the x and y planes. If a drawing is positioned in the middle ground of a visual composition, the z-axis appears to be moving toward and away from the viewer.

Some media forms attempt to work in true binocular vision. For example, there are those three-dimensional movies that require special eyeglasses. Or those flat, beaded surfaces (actually made with embedded optical prisms) that appear to have depth as you pass in front of them or twist them in your hand.

By convention, the x-axis is horizontal, the y vertical, and the z shows depth, moving either forward or back in three dimensional space. Holograms are true 3D objects, made to project in real space (not pages or computer screens). You can walk around a hologram and see it from different viewpoints. Perhaps this is a future frontier for personal media!

solids

Solids are familiar forms that have three dimensions.

Shapes like those at right are recognizable forms that have edges. These edges can be drawn as lines. The term **contour** is used for any edge revealed in an object. Artists practice drawing contours and will make distinctions between **geometric shapes** (based on mathematical relationships), **organic shapes** (which come from the natural world), and **freeform shapes** (not representational of a real form or object).

These are standard geometric shapes. Some drawing instructors emphasize using such easy-to-draw shapes as a deep structure for complex, organic forms. For instance, a rectangle can be a torso and an oval can be a head.

illusion of depth

Techniques that give two-dimensional drawings the illusion of three-dimensional depth.

Here are some of the techniques that illustrators and painters have long used to make their drawings on flat sheets of paper look 3D.

overlapping plane: A closer object overlaps the object behind it.

relative size/familiar size: With two or more similar objects, viewers assume the larger one is closer.

modeling: This technique is used to smooth transitions between values of color to create the illusion of light falling on a rounded surface. Another name is for it is *chiaroscuro*—the interplay of light and shadow as if on a surface.

atmospheric blur: Colors farther away appear less saturated.

relative height: The higher an object is on a plane, the farther away it appears.

texture grades: Recurring patterns reduce in scale as they extend toward the background.

converging lines: Seemingly parallel lines converge as they move into the far distance.

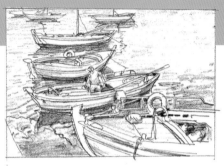

These three pencil drawings show how the illusion of depth is created by overlapping shapes of diminishing size, by converging lines, and by lighter tones and less detail with progressively more distant elements. Drawings from *Keys to Drawing* by Bert Dodson

linear perspective

Linear perspective includes a set of specific rules for making drawings appear to project or recede into three-dimensional space.

Many good artists have difficulty understanding the technique of drawing with linear perspective. The fundamental goal is to place objects in relationship to each other and to the plane of the earth. There are two concepts you need for an operational understanding of perspective drawing:

Objects above the horizon appear to be floating "in air," while those below the horizon line are perceived as being attached to the ground. Artists often begin a perspective drawing by sketching a light line to establish the **horizon line.**

All lines that are not parallel to the horizon line will converge at a **vanishing point.** There can be more than one vanishing point in a work of art. If drawn according to the rules of linear perspective, lines or surfaces that may in fact be parallel within an object will still recede toward one single point on the drawing.

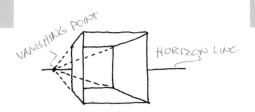

One-point perspective is a drawing approach that uses a single vanishing point. It took artists hundreds of years to perfect the rules that govern how to draw in perspective and create the illusion of depth. Most of Western codification about perspective was achieved during the Renaissance.

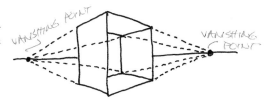

Two-point perspective is an approach that uses two vanishing points on the horizon line. Here a technical definition for perspective: As a plane moves into three-dimensional space, it gains depth and maps out volume.

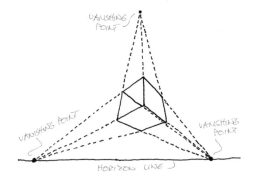

Three-point perspective is an approach that uses two vanishing points on the horizon line and one above or below the horizon line.

INPUTTING

**There are three ways to enter or input
drawn forms into a computer file: draw and scan,
draw in bitmaps, draw in vectors.**

Adobe Illustrator is the application of choice for professional graphic designers and illustrators. You draw in vectors, and this gives you tremendous depth, flexibility, and artistic range.

Although computer software facilitates and extends the powers of the human hand, it is still the hand, eye, and mind of the artist that drives the creative process. It can be a comfort to remind yourself of this at times when the gear seems to take over.

via paper and scanner

**When you draw on paper and then scan, you input
an illustration by digitizing an analog image.**

There are few expressive modes more trusted than our ability to hold a pencil or pen and make marks with it. The human hand sets the standard.

A scanner is a separate piece of gear that can capture all the nuances of a drawing made by hand.

Carolina Correa would be the last to proclaim herself an artist. Yet her dogs, drawn quickly as examples for this book, are quite terrific. The one done in pencil, shows the very light planning or "restatement" lines that have led to the final drawing. The colored drawing is a bitmap sketch, done in Photoshop. The third K-9 was done in Illustrator with a Brush tool, and thus shows lines of varying thickness or "weight." Carolina Correa

via digitizing tablet

A digitizing tablet is a computer input device that converts the motion of a hand-held stylus into both vector and bitmap images.

When using a tablet, the eye is focused on the computer monitor, while the hand holding the stylus moves across the plastic surface of a drawing tablet. With practice, the eye-hand coordination approaches pencil and paper accuracy and the digitizing table becomes as easy to use as the familiar computer mouse that it emulates.

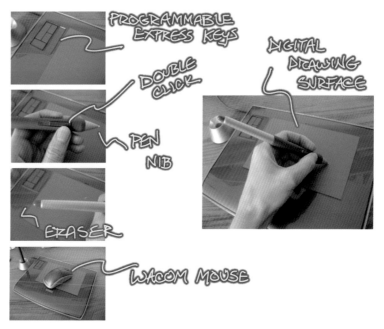

PROGRAMMABLE EXPRESS KEYS

DIGITAL DRAWING SURFACE

DOUBLE CLICK

PEN NIB

ERASER

WACOM MOUSE

Shown here is the Intuos, a 4 x 6–inch tablet manufactured by Wacom. If you are doing lots of illustration, a drawing tablet is recommended. But be aware that it takes some time and practice to achieve real fluency. Jamie Kruse

via mouse and keyboard

A mouse is a device that controls a cursor. A keyboard enters letterforms, numbers, and other typeface elements onto a computer display.

The mouse and keyboard are the default input devices for most computers. The way the hand holds and moves a mouse cannot equal the precision of fingers holding a pencil or stylus. Yet even by mouse alone, digital drawing proceeds ably when the cursor turns into cross hairs or tiny pen, pencil, and brush icons—depending on the application in which you are drawing.

VECTOR-BASED ILLUSTRATION

Vector graphics use geometrical forms to represent images. Mathematical equations provide the power of such geometric modeling.

Before I plunge you into the world of Adobe Illustrator, a word of caution: Illustrator is harder to learn than many other graphics applications.

You'll do best if you can ease into Illustrator a bit at a time. Fortunately Adobe provides a very robust Help Center with examples, tutorials, forums, and more.

PART II: **THE PAGE**

lines with a click

The Line Segment Tool yields straight lines, arcs, spirals, and two kinds of grids—rectangular and polar.

This tool seems to have an awkward name, until you put it to work. Like most of Illustrator's tools, tiny icons give a good sense of what it can do. There is great variety in the shape of the objects you can lay down and once an object is in place you can stretch, twist, color and manipulate it in endless ways.

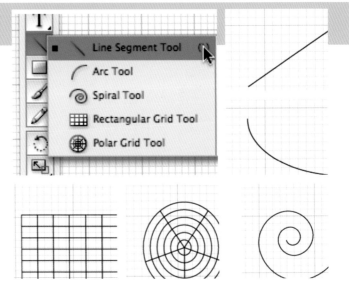

A good first goal is to become familiar with the interface and the different tools. A second one is learning how to draw with one hand on a mouse or stylus and the other hand on the keyboard, using the hand on the keyboard to change the functions of the drawing part of the tool.

geometric shapes

Illustrator creates shapes with what is called the Rectangle Tool. It actually forms a variety of geometric shapes, each with perfect symmetry.

Five submenus are available in Illustrator's floating toolbar: Rectangle Tool, Rounded Rectangle Tool, Ellipse Tool, Polygon Tool, and Star Tool. The sixth menu is for the Flare Tool, which emulates the lens flare you sometimes get with a camera.

If you hold down the shift key while making a new object, it is restrained to a square, circle, or other "pure" form. Polygons can have as many sides as you want, and a pop-up menu lets you set the number of points you want in a star plus the inner and outer radius.

joining shapes

Complex objects are built by stacking simple objects. Many finished illustrations are the result of arranging and layering shapes and lines.

You need to be a bit of an engineer when using Illustrator. There is a definite strategic art in arranging and layering the shapes and lines that combine to render finished works. Many instructional books and tutorials offer case studies about how to approach the construction process.

The birdhouse at right is an assemblage of the shapes shown in pale orange. As your skills with Illustrator evolve, you will begin to consider the alternatives before you actually begin to draw.

Books, magazines, and Web sites with step-by-step directions are very helpful when planning workflow for complicated projects. You will quickly learn how to analyze objects by their component geometric parts. Jamie Kruse

ANCHORS, HANDLES, PATHS, AND STROKES

Anchors, handles, paths, and strokes are the main working parts of Illustrator and similar applications.

Regardless of which tool you are working with, Illustrator sets down a series of points called **anchors** (also known as **edit points** or **control points**). These anchors are connected by lines, called **paths**. The paths between anchors would be straight lines were it not for **handles** that can be attached to anchors. This allows lines to be shaped into smooth arches, curves, or angles.

There in one paragraph you have the basics of drawing with a computer.

Two **anchor points** (left) are set onto a new Illustrator file. A grid has been placed in the background to help line things up. Illustrator immediately connects the points with a **path** shown with a thin blue line.

In digital drawing, forming a line or shape is one task. Giving it **attributes** is a different task. Near the bottom of the drawing toolbox is the stroke/fill icon (a very important tool). In our example the **stroke** icon is filled with the color fuchsia (middle). The stroke's width has been set to 6 points. The **fill** icon has been loaded with a color called cappuccino. Our path now becomes a fuchsia line (right).

points and straight lines

A point marks a single location on a vector drawing field. Straight lines connect two or more points.

Short of opening up a new document and experimenting with the points and lines, the best way to sort out anchors, paths, and strokes is by studying a set of examples. Let's start with anchor points of straight lines.

When a third point is added (top left), Illustrator automatically fills in the triangle, even though the third side of the triangle has not been given a path. If the Fill tool is assigned the "none" red slash (top, second from left), then the two lines do not fill in (top right). If the fill is assigned a color but the stroke is assigned none (bottom left), then Illustrator makes a lovely coffee-colored triangle (bottom right).

Do not be confused by the **boundary box** (the blue frame in single image above). When you select an object after it has been drawn, Illustrator surrounds it with a rectangle. There are eight square control handles—one at each corner and one midway on all four sides. These are not anchor points. They are used in repositioning, resizing, and other manipulations of the entire vector object.

bezier handles and curved lines

Bezier handles are the controls that shape pathways and form curved lines. The term is pronounced "bez-zee-aye."

In abstract terms, Bezier handles control the shape and direction of anchor points. In practice these handles reshape vector paths that can range from straight lines to curves, arcs, swoops, loops, and complex organic shapes of all kinds. It takes practice to get the feel of how these work.

Paths can have two kinds of anchor points—corner points and smooth points. Note that paths do not become "objects" until the points are closed to form a contained area, which can then be filled.

This drawing (top row, left) is made up of straight lines. The Pen Tool contains a version/option called the Anchor Point Tool. When you click on an anchor point and drag the cursor (top row, middle), a **smooth point** is created (top row, right). The further I drag the cursor, the longer my handle is and the fuller the arch gets that connects with the anchor points on either side of the one I have chosen. I can click and drag either direction point at the end of the handle (bottom row, left) to bend my line in different ways.

While a smooth point always has two handles that work together as a unit, corner lines (bottom row, middle) can have one, two, or even no direction lines. Corners can be sharp angles. The original shape of straight lines has been reworked (bottom row, right) to show how anchor points and Bezier handles join in all combinations. Note that Illustrator used the terms Direction Lines with Direction Points. It's a good habit to go with Adobe terminology.

Remember that the blue path lines and the blue direction lines don't print. Another tricky distinction: You have to select using the Selection Tool, whereas you manipulate points/handles using the Direct Selection Tool.

stroke treatments

Stroke treatments are attributes applied to a vector path or an object's edge.

Just to make sure it's clear: A path is *not* a line, but rather a trajectory, within a vector object. It connects two anchor points. Paths *become* lines when they are **stroked** with particular treatments among Illustrator's limitless options.

Paths can be **open** or **closed.** An open path might be a straight line, an arc, or a combination. A closed path is one that rejoins itself, regardless of what shape the paths are that connect any number of anchor points.

This illustration samples the various strokes that can be applied to a pathway. There are variations of weight, measured in point (pt) size. There are variations in stroke stylings like Neon, Dashed, and Image Effect. Jamie Kruse

WHEN TO USE WHICH TOOL

Deciding when to use the pen, pencil, and brush tools is easier when you see examples of effects each creates.

Illustration programs, Adobe Illustrator in particular, offer some of the most complex sets of tools in all of computer-dom. Witness Illustrator's **Toolbox.** No less than ten sets of tools are crammed into this stack of icons. The little triangles at the bottom right corner produce pop-out windows (detachable) with subsets. All together there are about seventy-five tools jammed into the toolbox.

There are thirty different **palettes** that further expand Illustrator's creative options. Plus there is a Control Palette that displays more options, depending on the type of objects you select. Are you keeping count? There are over one hundred discrete tools in Illustrator, and the vast majority of them have settings that can be adjusted this way and that.

Illustrator's army of tools works well together. You can start drawing with one and then switch to another. But precisely which one do you start with? While what follows is admittedly simplistic, it offers some getting-started insights that are hard to find elsewhere. And they include thoughts on which tasks each one is best suited for.

The call outs indicate groupings of similar tools but they may not make the stack less intimidating. Here's the good news: There are three main tools for putting down marks—Pen, Pencil, and Brush. If you can focus on these three, everything else will fall into place. They are different in subtle ways, but that is their strength.

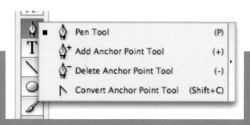

pen tool

The Pen Tool is the best tool to use when you trace.

The Pen Tool is a connect-the-dots tool. It sets different points on a blank **art board,** and then Illustrator joins these with lines. The anchor points can be turned into Bezier handles, which make the lines into curves. The Pen Tool is also very useful for adding and subtracting anchor points from any vector object. You can display and select the Add, Delete, and Convert Anchor Point Tools by clicking the corresponding icons in the Toolbox. You will quickly realize that keyboard commands work faster when one hand draws with the mouse or stylus while the other hand uses the keyboard to switch tools.

The key to working with a pen is to pay close attention to the cursor tip and to the teensy-weensy icons that pop up when the tip approaches a path or anchor point. The pen is great for tracing and for developing crisp, accurate drawings. A warren of control points (left) produces clean, consistent line work (middle). And of course it scales up or down like a dream. Jamie Kruse

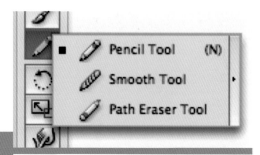

pencil tool

The Pencil Tool is the best tool for free-style drawing.

If you want a handmade look (scribbles, scratches, or twirls) then make the Pencil your first choice. With the Pencil it's easy to redraw lines, add to them, or erase them.

If you double click on the Pencil icon in the Toolbox you will access the **Fidelity** and **Smoothness** options. Fidelity determines the amount of space between points that appear in a pencil-drawn line (the higher the number the less points), and smoothness controls the amount of "smoothing" that Illustrator will add to your hand's drawn gesture (the lower the percentage, the more it will look like "your hand").

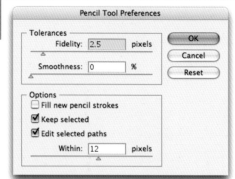

The Pencil Tool contains a Pencil Tool and Eraser Tool (you'd expect that) but also something called the Smooth Tool, which looks a little like a barber pole. It's quite useful. The Pencil Tool Preferences pop-up will adjust fidelity and smoothness, plus other options. The two drawings of a scribbled grass-line form show the differences in fidelity achieved by the Smooth Tool. Jamie Kruse

brush tool

The Brush Tool is used to make lines and shapes look like art.

In truth the Brush Tool is more of a stroke and appearance chooser than a drawing tool, but just like the Pen and Pencil Tools, you can put down paths with it. The Brush Tool draws with fluid strokes and uses few anchor points. This makes it ideal for many types of tracing.

The big deal about the Brush Tool is that you have so much control over the look of the path when a stroke effect is attached. You'll find many choices and controls via the Brushes palette. Or you can make a custom brush.

The Brush Tool itself (below left) doesn't have any choices until you open the Brushes palette (bottom left). Here is the same cityscape drawn with the Pen Tool (above). It will become the guinea pig to demonstrate four kinds of brush strokes. Jamie Kruse

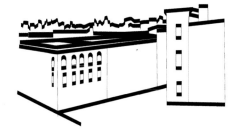

Calligraphic brushes. These lines look like strokes drawn with the angled point of a calligraphic pen. Only here you can control the angle, width, and depth of the point. Jamie Kruse

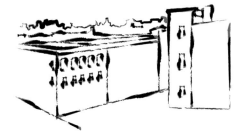

Art brushes. With this brush a long narrow shape is stretched along the length of a path, no matter how short or long that path is. Jamie Kruse

Scatter brushes. With this tool, copies of an object follow the path you put down. You choose the object. Jamie Kruse

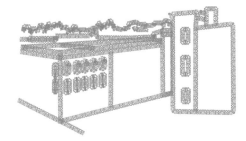

Pattern brushes. Via the Pattern Brush, a tiled pattern is repeated over paths via the Pattern Brush. Many effects are possible. Jamie Kruse

TRACING WITH ILLUSTRATOR

Tracing involves using a layer that permits the artist to work directly over the source that is being traced.

Tracing provides an express route into the world of illustration.

Even though we easily acknowledge we're not in the league of Renaissance masters, most of us are still reluctant to draw something from scratch. Illustrator offers a hidden door into the world of art. You start with a photographic (bitmap) image and then convert it into a (vector) drawing that conveys your own unique vision and hand. There are a number of ways to do this.

Before we consider the creative possibilities, however, let's take a moment to reflect on how a designing eye can trump rendering skills. The act of tracing involves a high order of artistic choice plus refined execution skills. To put it directly, tracing is not "cheating." It is legitimate. It can make a real artist out of you.

All of this comes together in tracing. You can work large (great control) and then reduce. The vector image will look great at any size.

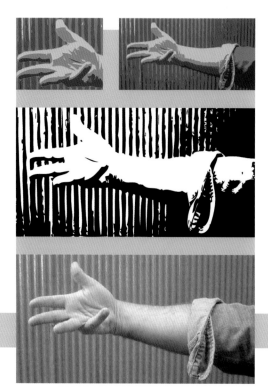

live trace

With Live Trace, Illustrator automatically traces a source image, creating a new file layer.

The source image can be a photograph, a line sketch that has been scanned, or a graphic imported from another program. This is a one-click operation, although the control panel provides lots of different treatments. Just look at the range of visual effects that are possible with Illustrator's Live Trace function.

The moment you drag an existing image file into Illustrator (immediately above is my source, a JPEG photo), the control panel offers the choice of Live Trace. The default treatment (middle) is a high-contrast version—all white or black. The cutoff point is adjustable.

Because my subject has a background with alternating lights and darks, one of the other Live Trace options works better for me. The example shows a "six colors" setting (top right). The close-up (top left) shows the anchor points and paths that Illustrator generates when you click a button marked Expand—it converts tracing objects to into paths. From here you work as you would with any other vector image.

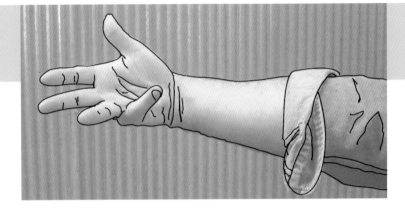

template layers

Template layers are locked, nonprinting layers that are used when tracing by hand.

Although live tracing can be great, more often than not, you may want to simplify the subject and make judgments about which contours to overdraw.

It's easy to do this by importing the source image onto a level within Illustrator. If you double-click the layer holding your imported source, a Layers Option screen lets you make a **template layer.** This immediately dims the source image by 50 percent so that you can easily see the paths you are drawing on the layer above. It's easy to toggle the underlying image on and off to observe your process.

The dimmed background helps you see the pathway and anchor points as you trace (top left). When you turn off the template, the tracing stands on its own (top right). I worked fast and loose on a new layer (middle right) using the same Pencil stroke as on the first layer. Then I overlaid Brush strokes (on a new level) and messed with levels of translucency to get the final version (bottom right).

FILLS

Fill is a color, pattern, or gradient inside an object.

The fill you bring to an object can form the entire shape of the object (no outlines), or its path can be stroked, giving it an edge of one kind or another. Fill is a design element unique to the world of digital illustration. Such "coloring-in" comes in five basic types: solid, pattern, transparent, gradient blends, and gradient mesh.

solid and pattern fill

When you use solid or pattern fill, you apply a visual treatment to areas of objects conscribed by paths.

transparent fill

Transparency is how much you can see an object beneath another object. Transparent fills often require that you work in levels.

With a quick adjustment of a box marked **Opacity,** you can change an object's fill from 100 percent solid to any degree of transparency. An entire aesthetic has evolved from the ability to stack multiple layers of artwork and then precisely adjust the "see-through ability" of each layer, including subtle gradients that feather opacity down to 0 percent. Such mixing of transparency levels also blends colors.

The letter Q and the colored strokes display a progressive decrease in opacity from 100 percent on down at intervals of 25 percent. The five colors layered atop the word **transparency** predictably "cut" the solid black type below. But when the colors overlap, the resulting hues are anything but predictable. Jamie Kruse

gradients and color blends

Gradients and color blends achieve a smooth merge or transition from one color or tone to another.

Computers create flows of value and hue with a precision that is impossible for the hand and eye alone. There are a variety of approaches including linear blends and radial blends, which are sampled.

Most graphic applications offer tools for creating blends from any mix of source colors. However, if there are not enough shades allocated to a particular hue in the bitmap depth for a given image, visible "banding" can occur.

A gradient fill must be created each time you choose to fill an object. These can be saved as **swatches.**

Linear blends travel in a given direction, which is adjustable. You can create gradients from just two colors (top left shows white and black creating a grayscale gradient), you can make them using parts of the color spectrum, or you can have them cover the entire rainbow. There is a **Blending Tool** that allows you to create a single gradient that covers multiple objects.

Radial blends move from a central point outward. The example above suggests concentric circles, smoothly transitioned. The purple one could be a ball with frontlighting. Heather Ben-Zvi

gradient mesh

A gradient mesh is a single, multicolored object on which colors can flow in different directions.

Perhaps we are getting into Illustrator esoteric here, but in logo design and other forms of illustration you may want to know about the mesh object tool and how it works with graduated blends of color. You begin by creating a fine mesh on an object and then manipulating the color characteristics at each point on the mesh.

A gradient mesh blend is often used to create a three-dimensional appearance. There is a Mesh Tool that creates and edits meshes and what are called mesh envelopes. Combined with gradient fills, this yields an extremely versatile and powerful illustration technique.
Heather Ben-Zvi

SCALING AND MANIPULATIONS

When an object is enlarged or reduced in size, it's called scaling. Vector illustrations permit a variety of manipulations to an object by changing some points and paths but not others.

The vector-based architecture of Illustrator makes it an ace at many forms of manipulation. A quick preview of yet more possibilities follows below. Because the Adobe sisters have such a strong family resemblance, the following will also provide a review of Photoshop's similar capabilities in the bitmap domain.

RESIZING HANDLES

scaling up and down

Scaling up and down refers to increasing and reducing the size of an object.

When you click on a vector image, a set of sizing points appears at the corners and midway on each side of the bonding box. These eight locations, also termed handles, can be click-dragged to do the resizing. To preserve the proportions precisely, you must hold down the shift key as you drag one of the handles.

This sample will remind you that vector graphics read well when either enlarged or reduced. It's smart to build an object in a larger size than you will need because when you shrink it down there is elegant, crisp detail. In the second version top row, the tomato has been scaled down without holding down the shift key and as a result its dimensions have changed. A slightly lopsided tomato is a tomato you can love. Jamie Kruse

asymmetrical resizing

When you enlarge its length and width in different amounts, a vector illustration will become distorted.

The various distortions of the pencil illustration shown provide a sampling of resizing without holding down the shift key. To resize the enire shape, even if asymmetrically, make sure you have selected all the shapes and lines that make up the image.

A single shape can be resized in ways that make the original object almost impossible to distinguish.
Jamie Kruse

rotations and reflections

When you rotate an object, you pivot the object around a central point. A reflection results when you flip an object.

A full rotation is 180 degrees but partial rotations create greater visual interest precisely because of their imbalance.
Reflections provide another secret weapon for designers. A single slice of a complex object can be built, multiplied, and rearranged. Note too that a section of an object can be flipped along a straight line.

The four pieces of birthday cake demonstrate rotation options. Jamie Kruse

shearing

Shearing involves slanting an object by a matter of degrees along the horizontal or vertical axis.

Shearing is valuable when working with letterforms and logos. Although type was the topic of Chapter 3, please note that Illustrator is often employed in the custom-styling of words, logos, and type layout. The example here just happens to show a pair of geometric forms that might read as a house or as an arrow.

A shear angle of 45 degrees. Jamie Kruse

SPECIAL EFFECTS

Digital illustration yields an array of special effects through specially concocted vector formulas.

Illustrator has a set of special effect plug-in modules, which are software programs that have been installed. Commercial plug-ins are also available and can be dragged into Illustrator's Plug-ins folder.

You should have a reason to use a particular effect. Just employing an effect because it is available doesn't hack it. Your audience will immediately sense if a visual effect has just been slapped on.

Pseudo 3D

Although illustrated graphics are two-dimensional, designers work with visual effects that cause the appearance of dimension.

The illusion of depth attracts attention because there is a echo of reality that visually flat images lack. It's basically a bait-and-switch tactic. Sometimes it is called "2-D as 3-D."

The examples clustered here identify four different forms of pseudo 3D: extruding and revolving; drop shadow; surface texture; and overlapping.

A **drop shadow** simulates the cast shadow created when an object is positioned slightly above a background surface with a primary light source coming from one direction.

Drop shadows are amazingly effective in adding a subtle and non-distracting level of interest to a computer screen or printed page. This effect seems equally effective with drawn objects, type, photographs, and other types of illustrations.

The drop shadow added to the star (top left) shows the default values of the Drop Shadow interface (right). Note that you can adjust the location of the drop shadow, its degree of offset from the source, its opacity, and its color.

Extruding and revolving involves a two-dimensional shape that is pulled (extruded) along its z-axis. You can also re-volve and extrude around the y-axis, which creates a circular path that builds the three-dimensional object.

The source of these images is the two-dimensional blue star with a thin stroke of latte color (opposite page, top row, middle). The object can be extruded with a cap that fills the object (the cap is the blue color) or without a cap (opposite page, top row, right). You can rotate the three-dimensional object. The 3D Extrude and Bevel menu (this page, right) generates a solid by spinning the shape (opposite page, bottom row, left). Here I revolved the star only partway. All this magic is done with one interface.

Surface Texture is the discernable surface quality (rough/smooth) of an object.

The four ovals are filled with dimension-producing effects located in the Textualize menu.

In the context of non-computer assisted drawing, surface texture refers to the physical surface on which a drawing is made. In digital illustration, surface texture relates to the treatment applied to the surface of a vector object. There are many ways to create the illusion of depth using such **texture mapping** techniques.

Overlapping refers to creating the impression that one ob-ject rests on objects behind it.

When the edge(s) of a self-contained object is superim-posed above another object, the object that appears to be on top seems to be closer to the viewer than ones "be-neath." The stacking is done by levels.

In this sample the arrows (left) seem to recede by overlap and size alone. The star shape (right) adds softening of the color green, which was done manually.

filters and effects

Filters and effects are commands from Illustrator's Main Menu that change the look of objects by applying a preset algorithm.

Illustrator's effects menus offer **live alterations** (which remain editable), while **filters** are permanent. Note that you can also export an Illustrator file into its sister program, Photoshop, where you can apply another huge array of special effects.

Here a shape with red, green, and blue colors (far left) has been put through a few of the filters and effects from Illustrator's Main Menu. There are dozens of them. Choose an object and conduct your own survey.

graphic styles

Graphic styles are sets of reusable appearance attributes that can be applied to an object with a single click.

When designers work on a series of graphics projects, they often use custom looks to achieve a consistent identity that viewers will like and remember. Illustrator comes with a Graphic Styles Library that has ten categories of styles including Scribble, Neon, Artistic, Textures, and more.

You can fashion a fresh and distinctive graphic style that you then save and apply to related projects. This is a strong visual branding technique.

Like everything else within Illustrator, the attributes of a style can be applied to a group of objects or to a layer. Everything is tweakable and reversible.

tiling

Tiling is a file size saving technique in which a small image is systematically and seamlessly replicated to create a regular, patterned, repetitive background.

Do not dismiss tiling as a gimmick. In textile design and in wallpaper design you can find beautiful examples of tiling where it is often difficult to figure out where and how a single pattern is repeating.

Mosaic tiling was refined to a high art form centuries ago in the Muslim world. If you spend time within the tiling sections of Illustrator you will find examples and instructions for making geometric tiles into borders. There are even tools to help morph a given pattern into a corner that extends a pattern in a new direction.

A sampling of various vector images "tiled" as a background or desktop image. One of the projects in Chapter 7 applies the technique of tiling to real world objects.
Jamie Kruse

MANIPULATING TYPE AND TEXT

Creating special effects with type and text is possible with Illustrator's letterform generator, which has specialized vector controls that make it powerful in using type and layout.

Although word-processing applications are good for routine handling of type and text blocks, only a true vector-based program like Illustrator can achieve the feats depicted on this page.

containers and paths

Illustrator will fit text into any object or along any path.

Build an object, and then use Illustrator to fill it with words. Even more useful is that if you can put down a line—even the most twisted one—Illustrator has a variety of ways to make words flow along that line with elegance.

The examples here apply drop shadow to a sans serif typeface. Illustrator's controls are so nuanced that there are many choices about the orientation of letters used in these ways. When graphics designers talk of original illustration, they often mean use of such techniques to make familiar elements of type and text find new and dazzling forms. Carolina Correa

kerning and leading

Kerning is the amount of space between letters, and leading is the amount of space between lines.

When making logotype and setting large banner type, you will often want to fine-tune the spacing with adjustments that are extremely precise. Vector illustration is the best way to achieve this precision.

Imagine all the people
Living for today

Imagine all the people
Living for today

The example above shows both kerning (tight words and spaced out words) and tracking (big gaps between lines of text and lines jammed together). All of these configurations are legible. But there is a clear difference in terms of impact. Carolina Correa

type outlines and stroking

Computers bring fresh treatments to letters and words by generating outlines of the letterform contours or by stroking object paths with different visual effects.

Illustrator's default view is to show type as objects. But you can also choose the outline view, which shows only anchors and paths. Because we are so thoroughly familiar with letterforms, these shapes become particularly satisfying to mess around with by playing with their outlines and then filling them in fun ways.

imagine

imagine

Type a word into Illustrator (top). If you highlight your word, go to the Main Menu, choose Type, and then Create Outline, anchor points and paths will show up (middle). If you ungroup these outlines, you can go to town on the letterforms, treating them with lots of Illustrator tricks as demonstrated in the treatment (bottom). Jamie Kruse

APPLICATIONS AND FILE FORMATS

In earlier days of computer graphics practitioners recognized two distinct types of illustration software: **Raster-Based** programs (including Adobe Photoshop, Corel Painter, Microsoft Paint, Paint Shop Pro, and others) and **Vector-Based** programs (Adobe Illustrator, CorelDraw, Macromedia Freehand, and others). But the distinctions have started to blur, and the largest applications move nimbly between vectors and bitmaps.

A new form of illustration software is making a space for itself. **Online drawing communities** offer free software and a place to create and share works online in real time. Sites to visit include Digital Doodle, Groupboard, iScribble.net, and MyDrawing.com.

I would be remiss if I didn't mention 3D rendering. This missing universe ranges from animated cartoons to architectural drawings to magazine illustration to Hollywood special effects. At the moment, these fields seem a pretty far reach for someone making personal media. But chances are it won't be long before three-dimensional drawing becomes one more item in the digital tool set we all use.

Adobe's Illustrator CS3

Illustrator has seen many incarnations. As part of Adobe's creative suite, it is well integrated with Photoshop and InDesign, with Adobe's

Adobe Illustrator. The *Tools Palette* operates much like the one in Photoshop. So does the *Option Bar*, as it provides refined choices for the tool that is active. The *Document Window* contains the *Art Board,* which is the actual area in which you create illustrations or work with type. The *Guides,* shown here, can help when you are doing multiple versions of something. On the right side are *Panels* with title bars. Note that Illustrator has both *Layers* and *Sublayers*. The latter are unique to this application.

motion-graphics applications (Flash and After Effects) and with video applications (Premiere Pro, Encore, Soundbooth). In this chapter you've been all over Illustrator's many specific creative options. Here is a look at the overall interface.

Corel Graphics Suite

CorelDraw runs on Windows PCs and differentiates itself from other applications as a graphics suite with specialized applications for vector editing (CorelDRAW), for raster creation and editing (Corel PHOTO-PAINT), for image capture (Corel CAPTURE), for converting raster images to vector ones (Corel Power TRACE), and for working with RAW file format (Pixmantec RawShooter Essentials). Some digital illustrators find Corel easier to use than Illustrator.

. ai (Adobe Illustrator)

AI is the "native" file format that saves levels, paths, and other working elements of a project. When working in Illustrator, this is your "source," so you will want to label and save it with care.

.eps (Encapsulated Post Script)

EPS pertains to fonts and is editable in Photoshop. When it was first implemented, this file format was used exclusively with Apple Macintosh. It signifies a PostScript document.

Corel Graphic Suite. The *Toolbar* and *Tool Box* are what everyone expects today with software interface. The *Property Bar* provides detail and control over the different functions. It's easy to use. The *Drawing Window* is larger than the Drawing Area, which lets you see the edges of images you are drawing. The *Toolbox* is a floating bar with tools for creating, refining, and modifying objects in the drawing. *Docker* is a window containing available commands and settings relevant to a specific tool or task. Beside it on the far right are tools tabs and a distinctive *Color Palette*. The *Document Navigation* controls sit at the bottom of the interface.

ALTER EGO AVATARS

Although its only 50 x 50 pixels, the tiny "buddy icons" that appear in instant messaging windows make a powerful representation of who you are and set a tone for your online persona.

This exercise is a roll-up-your-sleeves introduction to Illustrator. It requires you to get comfortable with the basic drawing tools. The scale of the project may be small, but the learning curve is big. I am banking on the fact that because it's your image you will be working with, there will be enough motivation to carry you through.

Permit me a word or two about working loosely. You are going to drive yourself absolutely nuts if you attempt to capture each and every significant detail in the photograph of yourself. Truth is that unless you let go of all but the most essential shapes, the resulting portrait will not only be a cluttered mess, you'll lose the likeness that is essential in such icons.

In fact, go for exaggeration. Try to assess which of your features—hair, eyewear, lips, eyes—is the most characteristic one. Work as caricaturists and cartoonists do when they draw our national leaders—take it to the extreme.

Your photographic source image journeys through many steps to yield the simplified self-portrait/vector graphic.
Jamie Kruse

1. HIGH CONTRAST SELF

You need a good portrait of yourself, head and shoulders and evenly illuminated. You can crop your image out of a larger one, but it's important to "square-up" the version you will use in this short project. Make it 300 x 300 pixels. This gives you an image that is big enough to work with, but small enough to help you from getting too fussy with details. Save the source picture. Next, turn your source image into a black-and-white version. Play around with the brightness and contrast so that your image starts to lose its mid tones. Save the high-contrast version as a JPEG, GIF, or PSD file.

2. VECTOR OVERDRAWING

Import your high-contrast image into Illustrator, place it on its own layer, and lock it. Open a new layer and start to experiment. Try the Pen, Pencil, and Brush Tools to see which you like best. I recommend you select no fill and start with a stroke that has a line weight of 5 points. You might want to try Illustrator's Template Tool or the Auto-Trace Tool. When you are done, label this traced layer "outline" and lock it too.

Sean-Michael Aaron

3. SIMPLIFICATION:

Now begins the process of reduction. Hide your original photo and make a new layer on top of the outline. Overdraw again, but this time simplify your first tracing. Work toward self-contained shapes and away from freestanding lines. Work in steps: Save a layer and then make a new layer. Keep going. Turn your image into a cartoon.

Katie Elmore

Your alter ego will meet your real ego as you mess with different coloring and filling in. Try to choose effects that don't just make you look gorgeous or darling, but that also reflect your personality. Jamie Kruse

Daniel Julius Kamil

4. ADD COLOR AND PATTERNS

Now you get to play with Illustrator's color and pattern palettes. Try monochromatic palettes or flashy ones. If you want to eliminate the outlines, match the color of the path with the color of the fill. Illustrator lets you fill with patterns of many kinds.

Benjamin Ing

5. TAKE IT ONLINE

When you have an alter ego avatar you like, save a few copies as JPEGs. AOL's Instant Messenger (AIM) is the most widely used format for avatars. AIM calls them "buddies." There are lots of other instant messaging services that use avatars, including ones provided through Windows, Yahoo!, Google, and Apple. AIM (over one hundred million active users) posts alter ego images at 48 x 48 pixels. Mac's iChat squeezes source JPEGs to 64 x 64 pixels. Because you have created a vector illustration, resizing down will not be a problem.

Daedra Kahler

Here is a small gallery of alter ego avatars. Thanks to my students for being guinea pigs. Send your avatar to mediapedia.net.

Larry Lowe photo and Ella Turenne drawing

SHARING your work

This third part of *Mediapedia* gets down to work in a different way. Chapter 5 bundles all the design elements of the first four chapters and turns them into a performance. Chapter 6 is about packaging what you make and about letting others see it. Chapter 7 provides a jump start for more ambitious projects in personal media.

WELCOME TO
THE FOURTH SCREEN

Media guru Marshall McLuhan observed years ago that it takes a while for a new medium to discover what it is uniquely good at. Thus it's unlikely that today's world of the internet will look the same in the future. Take rich media, for example. It wasn't until 2006 that you could easily and inexpensively upload videos with streaming images and accompanying sound tracks. The term **rich media** summed it up well: unless you were *rich* in resources or *rich* in technical knowledge, what you could share over the internet was limited to words and still images.

Today it's a new game. Everybody reading this book has access to a remarkable array of glittering media screens.

The first screen was the silver screen of cinema. The second screen was the "boob tube" of television. The third screen is the computer screen, showing files we create and files we browse on the Internet. The fourth is the "small screen" of mobile communications forms. It is poised for an explosive impact on the other screens and will in time become a thing all its own.

What will that thing be? No one knows yet. If pressed I would guess that the fourth screen will become a place where personal media reigns because of its relevancy and immediacy. There is a meta trajectory that points in just this direction. The content of film is *the story* while the content of TV is *the character*. The computer screen is different from those that came before it because its content is essentially that of *interaction*. The fourth screen—the smallest one in terms of size—will carry stuff that you program for it, not the other way around. The fourth screen is about *personalization*. It will be made up of bits and pieces

of digital content that you choose and manage. The small, portable, multimedia computers that we will all soon carry will first build and then service a far more personalized network filled with personal media—the kinds of stuff that this book is about.

WEB 2.0

The fourth screen is already upon us. In the last twelve months mobile phones have morphed to something new, thanks to Apple and Nokia. Faster and cheaper bandwidth, combined with wireless connectivity, has yielded an unprecedented evolution of online communities.

I'm referring, of course, to what is being called Web 2.0. If Web 1.0 was about finding, Web 2.0 is about sharing.

You will already be familiar with some and maybe all that Web 2.0 has to offer. But a quick look at the set of interactive communities can remind you of the opportunities out there to enrich and share the things you create.

APIs (application programming interfaces) are Web-based applications that make it easy to do things that previously required an installed piece of software on your computer. For example, Google has word processing, spreadsheets, collaborative space, slide shows, and so on. All are live online and all are free.

Blogs (weblogs) are personally run sites with regular entries posted in chronological order. Some blogs focus on particu-

lar topics, while others operate as diaries. A blog titled DailyKos has a half million visits each day.

Smashups are hybrid Web applications that combine data from multiple sources into a single tool available to all. Examples include Google Maps and real-estate data on Move.com.

Peer-to-Peer commerce. Web 2.0 is evolving its own versions of eBay— places where sellers can post their goods and buyers can find a bargain. Craigslist is the best known site, but there are many others that collaboratively pool reviews of products and sources for buying things.

RSS feeds are "push" publishing services that regularly e-mail multimedia content to those who choose to subscribe. RSS stand for "Really Simple Syndication." Typically these feeds pop onto your computer screen when it goes into "save power" or "inactive" mode. RSS requires a Web-scouring functionality that is built into almost all of today's Web browsers.

Social bookmarking lets Internet users team up to build, store, and share bookmarks for Web pages. The best known of these is del.icio.us, which is credited with popularizing the use of "tags" for cross-referencing. A tag is a key word used to index a site. Tagging is a central concept in Web 2.0 life.

Social networking sites are places like Facebook and MySpace. Here users build files about themselves that can

include photos, lists, blogs, music, and videos. The "social" part resides in programming one's list of friends and hence building a personal network of relationships.

User-generated content. Sometime in late 2005 or early 2006, Web sites emerged where anyone could post and share "rich media"—music files, photographs, videos, and pod casts. The gorilla in photography is Flickr. In video, it's YouTube.

Virtual world. Second Life is a three-dimensional environment that operates as a world with many parallels to our so-called real world. You choose (construct or buy) an avatar that represents yourself and can explore, do business, build out real estate, and interact with other "residents." Other virtual worlds include There and Activeworlds.

Web hosting is the backbone for Web 2.0—the availability of services, storage, and networking that is provided free to anyone with a personal computer and an Internet service provider (ISP) account. Hosting is provided by .mac, Gmail, Yahoo, Google, and many others.

Wikis are a form of software that allows multiple users to create and edit the same Web pages. The nifty term has its origin in the Hawaiian word for "fast." The mother of this form is Wikipedia, which features encyclopedia-like entries and cross links and is authored by more than twenty-five thousand contributors.

We are only just beginning to see the contours of Web 2.0. But already a migration is underway that is certain to change and expand personal media.

Lest we overlook the power of really big screens, here are some oversize posters created by Tsang Seymour Design for New York's Cooper-Hewitt National Museum of Design. Note how they read at a distance. The Cooper-Hewett is an inventive hotbed. Visit its site. Courtesy of Tsang Seymour Design & CHNMD. Used with permission.

DESIGN THINKING AND DESIGN DOING

There is a big difference between **Art** and **Design.** Art changes the world. It is transformative. Design communicates information. It is attached to a specific topic or "problem" to be worked on.

Media design has a foundation of ideas and practices that have been nurtured by architects and graphic designers. Sometimes the products of media design are quite artful, just as sometimes artists will weave content "messages" into their work. What distinguishes a designer from an artist is the **process of design.** This way of working unifies all the different design professions.

In contrast to critical thinking, which is a process of analysis and breaking things down, "design thinking" involves building things up. It is very practical and pragmatic and can be used on creative problems of all kinds. Design thinking, which is championed by David Kelley, chairman and founder of Ideo and Stanford Design School, is receiving corporate and academic interest because it is recognized as a driver of innovation.

There are eight steps in the design process: Define, Ideate, Storyboard, Prototype, Budget, Implement, Distribute, and Learn. My years as a media producer and teacher have enforced upon me the certainty that a measured, step-at-a-time way of working becomes essential as you approach the more ambitious kinds of projects introduced in Chapter 7, the last chapter of the book.

1. **figure out what you want.** The initial step for any large project is to study the challenge you are taking on. Say, for example, you were planning a birthday party and wanted invitees to send in funny pictures of the friend you have in common. Your "design brief" (as it's called in the trade) would identify two tasks: finding out how many were coming and soliciting JPEGs that you could blow up or mess with by adding bogus captions or outrageous doctoring. *(Define)*

2. **come up with ideas.** The second step in the design process is the most overtly creative one: Come up with ideas, large and small, that you'd like to use in your project. In our example, the ideas can be typefaces you like, photos you want to include, stories you want to convey, one-liners you want to position for maximum laughs. One of the best ways to come up with creative ideas is by brainstorming with friends. *(Ideate)*

3. **work it out on paper first.** Paper is a proxy for the real thing, and much easier to revise. This is the phase of strategy. Sort out the "why" behind the piece you are making. This is also where you bake in the structure, organize your ideas, and figure out how you're going to execute. Think outside the box by first listing the obvious

solutions, then racking your brain for unexpected approaches. Many designers draw a series of informal, thumbnail sketches to work out their ideas. Such storyboards need not be much to look at as long as they help think through production. *(Storyboard)*

4. **try it three ways.** It is always best to assemble a choice of three possible approaches. You want multiple ideas so you don't fall in love with one solution too soon. Besides, your different ideas will cross-fertilize each other. It takes discipline to come up with second and third choices when you think you've got it the first time, but you have to keep trying. Step 4 is where you will work your way to true originality. *(Prototype)*

5. **figure out the time and money.** The creative process shifts into a new gear as you lay out the production plan. Regardless of whether your project is large or small, expensive or cheap, requiring lots of collaboration or not, I recommend two obligatory documents: a schedule and a budget. This is the phase of tactics. Even the simplest communications job can require this kind of planning (in the birthday party example, you might realize you need to collect $5 from each person to help cover the blowup costs). *(Budget)*

6. **make it.** Here is where the design thinking pays off. You shift into yet another gear—production per se. Standard tasks and corresponding workflow will vary depending upon the medium in which you are working. Execution is commonly divided into three production phases: preproduction, production, and post production. *(Implement)*

7. **share it.** You've done your best. Probably some things didn't turn out quite like you'd have wanted them. But the work is complete. This is the moment of judgment from your target audience. *(Distribute)*

8. **evaluate it.** Please, please find time at the completion of a project to take stock of how things worked out vis à vis what was envisioned at the get-go. Was the effort worth it? Did you have fun? What's next? *(Learn)*

A BENEDICTION

All of us have lives filled with so much: work, family, friends, fitness, community building. Personal media takes time, so you need to be strategic about how many projects you take on, how much time you will give them, and how you will share them. The last of these—the sharing part—should be first in your mind as you evaluate what to take on next. What is going to make the most impact, give you the most satisfaction, and contribute most to your world? Because there are only so many projects you can do in a given year, make each one count.

chapter 5: SLIDE SHOWS

Slide shows are dorky, right? This is certainly true when people sit down for an endless and shapeless strings of unedited photos about a summer trip, the new baby, or some other subject they're wildly excited about, that their friends and family are mildly interested in, and that put third-party viewers to sleep. People used to do this all the time with slide projectors, and today they can do it electronically.

Such slide shows are cousins to dreary PowerPoint presentations of businesses, classrooms, and organizations. PowerPoint's predesigned style sheets (fonts, colors, layout, backgrounds, and so on) seem to leave no room for individual personality, wit, or design. The results are predictable, canned, forgettable.

Don't blame the applications. As a communications medium in its own right, slide shows are extremely powerful. Slide shows can be *transcendent*. They can inform and delight us. They can move us to tears. They can change attitudes. They can implant themselves into our memories just as a Hollywood movie or Broadway performance can.

THE POWER OF MONTAGE

Something special happens when images are strung together in a series. Ideas and emotions emerge. Within sequences,

meaning takes form in a way that's different from the way meaning is attributed to individual images.

Let's test this claim. Cover the bottom of this page and look at the three stills on the left page. Follow images from left to right. What expression do you see on the young woman's face?

Now cover the left page and look at the three images below. Study the face of the young wrangler. What does her expression tell you now?

Only the central image is switched in these three-image sets. The theory of montage, first put forth by Russian filmmaker Vsevolod Pudovkin in the 1920s, suggests that if you were to see only the first version, you'd perceive a different emotion on the young woman's face than if you only saw the second. In the first, the young wrangler's expression seems loving, as if she is responding to the long lashes and gentle eyes of her horse. Her expression in the second appears wary or even alarmed because of those teeth.

Our brains connect images that stream before our eyes. We are pattern-seeking creatures. We'll infer patterns among different sounds, gestures, or images. We are also symbol-reading creatures. We instantly imbue complex and abstract significance into words and images. It is so natural for us to make sense out of a string of pictures that we rarely give the process a second thought. In this chapter we will look closely at the process, because doing so leads to better and more effective slide show presentations.

TIME-BASED MEDIA

With this chapter we are entering the world of time-based media—forms like cinema, television, radio, music, and animation. Time-based media are a notch more complicated than photography, illustration, or desktop publishing, where the viewer can always pause, linger, and go back over something. Not so with media forms that roll on in an unalterable progression.

Slide shows are a media form that exist in time. Like theatrical shows, they

are generally shared by groups of viewers, all watching the same series of images at the same time. Slide shows share the same, expanded set of design elements as other time-based forms: **duration, sequence, transitions,** and more. This chapter gives each of these elements a close inspection.

While it may seem odd to study time-based media in the locked pages of a book, let me assure you it's actually good to spend time with images in a static format. I've spent many years making and teaching about movies, and I've learned that a storyboard format—images in a row, looked at from left to right—is the best way to figure out the different ways that images and sounds can be presented. Yet thumbnail pictures in a row won't do the whole job. To complete the process of making a time-bound, unified experience of a slide show, you need to incorporate an editing step in which you explore duration and test your sequences and transitions.

To round out your experience of the static images in the chapter, go to mediapedia.net and then to the section on Slide Shows. There you will find Quick-Time movies that present every slide show we discuss in this chapter.

WHY I REALLY LOVE SLIDE SHOWS

Slide shows are the world's most unrecognized medium. They can have the impact of the very best you'll see in movie theaters, on TV, or online. Anyone with photo library software can make one. They don't have to be dull and predictable. So to remedy low expectations I offer these express tips:

- **Avoid oversimplification.** Information-based presentations are often too dumbed down.
- **Humor** is always appreciated, even when the topic is serious.
- **Show, don't tell.** Make the visuals work hard. Don't let the reporting be dominated by written or spoken words.
- **Curate ruthlessly.** Your audience is less invested than you are; grab and hold their attention by using only your very best images.
- **Personal stories** enliven all presentations. Tell a few.
- **Be cautious about templates.** I know they are easy and slick, but it's not that much more effort to select colors and type styles that reflect the unique project you're working on.

TYPES OF SLIDE SHOWS

Slide shows are a fixed sequence of still images displayed either as an automatic event or a when-clicked event, with someone doing the clicking.

There is a really important distinction about how slide shows are triggered.

Automated slide shows usually have a recorded sound track. The presenter hits a button and the show proceeds from start to finish without stopping. These slide shows operate in the tradition of movies.

When-clicked slide shows are driven by a presenter. Improvised or semi-scripted commentary accompanies the presentation. Usually there is no sound track. The person who clicks from slide to slide can pause wherever he or she wants. Questions can be answered. The slides can even be reversed to take a second look. Such slide shows operate in the tradition of live theater or the classroom.

Both triggering mechanisms—click-through and run-through—can be found on the Web as well as in the living room. Showmanship and artistry is required for both. Al Gore's Academy Award winning feature film, *An Inconvenient Truth,* shows that the best qualities of the presenter and filmmaker can be combined.

It's worth starting out differentiating three slide show genres: text driven, picture driven, and story driven.

text-driven slide shows

A text-driven slide show is a series of slides that delivers information in a carefully structured, discursive sequence. Individual slides often combine titles, body text, and imagery.

In the business world, Microsoft PowerPoint is an essential tool. Large companies maintain designers who specialize in making slick presentations, decked out with logos, custom-designed palettes, music, and animation.

This book is about personal media, not business media. But it's quite common to find situations in which you will want—or will be asked—to make an information-oriented presentation.

information architecture

You must organize and streamline the ideas and data you want to present. Bullet points and other organizational shorthand are often used to keep data trim.

With PowerPoint, you want to keep people from actually having to read your slides. Instead structure your information so it can be easily skimmed. PowerPoint 2007 version offers a function called SmartArt. This tool lets you choose from a series of lists, diagrams, and charts to help you present easily consumed information.

The thumbnails are surprisingly clear in suggesting how information can be chunked and sequenced. SmartArt dialog boxes let you customize the graphic forms.

themes

Themes are sets of font choices, backgrounds, color palettes, and other design options available with PowerPoint. For many people, the look and feel of PowerPoint's themes are compelling features of the presentation software. With a single click you can apply a coordinated set of visual treatments to your entire slide show.

Preconfigured themes are great if you need to work fast. But you can also customize: text; effects; color schemes; backgrounds; layout; multimedia content.

These are three PowerPoint themes applied to the same title, line of text, and image. These examples were made with an older version of PowerPoint (2004 for Mac, version 11.3.5) that has no less than 110 theme choices.

movement

There are menus and a formatting palette that let you add animated movement to your PowerPoint slide show. The general design strategy is to take direct control over the viewer's eyeballs. Animated movement helps to keep the viewer's eye engaged without upstaging the "points" being presented. In addition, a little showmanship is always appreciated: humor, surprise, a visual joke, or sound effects.

PowerPoint presentations work best when information is staged a little loudly. Here the color palette is limited to red, black, white, and yellow. The backgrounds sample a solid color and two variations of gradients. Other design elements: different fonts, drop shadow, and rotating text at an angle. All three by Elizabeth Ellsworth, Jamie Kruse, and author.

picture-driven slide shows

A picture-driven slide show is a collection of images that shares a source or theme. These typically have no sound track.

Warning: This is the kind of slide show that has given the medium a bad reputation.

The key to making a slide show that will delight both you and the people watching is weeding out the not-so-great shots.

Do you know the secret code word? It's KISS: Keep It Simple and Short. Here are three more things to keep in mind:

organization and groupings: Chronological order is a proven effective structure. Thematic structures are also natural to some types of subject matter. Remember: We're pattern seekers, and discovering clear patterns makes the viewer feel good.

visual continuity: Your audience may not have a conscious awareness about visual tidiness, but they feel it. Make sure that every image in a slide show is cropped to eliminate messy bits around the edges and to fit with the other images. It's distracting when a slide show jumps between horizontal (landscape) and vertical (portrait) framing.

pacing: Estimate how much time your audience is willing to spend looking at your photos. Then subtract 10 percent. This is your maximum running time. If you are clicking through a gallery of photos, make note of how long you want to look at each slide. Three seconds seems like a short time when you've only got one image in front of you. Yet when you're viewing a long series of slides, the same three seconds can feel like they're dragging.

 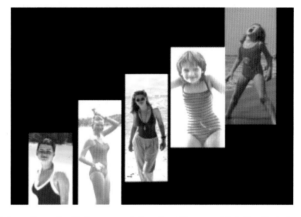

I made a ten-minute slide show for the rehearsal dinner the night before my daughter, Emmy, was married. People call me a cry baby, with reason. That night I turned the tables on them with a gallery of shots from my family archive. The show was all pictures, but I did set them to music.

A title slide set the context (pevious page). I arranged my slide show in chronological order, beginning with shots taken at the hospital the morning Emmy was born (pevious page). Then I included three sequences in which I had scanned and resized some old photos and then "slid" them through the frame (this page). By cropping and resizing I was able to pack in multiple pictures. The joke of Emmy's mugging for the camera was done with quick cuts (top row, first two). I had fewer pictures to work with for my son-in-law, Greg (top row right). The final six images are from a series of twelve in which Emmy is looking straight into the camera. The dissolves between images took less than thirty seconds to portray a baby growing into a young woman. I used square-formatted photos on a gray background. There was a change of music and mood. The last image was repeated, but on a black background that subtly resolved the time-lapse of Emmy and signaled the end of the show.

I used Apple's Final Cut Pro. This video-editing application is a lot like Apple's iMovie, but it offers greater control over manipulation of still images. You can see the slide show at mediapedia.net.

story-driven slide shows

Story-driven slide shows feature narratives locked to sound tracks. They come in two flavors: journalistic and anecdotal.

A raconteur is someone who excels at telling anecdotes. These are most often very personal accounts of first-hand experience.

journalistic reporting

Journalism reports on human affairs—people, events, places, and things. You don't have to work for the *New York Times* or *National Geographic* to be a journalist. We are all reporters who cover the important events in our lives. But few of us act like good journalists. We don't take the time to think about either the scope of coverage or the specific details.

Trained reporters look for a "hook" to grab their audience's interest. And right from the beginning, they hunt for a satisfying way to end their report. Here are some other things to keep in mind:

voice and tense: Do you want to include your own voice as an active observer? There is the third-person, past-tense approach: "The bikers assembled at dawn." Or there is the first-person, present-tense approach: "I am shivering as I join the other riders."

one represents many: This is a classic gambit: select one person to stand for the experiences of larger groups. U.S. presidents do this when they address Congress by pointing to a few unsung heroes sitting in the gallery and looking awkward.

pros and cons: Good journalism always seeks to tell all sides of a story. Try to be a neutral observer, even at events where you are an insider.

calls to action: A slide show can be a rant or a plea or a cautionary tale. It can involve a very specific call to action.

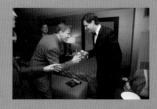
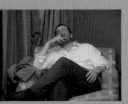

Amani Willett

Everyone likes a party. We find any excuse to gather and have fun. But it's not easy to document these events in a way that catches the quality of the event and sidesteps all the clichés. The slides here were shot by a really accomplished photographer, Amani Willett, at the Las Vegas bachelor party of a college chum. This sample contains about a quarter of the material, yet it demonstrates a number of solid journalistic techniques.

Here are five tips for getting good coverage of an event:

1. Set the stage. Start shooting before things start. Here the photographer establishes Las Vegas and introduces the bachelor (shots 1, 2, and 3, top row).

2. Choose "B" characters. Try to build short sequences around one or two people who are not at the center of the story. Here a running joke evolves around a friend who did a lot of sleeping (shots 4, 5, and 6).

3. Build to central event. Both the selection of shots and their duration should build in some way. The largest part of the show follows contours of the party (shots 7 through 10).

4. Look for details that say a lot. Artsy details reveal character and provide little breaks between different parts of a slide show. The photographer shot himself stalking good pix, and he spotted provocative architectural details (red wall, and empty corridor) to use in transitions or to fill in a sequence.

5. End with a flourish. Your slide show audience should know it's at the end. A last signature slide is essential.

anecdotal storytelling

Anecdotal storytelling is a first-person account of a meaningful experience. This kind of slide show is driven by a voice-over track that is written and delivered by the storyteller him- or herself. It is my favorite genre of slide shows.

The production can be really simple: a few photographs, some old snapshots—and your voice. But the effect can be truly moving. (See Chapter 7 for four examples from an international movement known as Digital Storytelling.)

The images that follow come from an account that one of my students created about sleep paralysis, a chronic disorder that involves visual and aural hallucinations.

Slides from a two minute slide show titled "Sleep Paralysis." The creator recounted three types of hallucinations: one in which the sleeper imagines a malevolent presence in the bedroom; one in which nightmarish sounds are heard; one in which there is sleepwalking. Ananda Tinio

SCREEN STRUCTURE

Screen structure is the combination of writing (conceptual) and direction (design) that holds a viewer's attention during a time-based media presentation.

There are four—and only four—basic kinds of screen structure: Narrative, Documentary, Artsy/Designy, and Emotional. If you understand these four ways to select images and edit them into a fixed sequence, your slide shows will reach a new level of impact.

narrative structure

In narrative structure, the primary criteria for image selection and sequencing centers on an unfolding of series of events that involves one or more characters. The constant question in the mind of the viewer is: "What happens next?"

Examples of narratives are everywhere: the movies; TV sitcoms; crime dramas. Most advertising is built on narrative structure. This is the world of **storytelling.**

A few years back I visited a ranch in the Rocky Mountains. I got to know a friendly and capable young wrangler named Jody. At dawn one morning I shot about fifty or sixty stills as Jody did what she does every morning: wrangle the horses and groom them. Later I shot more stills of the ranch building and surroundings.

For the Narrative mode I start with an image taken at dawn (upper left), which sets a tranquil mood. We follow the young wrangler as she heads out to the corral and halters a horse named Harry (slides 2 through 5). Jody grooms and then saddles Harry (slides 6 through 9). The sequence ends with a shot of rider and horse and dog, heading out onto the range.

The author thanks Jody Goldbach for permission to use these images and those in the following slide shows.

 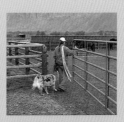 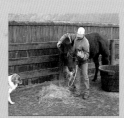

Many elements characterize narrative structure. Most important is that the story line is clear, even if there are jumps in time. Each image is important in building the story. Unless you are getting very artsy, your story should have a beginning, middle, and end.

documentary structure

In documentary structure the primary criteria for image selection and sequence centers on reporting about a particular place, group, or occurrence (often all three). The constant question in the mind of the viewer is: "What's going on here?"

Examples of discursive structures are abundant: TV news coverage, public-affairs documentaries, instructional movies, online tutorials, infomercials, pictorial features in magazines and more. This is the world of magazines and reality programming.

With this type of slide show, the goal is to inform the audience about what's going on, who the participants are, and what's at stake.

Such discursive productions often carry an expectation for being dull and predictable. One might appreciate that the piece is about something "important." There's a big reward when you reverse expectations.

The ten shots seek to establish a sense of place. Wide shots portray mountains, a river valley, and grazing pastures. The fourth image leads the viewer's interest into the ranch compound. The sequence establishes buildings (slides 5 through 7) and then moves inside to look at three shots of cowboy tack. The emphasis throughout is on objects and architecture, not on people or livestock.

artsy/designy structure

Here structure is about form, not content—how the pictures appear and not necessarily the content they convey. The constant observation in the mind of the viewer is: "I never saw it that way!"

This is a world where looks and form are everything. It's a world of pure design, of being artsy. The best places to look for artsy/designy sequences are music videos, TV spots, and the opening title sequences of feature films.

When working with this type of structure, primary attention is toward a look. Story and information take back seats. The media maker should be preoccupied with finding shape, colors, textures, and screen directions—all formal design properties.

When a series of images is thus structured, it tends to flow with heightened intensity and grace. The viewing experience is like that of listening to music or watching dance.

The goal is to make a visual connection that does not have to do with content. Here are the formal elements around which each link was made: parallel lines (between slides 1 and 2); matching shapes (between slides 2 and 3); color (shade of blue in slides 3 and 4); form (black arches in slides 4 and 5 and circles in slides 5 and 6); points of stars (slides 6 and 7); gray background (slides 7 and 8); texture (of fabric in slides 8 and 9); and directional lines (slides 9 and 10).

emotional structure

Intuition becomes the primary criterion for image selection and sequences in emotional structure. The constant awareness in the mind of the viewer is beyond a simple question or observation: It becomes the sensation that one is directly experiencing something.

Emotional structure is the world of dream and subjective experience. The most widely seen and popular examples of intuitive structure are represented by music videos and within experimental filmmaking. This mode of selecting and ordering visuals seeks to connect with deep symbols, even mythologies. The viewer's ability to think critically is suspended as the psyche receives a rich and provocative bombardment of emotionally charged input.

Here viewers are far more concerned with the feelings, or the resonance, of the screen experience than they are with look, or content, of the story. The media maker's creative powers focus on evoking a deep emotional response.

I did some riding at the ranch and marveled at the superbly trained horses. A slight shift in the saddle or pressure of the knees becomes a clear signal to these powerful animals. They were gentle and extremely attentive. They were big. And to a city guy like me, they were scary, too. When I got my camera close to the horses, they sometimes nuzzled me or opened their lips for a treat. Back in New York I did a gut-level assembly of shots that played with a sense of menace.

putting it all together

Put down this book for a moment and go online to take a look at the one-minute movie from the ranch pictures above. It contains just over forty images and is set to an original piece of music. If you watch closely, you will see that all four kinds of screen structure were combined in fashioning the piece. The editing is synchronized with the beats of the accompanying score. This slide show was built in an early version of iMovie, and all the effects used—including transitions and titling—are common in almost all slide show applications. The direct link to this QuickTime movie is http://mediapedia.net/Jody.

The short piece of music in this slide show was created by Tom Pompesello and is used with permission. Author again thanks Jody Goldbach.

TIMING AND RHYTHM

Each image in a slide show occupies a precise amount of time while it's displayed. The patterns that aggregate from these timings can form repeating rhythms.

Choosing and ordering images is about half the art of making a slide show. The other half is setting it into motion. And motion takes place in time.

Pacing, tempo, and visual rhythm become powerful factors in shaping your audience's experience. Most slide show engines come with tools that allow you to control how long each slide is held on the screen. Even if you are conducting a when-clicked show, it is important to remain aware of how the rhythm of the slide sequence changes your perception.

Whether a slide show is automatic or when-clicked, its audience eagerly awaits the flow of a well-paced presentation. It should vary: slow and measured to fast and exciting.

measuring time

Minutes, seconds, and frames are the standard measures within time-based media.

When slide shows are improvised, it's up to the presenter to control how long each image is projected. This is no easy feat, and many ponderous shows result from those who are unpracticed in the art of controlling the velocity of a presentation.

Inside every computer is a clock. It is always turned on and never runs fast or slow. Many media forms hook into this foundation of measured, reliable time.

Time code is a precision standard by which time is measured in professional media. Consumer-level slide show applications are abandoning the use of time code in favor of less-accurate measures of seconds. This is not a good thing. If your slide show program tracks time only via seconds, not parts of seconds, you'll have to rely on trial and error instead of frame-accurate markers to sync images and audio.

Time code is used in making video and audio. It consists of a sequence of numeric codes generated by the computer. In the example here, the first pair of digits is for minutes, the second for seconds, and third pair is for thirtieths of seconds. When time code is used to record over extended periods of time, the gauge adds two more digits at the beginning, to record hours.

duration

Duration is the amount of time a visual image or audio event is held within a time-based medium. Duration affects perception.

A single image is certainly readable if it is held for one second. Viewers automatically adjust their perceptual threshold so that within a fast barrage of images their eyes can discern a flashed image that is held for ten video frames (a third of a second) or even less. But if you put the same ten-frame shot amid a stately procession of three-second images, the viewers will miss it.

Viewers will quickly pick up on an established **tempo.** Humans have an inner clock that seeks out repeated patterns within time. We expect breaks or changes in an established rhythm to signify or accompany changes in meaning. Make full use of this technique in your slide shows.

IN-FRAME MOVEMENT

In-frame movement is the apparent movement created when there is panning or zooming within a single, static image.

Slide show applications let you move into, out of, and across the surface of a picture. This technique was developed in the days of animation cameras that allowed an animator to make precise, frame-by-frame adjustments. If the camera moved up or down, it looked like a zoom closer or farther back. If the artwork moved from side to side, it seemed to pan.

Computers simulate such **optical moves** in real time. The set of images below attempt to show how movement is created within a still photo.

pans: A fixed frame size travels over time from one location to another.

zooms: A frame starts wide and then moves in a specified time to a closer framing, or the reverse—a zoom out.

compound shot: A combination of zooming while panning. The frame begins with one location and size and moves in time to a different location and size.

The *pan* from newborn to mom could go either way (left). The *zoom* from wide shot to close-up (middle) cannot show the whole of baby Henry without shooting off the frame. The *compound shot* (right) would begin with Henry's right foot, pan to his left foot, than travel north to his tiny face. Tiffany Zehnal

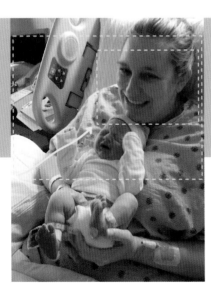
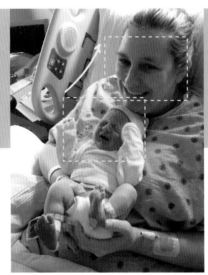

TRANSITIONS

A transition is the visual passage from one image to another.

Whether clicked through or automatically set, slide shows offer a variety of transitions that can add interest—or become distractions.

The simple **straight cut** is the most familiar kind of visual transition: The viewer's eye jumps from one subject to the next. But over the years filmmakers have concocted a variety of familiar transitions such as **cross-dissolves, fade-ins** and **fade-outs**, **pushes,** and **closing circles.** All of these effects have made their way into the digital engines that make slide shows.

Transitions must be used with restraint. At best they feel right as the way to join one image and the next. But they can also feel wrong—annoying, gratuitous, in the way.

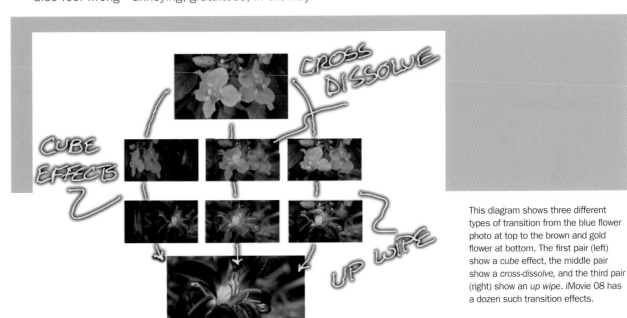

This diagram shows three different types of transition from the blue flower photo at top to the brown and gold flower at bottom. The first pair (left) show a *cube* effect, the middle pair show a *cross-dissolve,* and the third pair (right) show an *up wipe.* iMovie 08 has a dozen such transition effects.

SCREEN GRAPHICS

Screen graphics include text and other visual material that is integrated within the images of a slide show.

It's tricky when text and images share the same screen. Reading a picture always requires more time than scanning a picture. Plus, text on one image tends to pull the reader out of a slide show's flow. Generally speaking, there are three types of screen graphics: titles, lower-thirds, and credits.

title slide

A slide at the beginning of a slide show featuring a few words that give the piece a title and optional subtitle.

Sometimes it's smart to place a title slide on a black or neutral field. This give the audience time to register what the show will be about. Of course text can also be superimposed on the first slide. Legibility is always an important consideration, and choice of font, color, and size is critical.

The black edges around the letters of the title, "Jamaica," help it stand out from what is a busy background. The choice of color also helps.

lower thirds

Lower thirds refers to text that is inserted low in the frame and provides information that identifies the visuals.

The term lower thirds originated in television, where electronic character generators inserted the names of talking heads on the screen. For many years, a set of conventions controlled the placement and size of this on-screen identification. Now, of course, digital tools can quickly create text, size and color it, and move it to any position within the frame.

Television programmers have stepped up the practice of inserting network logos and promotions for upcoming shows into corners of screen left or screen right. As a producer of television fare, I reflect on how little respect such usage has for the visual integrity of the shows being aired.

end credits

End credits cite some or all of those who worked on a particular project, plus give copyright acknowledgments and any other information about the production of the slide show.

End credits are often shown as credit rolls, which start off screen and ascend through an underlying image. End credits can also be configured as cards or individual slides. People inevitably lift their chin a bit higher when they see their name on the screen, some generous with credits. But be kind to your viewers, too, and keep the credit rolls a reasonable length.

This frame suggests a credit roll. It's good form to acknowledge those involved in creating your slide show.

AUDIO

There are two categories of audio information: That which is sought out by the human brain (signal) and that which the brain purposefully does not attend to (noise).

Audio was the first of the time-based media. Along with the earliest words, there surely came the rhythms our ancestors drummed and chanted. Human ears and eyes want to work together, and personal media has most impact when pictures and images are delivered in concert.

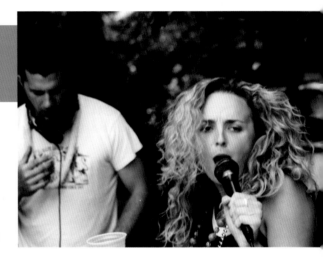

human voice

The human voice includes words, singing, and utterances such as screams and hums of delight.

Either a scripted or an improvised voice track often accompanies slide shows. Voice comes in three flavors: narration, which is often objective and detached; first person, which features the word *I* and personal commentary; and dramatic readings, which can include dialogue among actors or a monologue by one person. Try them all.

Let's not forget music. This photo is a reminder that a singer, in this case Erin Donohue, has a range of expression that can become the main attraction in a slide show. Behind Erin is Brian Littlewood, who is the DJ. The live mixing of recorded tracks is a bonafide performance form in its own right, and you might want to incorporate it into a slide show, too. Jeff Ertz

recording sound

A microphone converts the energy of sound waves into the energy of electricity, which is then measured and recorded as digital information.

Very inexpensive microphones are available that you can just plug into the USB port on your computer to record audio. You can buy a microphone attachment for your iPod and start recording sound with little or no setup. It's not easy to record high-quality audio, but if you take reasonable care in positioning a microphone close to the source you are recording, and if you try to record in a space with little ambient noise, it's possible for almost anyone to get a clear recording of voice or music with even the most inexpensive device.

Blue Mic's Snowball (left) has a cool retro look and costs around $160. The Samson condenser microphone (middle) is around $75, and the Logitech's USB model (right) costs under $25. Keep in mind you always have to keep the microphone steady. Never tap it with your fingers to see if it's picking up sound; that could damage the microphone. Snap your fingers instead.

importing music and sound effects

Slide-making applications have protocols for attaching digitized music and effects tracks, called *cues*.

PowerPoint, iMovie, and other slide show engines all include ways to import digital audio files that will play along.

Such cues can be **looped,** which means they repeat themselves automatically. This is useful if you are conducting a click-through presentation. A very specific cue—for example a burst of wild applause—can be synchronized to accompany a particular slide. Finally, the rhythm of a musical selection can provide specific beat points where slides are automatically advanced.

Many slide show applications come with small libraries of sound effects and generic musical tracks. Problem is, they sound generic. Just as there are plenty of clip-art libraries on the Internet, there are also libraries of stock music and sound effects—some free and some you have to pay for.

This screen capture shows what a chunk of audio looks like in the free sound-editing application Audacity. You can see two stereo tracks and the range of frequencies in each.

sound editing and mixing

Sound editing and mixing is the process of building voice, music, and special effects tracks and adjusting their relative volumes (the mix).

Neither iTunes nor PowerPoint provides much heft when it comes to building tracks. QuickTime, typically used as a cross-platform media editor, allows you to do audio and video edits (if you pay for the pro version). However it doesn't have any effects or allow for fades. If you want to mark the beat of a particular rhythm, place an effect at a precise spot, or adjust the relative volume of different tacks—in other words, if you want to get really creative with audio in the same way this book is encouraging you to get creative with imagery—then you should check out one of the editing and mixing applications listed below.

This is a taste of a program called **Logic** (background application above), a professional sound-recording and mixing application that we won't cover here. This screen capture also shows a **Matrix Midi Editor** (left) that is used with musical instruments, the **Synthesizer** (top right) that generates audio signals, and the **Mixer** (bottom right) that allows you to adjust different sources. Jeff Ertz

APPLICATIONS
AND FILE FORMATS

There are literally dozens of computer applications that generate slide shows. All digital camera makers ship software that contains slide shows, and many cameras build in slide show playback.

Not covered in these pages is Apple's Keynote, a dedicated presentation application that is much like PowerPoint. High-end video-editing applications such as Apple's Final Cut Pro and Windows-based programs like Avid Express and Premier are superlative for making slide shows. Adobe's After Effects and Flash are animation/motion-graphics applications that can turn out eye-catching slide shows with synchronous sound tracks.

PowerPoint

The overarching service of Power-Point—part of Microsoft's Office suite and designed for business use—is in emphasizing the information architecture within a presentation, providing a structure that helps people present their ideas simply and clearly. It offers dialogue boxes that let the user control all the text elements, including something called SmartArt (new to Office 2007) that provides customizable graphics that lay out items of information in the shorthand forms that are naturals to a presentation screen:

Microsoft PowerPoint: At top left is a new *MS Office Button,* introduced in the Windows 2008 version. Microsoft is excited about the integration of PowerPoint with other programs. The *Function Tabs* open up to full view the *Thumbnail Options.* This feature is well designed and presents many, many choices. *Slides* along the left show thumbnails of the slides you've made. The *Slide Pane* holds the slide you are working on at the moment. In this example you can see one of the *SmartArt* configurations discussed earlier. The *Notes Pane* is where you write notes to yourself. This is useful when you're clicking through a presentation, but it's not so useful when you're building slide shows that play automatically.

lists, cycles, pyramids, hierarchies, and other content relationships.

But PowerPoint is also a true multimedia program. You can insert photographs, clip art, objects, charts, sounds, and movies. There's even a little bit of animation—entrances and exits, growing and shrinking, and spinning—that you can attach to any object or text element.

PowerPoint's bias for talk-and-click mode is evidenced in how the program lets you work with audio. The slide-timing device lacks split-second accuracy.

.ppt (PowerPoint Presentation)

Presentations can be saved and run in a number of file formats: PPT (the default format), PPS (for PowerPoint Show), and POT (a format for Power-Point templates).

Apple's iMovie

Apple's iMovie is a giveaway application that comes bundled in all new Macs as part of a suite of consumer-level software called iLife.

The latest version of iMovie has been dumbed down from earlier versions. No longer is there a time line on which you can put down marks that are perfectly in sync with a music track. No longer is there a semi-precise control of the clock—down to frames within a second of time.

If you are a Mac user, iMovie

iMovie is designed primarily for video, although it works well with slides. The iLife '08 version, sampled above, has a *Project Library* that holds all your movies and slide shows. The *Project Viewer* works with the *Viewer* to show all the slides in a show. A *Tool Bar* is conveniently placed above the *Source Window*, which here contains Slides. The *Events Library* logs transitions and special effects.

integrates smoothly with your photo collection (iPhoto application), your music collection (iTunes), and Garage-Band (a really slick and powerful engine for creating original music).

If you work on a PC, then Adobe Premier is your best choice for a true video-editing program that will also handle slide shows and sound tracks.

microsoft's MovieMaker

MovieMaker is Window's free video-editing software that comes installed on new PCs. IMicrosoft has evolved this application very well, whereas Apple has devolved its comparable iMovie software to the point where it is too automatic for really creative work. With MovieMaker you can edit videos and import stills and layouts. On the sound side, you can sequence and edit narration, music, and sound effects (SFX).

.mov (QuickTime)

MOV is a multiplatform file format that contains tracks that store different kinds of data: audio, video, effects, or on-screen text. QuickTime is well suited for editing, exporting, and the playback of slide shows, audio files, and videos.

iMovie and other applications like it are mainly for editing videos. Slide shows are secondary. *Toolbar* has the standard items. The *Transitions Pane* is open here. Note the rich variety of transition effects and how they are clearly visualized. To the right is the main *Panes* window where you see what's on the screen. *Storyboard/Timeline* lets you work with images in order, or via a time line that logs tasks to be performed at a specific time during a prerecorded track. The time is displayed as a time code.

. mswmm (Microsoft Movie Media Maker)

Microsoft Movie Media Maker is Microsoft's proprietary format. It is also designed to work with slide shows, movies, and audio.

ProTools

A cross platform (Mac/PC), ProTools is a professional audio application program made by DigiDesign (now owned by AVID). This application allows you to layer tracks, apply effects, mix, work with virtual instruments, and do just about anything with audio.

Apple's GarageBand

A multitrack editor, recorder, and synthesizer that comes with Apple's iLife Suite, GarageBand is easy to use. The application's focus on looping chunks of music lets non-musicians build complex and very satisfying original compositions.

.aiff (Audio Interchange File Format)

AIFF was developed by Apple and is now widely used on all platforms. It is uncompressed, which means it will be a large file.

.wav (Wave Form Audio)

WAV was developed by Microsoft and IBM. This is the main format for PCs but is also widely used on all platforms.

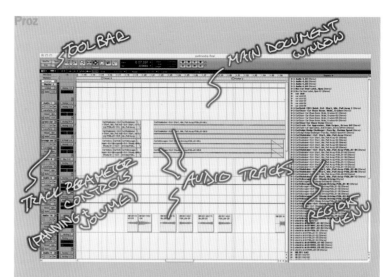

Pro Tools. This screen shot shows the *Main Document Window*. The purple, green, and orange items are *Audio Tracks* that have their own audio files. The *Toolbar* provides various tools for recording, playing, moving, and otherwise manipulating *Track Parameters,* such as panning or volume. The *Region Menu* on the right shows each portion of each track used in the file. Pro Tools edits nonlinearly, which gives you the ability to manipulate files without changing the originals.

.mp3

MP3 is an audio-encoding format that compresses audio files, by removing the higher and lower parts of the sound frequencies.

.m4a/mp4 (MPEG 4 Audio File Formats)

M4A and MP4 shrink down the size, but without requiring licenses or payments associated with some MP3s.

.wma (Windows Media Audio)

WMA, Microsoft's proprietary audio format, works really well on its native players (like Windows Media Player), but it may not work on other programs/systems not designed by Microsoft.

MIDI (Musical Instrument Digital Interface)

MIDI is the standard for synthesizers and virtual instruments. It represents values for a note's volume, pitch, length, and in some cases timbre (quality/type of sound).

.avi (Audio Video Interleave)

AVI was developed by Windows. As with WMA, it's proprietary. As with MP3, M4A, and MP4, it's compressed. But if you're going to work in PowerPoint, it works really well.

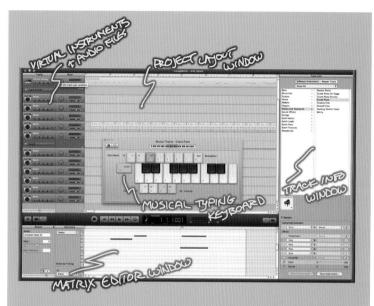

A **GarageBand** document window holds *Virtual Instrument* and *Audio File* tracks to the left and positions a *Project Layout Window* in the center. Audio files can be "dragged" into the project or can be recorded directly with a built-in or external microphone. Sounds can be created from MIDI instruments and can be played live with the *Musical Typing Keyboard*, which allows you to play notes live with your computer. The *Matrix Editor Window* (center, bottom) lets you change characteristics of notes after you've played them on the keyboard. The *Track Information Window* allows you to change parameters of entire tracks by adding effects or changing the instrument itself.

A PARK IN FOUR MODES

Here is a salvo of small assignments that throw down this challenge: Make four slide shows about one place but use four very different design approaches. It's a fun way to anchor the ideas about screen structure.

Usually when taking photos in a park, your goal is to get a little bit of everything—to cover the topic and get some great individual shots. Here you are asked to use each of the four distinct approaches. And to test your mettle, the four approaches should be shot at the same location in the park.

If parks aren't your thing, select another place: a market, a ball field, a mall, a marina—almost any location can work as long as there are people there engaged in various pursuits.

This project is about screen structure, the fundamental ways you select images (the way you **shoot them**), and their arrangement into a fixed sequence (the way you **edit** them). It's not just about taking pictures. It is also about thinking ahead to how to arrange sets of ten to fifteen images into a coherent slide show that will be about a minute long.

Start by walking around the park without your camera so that you can consider all your options. Think ahead about the four different approaches that are at the heart of this little project. Anticipate how each approach will shape your camera work.

 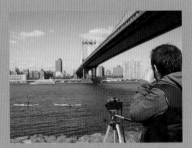

APPROACH 1: NARRATIVE

With the narrative approach, you will be telling a story. One way is to recruit an actor or two whom you can direct. The narrative can be extremely simple—but be sure there is a very clear beginning, middle, and end. The end product will have ten to fifteen images, but I suggest you shoot many more than that, covering more details or moments within the story than you will end up using. Later you will select which images to put in what order.

APPROACH 2: DOCUMENTARY

In the documentary approach, you will be reporting on the specific location you've chosen. Work for a general sense of the place. Think like a journalist: who, what, when, where, and why. Anticipate your final slide show. Should it go from general to specific or the opposite way?

APPROACH 3: ARTSY/DESIGNY

With the artsy approach, the goal is to capture stills that imbed formal design elements, including shapes, colors, textures, unusual camera angles, framing, blur, and so on. In editing you should try to find a logic that links one image with the next by matching visual qualities.

This project suggests you find a location in a park. But many other environments will work as well. You can find fascinating activity and people in the heart of the city, at the beach, along a waterfront, in a cemetery, or at a parade. Smudge Studio; Greg Podnovich; Smudge Studio; Todd Calvert; Geraldine Laybourne

APPROACH 4: EMOTIONAL

The emotional approach may be the most difficult, because you have to convey a specific intention. Begin by identifying a specific feeling you want to build. Capture images that are emotionally charged. Rely on your intuition. Try to imagine the way this place would appear in a dream. Whereas editing in the first three approaches can follow a clear and logical flow, here your editing is intuitive. You will need to trust you instincts.

THE EDITING PROCESS

Choose the best photos and then begin putting them into sequence. Work fast with the initial order. Next, lock in the duration of individual shorts. Experiment with patterns of quick cuts and slower montages. Then add camera moves within images that are held for longer duration. Then add transitions. Last, add a title card for the front.

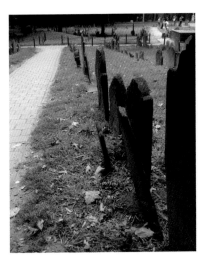

chapter 6: DISPLAY AND DISTRIBUTION

This chapter looks at ways to produce, position, and distribute the personal media you make. Don't think of this as a boring, perfunctory obligation.

A close-to-home project may surprise you when it suddenly seems to jump beyond your immediate circle. Word will get around quickly that you've got creative chops. Before you know it, family members, local organizations, and workplace colleagues will be asking for your help.

This can be one of the best rewards for your investment of time, effort, and cash. For while it's fun to feel your skills getting stronger with each project, it's even more fun when those skills are recognized and can be put to work in the service of a cause you care about.

BRANDING YOURSELF

If corporations and government agencies brand themselves, why shouldn't you?

A brand identifies the originator of particular goods or services. I used to think that efforts to promote oneself were obnoxious. But over the years I've changed my mind. I slowly realized that believing in something you've made *always* involves attaching your name to it. I learned that collaborators need and deserve the credit you can give them. I've come to see branding as a way of building contacts that will lead to projects you can't imagine.

In an era of clutter and hype, authenticity and differentiation will win out. Authentic work is work that springs from a real need and a real person. Differentiation is nothing less than your unique signature as a media designer. When you put your name on a project, you're creating your own brand. So develop a personal style, be sure people know that every photo, card, scrapbook, and slide show you create was made by you, and celebrate your authorship and unique perspective.

DESKTOP PRINTING

Three big breakthroughs have fueled the growth of desktop printing. The first is color. Ink-jet printers produce beautifully nuanced, full-color photographs. Second comes multifunctionality. Your printer is no longer just your printer. It can copy. It can scan. It can fax. The third breakthrough is cost. You can buy a quality "all-in-one" printer for under $100.

Pictured here are Hewlett Packer ink-jet printers. The Officejet 4315 (left) is the least-expensive model that prints, scans, faxes, and copies. It costs less than $100. The Photosmart C6180 costs just under $250. Its features include fast printing (thirty pages per minute), automatic two-sided printing, printing from memory cards, higher scanning resolution, and networking.

one pagers

The range of personal publishing projects is vast. Standard letter-size paper is required for school reports and business correspondence but is restrictive for projects that require less space and more personality. Some of the things you can make with your desktop printer include the following:

- **invitations**
- **brochures**
- **fliers**
- **labels**
- **gift tags**
- **menus**
- **postcards**
- **greeting cards**
- **newsletters**

My friend Sandra Chamberlin helped create a postcard to announce the party of a friend (left). She worked in Photoshop but included handmade illustrations and archival clip art to create a very warm tone and color palette. The thank-you note (middle) was designed to be folded in half and then inserted into a standard envelope—well, almost standard. Sandra cut a hole so that one of the eyeballs would show. She also ripped the edge and reglued the ragged edge. She notified the local post office to the odd envelope, and the postal worker hand stamped it and sent the letter along its way. Sandra Chamberlin

bound documents

There are fewer options for binding your publications than in sizing them. Perhaps the simplest technique is to staple a publication along a middle fold line. When binders do this, it's called saddle stitching and is done with a special machine, not a stapler. If you do this yourself, and if you print the outside cover on a heavy paper stock, you've produced a serviceable booklet.

There is also a range of inexpensive binding types that you will often see in office documents that you can apply to your personal media project. The samples shown require special punches and mounting gizmos, but these are not terribly expensive and produce a solid binding.

- **coil binding**
- **wire binding**
- **comb binding**
- **stapled**
- **strip binding**
- **folded**

I like binders that open "flat." This is particularly useful for looking at visual material you want to study carefully.

Thanks to Edward Flathers and Manuel Gomez

photographs

Ink-jet printers contain color ink cartridges that produce full-color prints from all image file formats. Even the simplest color printer will deliver adequate images at a small size. These can be placed into albums or tacked to a bulletin board. But when your aim is to frame and mount a photo, a bit of extra care is required.

dedicated printers. The huge market for amateur photography has spawned a range of specialty printers. Printers that produce 4 x 6-inch pictures are sometimes sold bundled with cameras. They make it a snap to print out snapshots. At the other end are high-quality printers that support resolutions up to 4800 x 1200 dpi (on advanced photo paper) and handle prints up to 13 x 19 Inches. See "Landscape Tweaks" (Chapter 7) for a look at the fancy consumer-level large-format printers.

resolution revisited. A picture shot with a resolution of 2 megapixels or more is going to give you a lovely 5 x 7–inch image on your desktop printer. But as prints get bigger, higher resolution is needed. If you want to print at 18 inches or larger, the size of your image should be 8 to 10 inches along one of its dimensions at a resolution of 300 dpi (dots per inch).

paper for photographs. Here is a reverse food chain of photo papers, starting with the most expensive papers and working backward to the least expensive:

- **Premium plus** papers have a special coating that's fade resistant. Use this for photos you will frame. From 4 x 6 inches up to 13 x 19 inches—the largest size on consumer printers.
- **Premium papers** are designed to look and feel like traditional photographs. The biggest are 8.5 x 11 inches.
- **Advanced papers** have heavy stock. They are the default choice and come in all sizes.
- **Everyday photo paper** is an affordable alternative to plain paper. Colors don't show through. A good choice for businesses and schools and newsletters. They come in 4 x 6 inches and 8.5 x 11 inches.
- **Color stock** is available at all stationery stores. The range is astonishing.
- **Heavy-duty card stock** is great for post-cards, signs, menus, gift cards, and more.

SERVICES OUTSIDE THE HOME

The name *service bureau* is competing with the name *office and print center* for an emerging category of neighborhood shops targeted both at businesses and personal media makers. As you cruise around your neighborhood, look for office-supply stores, mail centers, mom and pop shops, and computer cafes that offer services such as custom printing and photofinishing. When it comes to making a choice among the different shops, look for a place with a knowledgeable and accommodating staff. You will come to rely on them for:

- **workstations** for experimenting with or using Windows and Macintosh flavors
- **high-speed and high-volume printing**
- **computer docking stations**
- **DVD and CD burning**
- **high-speed Internet access** and Wi-Fi wireless Internet access.

enlargements and posters

You can have any printed graphic made larger than standard letter size. **Posters** have a range of costs, depending on the size and materials used, such as photo paper, canvas, watercolor paper, adhesive floor vinyl, and backlit film. A standard size is 20 x 30 inches (under $25) and requires a minimum resolution of 1800 x 1200 pixels. **Indoor and outdoor banners** start about around $100. They come in durable vinyl and can be up to five feet wide and virtually any length. Guaranteed as a blow-them-away gift.

mounting and displaying with frames

Mounting involves affixing the relatively thin and flimsy body of a photographic print to a stable background material that will both protect and display the print.

- **Off-the-shelf framing.** A full range of inexpensive picture frames is available in standard sizes. Most such frames come with precut mattes and glass that protect the photo or artwork.

- **Custom framing and matting** costs more—in fact it is amazing how expensive it is to have a piece custom framed. Yet the choice of materials is vast, and the expertise of framers is worth the cost.

- **Dry mounting.** A wax tissue is sandwiched between photo and backing and then heated with an iron.

- **Electronic frames** are digital wireless picture frames that come in seven- to ten-inch displays.

other options

Your photography and graphic-design favorites can make their way to an assortment of branding platforms, such as:

- **ready-to-apply decals**
- **rubber stamps**
- **business cards**
- **custom letterhead/stationery**
- **envelopes**
- **vehicle magnets you can stick to the sides of a car**
- **rigid signs in corrugated plastic, PVC plastic, and metal**

One of my favorite frames is this inexpensive one that alligator clips a snapshot (top left). It was recently joined by a digital picture frame (top right), a gift for my wife. The mantel in our guest bedroom (bottom) has an eclectic collection of frames. The mix is nice.

ONLINE STORAGE, GALLERIES, AND PUBLISHING

How cool is it that you can upload images to a site that will store your files and also make them available to others—all for free. Of course there is a commercial agenda for such largesse. Such sites inevitably offer an extended range of additional services that they want you to pay for. These are generally very good deals. The photofinishing (printing) comes out with a polish you can rarely match on your desktop.

There is room here to list only a few of the largest, oldest, and best-known sites.

Flickr offers online photo management and sharing, with over two million geotagged photos per month.

KodakGallery used to be called Kodak Easy Share Gallery. You'll find a line of Martha Stewart exclusive designs.

Shutterfly claims to be number one among professional photographers. Its services include storage, sharing, editing software, and many related products.

Snapfish announces over forty million users on its home page. It seems to have more products than the others.

Zazzle is less a storage space than a creative zone where you can show and sell your own design work.

YouTube is the 600-pound gorilla of user-generated video.

Vimeo takes a customizing approach that lets you exchange videos only with the people you want to.

cards and stamps

Your personal media can be handsomely circulated via our fine U.S. Postal Service. So don't overlook these options:

- **greeting cards**
- **postcards**
- **sticker books**
- **note cards**

Zazzle.com lets you choose a size and the denomination you want (27 cents for a postcard, 42 cents for a first-class stamp, and so on). Turns out the U.S. Postal Service is eager to turn a buck. You can choose a photo or a personal logo that will be printed onto a stamp that can be sent through the standard mail.

books and albums

Online services like those above make it quick and easy to turn your photographs and other design artifacts into professional-looking publications. Costs are very reasonable. And the best parts are that a bound volume of your work finds an elegant home within your home, exists in a hard copy in case your computer dies, and can be viewed intimately by individual readers. The last of these is the most important. Due to the years of conditioning we all receive, the act of reading spins a cocoon of focus and privacy. The simple act of leafing through a book may be the very best way of all to share your work.

Here are five examples of the types of books and albums you can create:

- **Classic landscape format.** This is an 8.5 x 11–inch coffee table book with a cloth or leather cover.
- **Digital scrapbooks.** These often come in a 12 x 12–inch format.
- **Mini albums.** These small, bound books can hold collections of snapshots.
- **Pocket photo books.** These often come in a 5 x 7-inch size. This is a nice format size for personal photos.
- **Coloring books.** These books include outlines from your original photos. Then kids can color them in.

For a long time now my wife has been using Shutterfly to create a series of spiral bound, 5 x 7–inch albums (top photo) with the copyrighted name **Snapbooks.** The first twenty pages cost $10 or $15 with additional pages 50 cents each.

A talented young couple visited our family with their dog, Jack. A few weeks later we got the book sampled in the bottom two pictures. Each shot felt appropriate to a dog's point of view. Apple was the provider of Jack's handsome cloth-bound volume. Geraldine Laybourne; Todd and Hannah Calvert

calendars

Calendars help you celebrate and display with your work within a daily ritual. Calendars feature relatively large images—twelve of them plus one for the cover. You can mirror the different seasons in your selection. Or you can build subtle narratives, just as you do in making a slide show. Some calendar templates let you insert tiny photos or drawings onto specific days—a nice way to anticipate someone's birthday.

Here is a family tradition that rivals any photo album. With calendars, you share your pictures throughout the year. Emmy Podunovich

unbusiness cards

You don't need to be a captain of industry to make good use of a business card. Actually, you can show how smart a business person you are by scoring your cards for free!

The thickness of card stock is one of the distinguishing features of cards. Another is the traditional size of 2 x 3½ inches. If you use your home printer, you may not be able to duplicate the thick, raised type of a professionally printed business card, but you can make up for it with color and design.

A free online printing service provided a template (left) with a yellow dotted line for "safety" cutoff (all important items inside it), a red line to show the edges of the actual cards, and a black line for "bleed" (if a design element were to go to the edge of the card). The designer started out with nine different layouts, of which three are sampled here (middle). The finished cards (right) carry the same aesthetic of this online learning resource. Jamie Kruse using 4cover4.com.

SOCIAL NETWORKS, WEB SITES, BLOGS, AND WIKIS

The topography of the Web 2.0 is vast and varied. Here is a closer look at four mountain ranges that continue to rise to towering heights.

social networks

A social network is a virtual community of individuals who share a common interest. Those who build these things speak of **nodes** (individual units within the network) and **ties** (the source of the relationships between people).

Mention the term social networking these days, and most people think of MySpace and Facebook, two Web-based networks that connect friends (virtual or face-to-face) and give users ways to interact (chat, instant messaging, e-mail, voice, file sharing, blogging, discussion groups). Here's a little bit about each.

MySpace emerged first as the most popular social networking service. It evolved to highlight music and bands. Perhaps it was a little too open; ultimately its interface and frivolity drove away those users who wanted a little less noise in their signal.

Facebook, the current king of social networking services, started out as a finely tuned mechanism for connecting college students. Today anyone can join. Facebook tries to be the best of breed, with easy-to-use tools and an open developer platform that allows others to add functionality.

While the vast majority of interpersonal relationships are purely social, at times even the most informal, entertainment-based networks spawn serious sorts of social agency and political action.

web and blog hosting

A blog (short for "Web log") is the Web site of an individual on which he or she writes entries in the style of a diary or journal. The postings are often done in chronological order.

Blogs have become hugely popular, and many of the most successful are now commercial operations with full-time staffers. This does not mean that there is no room or value in personal blogs. Quite the contrary: Blogging is the very best way to display and distribute personal media.

Blogging software comes in many forms. The good news is you can blog for free. The better news is that most blogging sites offer a distribution protocol called **RSS** (Really Simple Syndication). RSS is a feed format that lets you publish (and receive) frequently updated content in an automated manner. RSS readers are built into all of today's browsers.

Building your own Web site can be a lot more complicated than doing a blog. The most popular application for site layout is Adobe Dreamweaver. It makes progress in automating the complexities of working in hyper text markup language (aka HTML). However Dreamweaver remains among the most difficult to master software applications. So if you want to try out a full site of your own, I recommend you start by using one of the Web services listed below, or, if you are a Mac user, go immediately to Apple's iWeb application, which is a marvel of integration and flexibility.

Here are four very manageable ways to give yourself a home on the Web:

Blogger.com is one of the leaders in blogging, Blogger was purchased by Google and the original team continues to focus on organizing the world's information from the personal perspective.

LiveJournal.com presents itself as a site that operates as a private journal, a blog, a discussion forum, and a social network. Fifteen million journals and communities have been created since 1999.

WordPress 2.0 offers good control over the final look of your blog. Its software is highly customizable through plug-ins and template editors. WordPress can be used with most blog hosting services or with WordPress's own servers. As is typical of freeware, there is limited or no technical support.

Tumblr claims it can have you signed up and posting in ten seconds. It connects mobile uploads, RSS feeds, audio posts, videos, instant messenger, and custom domains.

wikis and collaborative tools

Wikis are a generic form of software that permits a distributed group of individuals to author collaboratively via the web.

Wikipedia is the largest and best known of the wikis. It's a remarkable resource that can be extremely helpful in learning more about personal media. More than forty thousand individuals have contributed to the database, and you may want to join them. The term wikipedia brings together the words *wiki* (from the Hawaiian language) and *encyclopedia*.

PB Wiki is a free service targeted at businesses, but it works great for groups of any kind. It allows collaborative work on shared documents and databases. There are many similar services.

Del.icio.us focuses on bookmarks—yours and everyone else's. It is an open-ended system that allows you to access your information from any computer anywhere. People use it for research, list keeping, pod-cast collecting, and, of course, collaboration.

Google has become a multifaceted tool for Web life. There's the Google search engine, which is baked into many browsers. There are also Google Maps, Video, News, Groups, Image Search, Earth, Toolbar, G-mail, Book Search, Page Creator, Creator (Web pages), Picasa (photo editing), SketchUp (three-dimensional software), and Weblog (spreadsheets, calendar, and word processing).

CDS, CD-ROMS, AND DVDS

The deeper you venture into personal media, the more storage you are going to need. Right now you may have a sweet computer with what seems like endless gigabytes of space. But chances are you'll eat this up in no time. Programs take up more space than you think. Any time-based media like video or audio can quickly fill a hard drive.

A portable external hard drive will let you download pictures from your camera while you're on the road as well as back up your photo collection. An external hard drive will not only allow you to move from one machine to another with all your needed files, but will allow you to back up your system, just in case. It's a good idea to copy your project files once a day. At the very least, back up projects every time you reach a critical creative point and back up your whole system once a week. When you're finished with a project, archive it on CD or DVD disks.

Hard drives aren't the only solution to storage, but they are the most convenient. Here are the different storage options you will find in operation today:

- **ZIP drives.** These are out-of-date storage systems built into older laptops. Will store 40MB to 750MB.
- **CD** (compact disc) stores digital data. It was introduced in the 1980s as a medium for playing back up to seventy-four minutes of recorded music.
- **CD-ROM.** (ROM stands for "read-only memory") is a storage device that slips into computer drives and records data (CD-R) or is rewritable (CD-RW). These optical discs typically hold up to 700MB of data.
- **DVD** (digital video disc or digital versatile disc) is an optical storage device that has reached ascendancy as a simple, inexpensive, and stable platform for digital information of any kind. Variations such as DVD-RAM, DVD-RW, DVD-R, DVD+R, DVD-Video, DVD-Audio, or HD DVD represent all the different ways that data is written onto the shiny plastic surface. Most modern DVD drives will read all formats, but not all formats can be written by all computer drives. Check your computer's

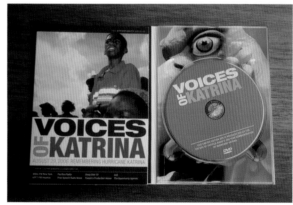

The little cluster of discs (top) shows a range of packaging choices (remember, "the package is the product"—or so an old advertising adage tells us). The custom box for a DVD (bottom) about Hurricane Katrina is a three-panel presentation that displays information about the disc. Discs from Michael Dougherty, Maria Bachmann (red), and Carolina Correa; disc set by the Creative Counsel, the Opportunity Agenda, and other not-for-profits.

specifications before you buy a pack of one hundred incompatible discs! Depending on the type, a 12-centimeter single-sided DVD holds 4.7GB (the contents of seven CDs) and a double-sided version holds 9.4GB. Either way, that's a huge amount of data.

- **Portable hard drives (also known as pocket drives).** Portable hard drives require no AC connector; you just plug them into the Firewire port of your computer. They are very useful in transporting files between computers. The smallest you should buy is 80G.

- **External hard drives.** These are the best buy. They use an AC adaptor and are slightly bigger than portable versions. They connect to your computer by Firewire, which is traditionally used for video and USB, which is more commonly found on PCs.

- **Flash drives (also known as thumb drives).** Flash drives are portable, lightweight data storage devices. They connect via the USB interface. Their capacities are always expanding. Current ones hold between 1GB and 4 GB.

printing onto a disc

Special printers will directly print onto a blank DVD or CD disc with the design and information appearing to be embedded in the plastic surface of the disc.

The really high road is reached with one of the specialty printers shown here. A technology called Lightscribe uses a laser to burn low-resolution images into the face of the disc. It's a clean, easy way to make good-looking discs.

The Epson Stylus RX595 (top) costs about $130. The Pixma iP430 is about $180.

labels

Labels are handwritten or printed matter that provides identification and other information about a media object.

Sure, you can grab a Sharpie or another similar permanent marker and write directly onto your disc. This doesn't interfere with the playback, although some warn that the ink from a marker may eat away at the disc. (These are usually people trying to sell you an expensive "disc-save" pen.)

For a little more polish and branding value, along with greater perceived quality, try labels. There are specially configured sheets of self-sticking paper you can buy at the computer store and use with your desktop printer. Be sure that you align the label perfectly when you stick it on a CD or DVD, because an off-center label can unbalance the spinning disc and cause problems, especially in slot-loading drives.

These samples come from an archiving project detailed in Chapter 7. Carolina Correa designed a jewel case for her DVD of family photos (top left). The slip of paper that slides into the case was printed on normal computer paper after being designed with a Photoshop template (top right). When folded and inserted, the five items listed to the left of the layout become an interactive map. Carolina created a stick-on cover for her DVD (bottom left) which was designed via a second Photoshop template (bottom right) which was then printed onto special self-adhesive sheets of paper. Carolina Correa

SWAG

Swag is a delicious term, isn't it? It is used widely in reference to heavily logoed premium items that are given away or sold by companies. Think of pirates, burying their swag as they drink from bottles of rum.

The swag we encounter normally is the booty of advertising people, product-placement experts, licensors, and merchandisers. You can have swag of your own! Let your eye cruise the galaxy of options. Put mental circles around items that might be fun for you to make.

- **aprons**
- **baby bibs**
- **baby onesies**
- **backpacks**
- **baseballs**
- **beer mugs**
- **boxer shorts**
- **bumper stickers**
- **buttons**
- **calendars**
- **canvas prints**
- **coasters**
- **cosmetic bags**
- **cutting boards**
- **desk organizers**
- **duffle bags**
- **gift tags**

- **handbags**
- **hats**
- **keepsake boxes**
- **key rings**
- **luggage tags**
- **magnets**
- **mailing labels**
- **mouse pads**
- **mugs**
- **neck ties**
- **notepads**
- **ornaments**
- **pet bowls**
- **photo sculptures**
- **pillowcases**
- **placemats**
- **playing cards**

- **puzzles**
- **refrigerator magnets**
- **scarves**
- **serving trays**
- **stickers**
- **sweatshirts**
- **teddy bears**
- **throw blankets**
- **thumb drives**
- **tote bags**
- **towels**
- **trivets**
- **T-shirts**
- **umbrellas**
- **vases**
- **wristwatches**

FILE NAMING PROTOCOL

Of the many items of general advice this book offers, I have pulled out one of the most important to detail here: file naming. Read it or weep.

Imagine you are looking for a specific photo you shot years ago. You have a vague memory of when it was taken or the project it was associated with. Of course there would be a mental image, but it could be described in many ways. To make retrieval even more difficult, there could be a number of versions.

A photograph like the one shown is easy to lose unless a good system is in place. Review the different ways—all logical—that could be used to name the JPEG file above.

- **IMG.2233.JPG.** These are the random numbers assigned by my digital camera.
- **fence detail.** This phrase is nice and short but too vague to be much use.
- **fence close-up w/frost & blue tone.** This option is awkwardly long, although it's very descriptive. There are special typeface characters that won't work for Web posting.
- **Colorado_Dec05_#18.** This records when and where the shot was taken and would help find it in files.
- **wolfr_CUfence_1.0source:** This is the protocol I would normally use and is explained below.
- **mp3_protocols_filename_01.** This is the naming convention required by my publisher—twenty-six characters maximum.

What you need is a lock-step, rigid, consistent, compulsive way of naming image files. Although it will take a few extra moments to apply a file-naming protocol to your pictures, it will save hours and hours and hours in the long run.

Here are recommendations for a trim, dependable system:

author

Step 1. Before you start, always remember: no blank spaces allowed. When you post image files to the Internet, there can be no spaces or special characters in the label you give them. Right from the beginning you should start using an underline mark to space words.

Step 2. The first element of a file name should cite the project, subject, or location. This is your keyword, and it should be something you think you would use in a search of your archive. For the picture to the left, **Wolf** was chosen because the shot was taken at a place called Wolf Ranch.

Step 3. The second element of a file name should be descriptive. **CUfence** was used for the photo to the left. *CU* is short for "close-up" and *w* is short for "with."

Step 4. The third element is always a number. The source image (the original one) can be labeled with a **1.0.0.** Thereafter you can give numbers for various changes you make. For example, a cropped version would be 1.1.0. If there are yet other versions, you could number them 1.1.1 or 1.1.2. You get the idea.

Step 5. If you share your work with others, you should include your initials next. Hence, the **KL** for the photo to the left. This also helps with photo credits.

Step 6. The file name always ends with a . (dot), followed by the suffix tag that indicates the file type. Most photo files will be finished off with a **.jpg**.

Using this convention, the photo to the left would have the file name:

Wolfr_CUfence_1.0.0_KL.jpg

Many servers can only read filenames up to 30 characters. But don't worry, for your computer will warn you if the file name has gotten too long or if it includes forbidden type elements.

Of course the system you devise must conform to your own needs and personality. You do not need to assign file names until you start to use pictures within a project. Otherwise you can keep them in folders that are labeled by date and also by the keyword (for example, Wolfranch).

APPLICATIONS
AND FILE FORMATS

Transmedia is a new term that references the fact that in today's all-digital world, media projects move effortlessly over cable and phone lines, through home TV sets, and wirelessly to smart phones and PDAs (personal digital assistants like Blackberry and Palm devices).

There are two primary distribution media that you need to know about. The first is the PDF (Portable Document Format)— a file format that has been around for years and is the default of choice for locking a multimedia document that contains precise formatting (type, layout, photos, and illustrations).

Adobe Reader 8

Adobe Reader is an essential application that lets you open, read, and print PDF file format documents. Formerly called Adobe Acrobat Reader, there are versions of this free software for Mac and Windows computers.

All who create personal media need rock-solid, global standards. Files crafted within a specific application and carrying a specific file format must be easily opened by those who don't have the application and won't know anything about formats. A PDF is just such a standard.

Adobe Reader. It couldn't be easier to create a PDF in any graphics program. When you go to print a document, instead of shooting it to a laser printer, just select the button shown above. Note that there are different options. The menu here is from a Mac and shows just how deeply the PDF has been integrated into daily workflow.

Adobe Acrobat 8 Professional

With a name that lives up to its promise, Acrobat is the de facto go-to application for locking elements in place on your page while creating a separate new document. If you want to preserve and share a particular layout you've sweated to create, Acrobat is your first choice. With Acrobat 8 Professional you can make PDF files from almost any application and merge files from different applications into one document. You can also create and manage shared reviews and use advanced security and control features to protect your documents.

DVDs are the format of choice for storing information within a portable, inexpensive, universally accessible "hard medium." DVDs are an all-medium medium because they can preserve formatted text documents, slide shows, movies, music files, games—anything digital. Also, DVDs offer interactive menu systems that leave it up to the individual user to determine how he or she wants to move through different items stored on the same shiny plastic disc.

Adobe Acrobat. *File Tools* and *Task Bar* open by default: Tasks, Files, Page Navigation, Select and Zoom, Page Display, and Find. The *Navigation Pane* (partially seen) has a handy Bookmarks panel. The *Document Pane* carries the goods. These include the *Comment* and *Mark Up Toolbars.* See the *Editing Notes* in sample above as well as a *Watermark,* "Kit's 1st Draft."

Apple's iDVD

The popularity of Macintosh computers among media makers had dual sources. First, the operating system is intuitively easy to learn and use. Second, Apple has made it very easy to move elements from one application to another.

The latter is seen best in iDVD, Apple's program for making interactive digital video discs. Let me emphasize the word *interactive*. While backing up and storing data is a survival function all its own, there is a higher order of craft when you arrange information in ways that encourage others to use that information according to their interests and needs.

Interactive design is a science and an art form in its own right, of course. These pages hardly touch on that. Perhaps a future volume will. The emphasis here is on the fact that authoring an interactive DVD—using whomever's software—is a creative act that requires a unique cluster of skills.

iDVD. *Drop Zones* come with some of the *Themes.* Here you deposit images, movies, and audio files. Called out in the interface screen capture are the Add Button, Scrubber Bar, and Motion Button. The *Map Button* is important. Use this to plan the content structure and pathways your users will follow. The *Scrubber Bar* and *Motion Button* let you move slowly through different items in the DVD. The *Burn Button* and *Editing Panes* are at the bottom right.

Corel's InterVideo's WinDVD Creator

Many new Windows PCs come with Corel's InterVideo's WinDVD Creator software. This all-in-one application allows you to digitize video, edit, import pictures, design layout and menus, and burn your DVD. The only thing it doesn't do is print the label, make duplicate discs, and then wrap, stamp, and post them to family members.

.pdf (Portable Document Format)

PDF is a file format created and owned by Adobe Systems. It embeds text, images, and formatting of text, making documents appear exactly the same across platforms.

qt (Quicktime)

QuickTime is a wrapper file format that can contain many different compression codecs. Dealing with video formats and compression is a kind of a black art and, thankfully, rests outside the scope of this book.

WinDVD Creator. My example of Jamaican flowers made it irresistible, if totally cheesy, to pick the flower's theme that I found among the menu themes of this application. This example also shows the "Daisy" button, which I consider kind of funky too. The *Toolbar* sits beside the *Process Tabs*, which do the work of capture, editing, and drag-and-drop design work. A Make Movie button actually burns the DVD. The *Preview Window* is where you see what the viewer sees, whether you are making a movie, a slide show, or a DVD. Tabs of *Media Libraries* and *Time Line* work together while you are authoring.

TIME CAPSULE

Decades back, NASA commissioned a platinum disc that was sent into deep space with the hope that some distant civilization might recover the artifact, figure out how to access the information within it, and hence be introduced to humankind. The designers of this time capsule faced the challenge of embedding data and recording images that would represent our species in a world and time beyond imagining.

This little assignment is along the same lines, only you will be going low-tech. And instead of building a record for extraterrestrials, the creature to discover your probe is your very own self—a future self.

The immediate challenge is to use your cell phone as an anthropologist might. You are to systematically make field photographs that show your daily experience over three days. The broad goal is to capture those small moments that make your life yours and essentially meaningful.

To get ready, try out your mobile phone's camera. Figure out how to send the images to your computer. Research the file format used by your camera and learn how to transfer your images into JPEGs. Wear a white suit, goggles, and a face mask, just like NASA techies. Give yourself a whole day for testing.

In 1977 NASA launched the first man-made object that would escape Earth's gravity and sail into the cosmos. It carried two golden discs. One was a plaque filled with symbols that another intelligent species could figure out (left). The second disc (right) was an analog recording of the sounds of Earth—different languages, music, natural sounds. Wikipedia has excellent articles explaining this landmark probe into interstellar space. NASA by way of Wikipedia

I. BLAST OFF

Start this project without thinking too much about what will emerge. Let the natural patterns of your days dictate what to shoot. But do shoot often—at least one shot on the hour and on the half hour. At the end of the day, download and look at your pictures. Label them. Don't throw anything away. At this point consult the following checklist. Between what you shot on day one and what gets triggered by this list, give yourself some specific objectives for the last two days of shooting.

- the first thing you see waking up
- a photograph of a photograph
- an object in your room
- a special person in your life
- the view from your window
- an addiction
- lunch or dinner leftovers
- the place you feel most comfortable
- a person you don't know
- an article of clothing you wear frequently
- a pet
- getting exercise
- what you watch on TV
- something you are proud of
- your biggest fear
- self-portraits via mirrors and surfaces
- someone you are jealous of
- a favorite creation
- a present from someone or to someone
- the neighborhood gathering place
- shelves: kitchen, bathroom, office
- a sentimental object
- water
- the palm of your hand

- multiple pix: same place, different times
- a habitual action
- aspirations
- family

2. DEEP SPACE

Direct yourself more on the second day. Select some parts of your routine you want to document. When you look over the day's pictures, scan for patterns. Are there more favorite or less favorite things you want to show yourself some years hence?

3. DEEPER SPACE

On the last day of your Time Capsule, revisit things that you liked seeing in your pictures from days one or two. Perhaps you've covered the obligatory stuff in your life and can now find something totally new to shoot. Finish with a sprint: Shoot more pictures on day three than on the other days.

4. BEYOND THE RADAR

The final "capsule" can take a number of different forms, from a set of photo prints stored in a box to a slide show you put on a DVD and save for your grandchildren. Give yourself a full evening (around three hours) to finish off this project. Take a moment to compose a short note addressed to self. Wrap up your time capsule so you cannot even see the container. Label it "do not open before" and give a date (2020? 2018? 2013?) and store it somewhere safe. Last but perhaps most important of all, erase all the images from your hard drive. This ensures that the time capsule, when discovered, will feel like a true missive from a distant shore.

chapter 7: PROJECT IDEAS

Very few grown-ups decide to get good at something and then methodically school themselves. Instead, most of us gain expertise by letting it evolve naturally. We find ourselves grabbed by an idea or a project. We get started because we want to make something. A short-term goal drives us, not a long-term goal. We learn slowly, over time.

This chapter will try to feed into that organic, self-directed process by offering ten project ideas to help you get going in a new direction. These projects use many of the terms and techniques you have reviewed in the preceding chapters. You will find step-by-step workflows, but the directions I prescribe are general enough to be adapted to many situations or interests.

I am indebted to my friends who came up with these projects and allowed me to share them here. The write-ups, although compressed, try to capture each individual's perspective and passion. I hope you will be inspired to integrate something you find here into your own personal media.

SKETCHING VS. PAINTING

Let's think about the difference between a painting and a sketch. A sketch is a learning opportunity. Even artists who are well established will spend time sketching, because it gives them a powerful way to study composition and work out an approach to something. With a painting, on the other hand, the finished work is everything. Paintings are more ambitious undertakings that require more time and resources—and more ego, too.

All the project ideas that follow are *paintings*, not *sketches*. Each one has already passed through the process of trial and error. Certainly those who have provided these projects had their false starts and dead ends. That is part of the creative process. But the individuals you will meet had the vision, drive, and tenacity it takes to see a project through

to completion. They paid attention to each detail and, in the end, that is what always makes the difference.

Elsewhere I've talked about the value of trying out your skills with small projects. Each of the previous chapters ends with an activity that involves playing around with one or more of the techniques and creative options met in that chapter. The "Playing Around" sections are like sketches. Here I'm encouraging you to try larger projects. However the ideas here are motivational and directional, not prescriptive.

WHERE IDEAS COME FROM

Nourish your creative radar. Prowl the airwaves and the Web in search for inspiring works. My partner for many years was Eli Noyes—one of the most creative souls I have ever met. Eli always worked beside a huge bulletin board, and he'd use pushpins to post things that caught his eye: an invitation, a doodle, a clipping, a postcard. He'd move these around and switch them out from time to time. Eli said that the board edited itself: Stuff that held his interest would tend to move toward the top. Eli wasn't collecting good ideas, per se. He was simply responding to what caught his interest. I once asked him which ideas had made it into his work as an animator and director. He couldn't remember any specific use but was quite sure that the bulletin board kept his imagination limber

and encouraged his eye to wander with purpose.

There is no particular order to the ten projects that follow, except that I tried to put the simpler and quicker ones at the beginning. Skim over them all quickly and then return to places that pull you back. Creative minds work best when they follow their own interests. Here's the lineup:

ROGUES' GALLERY: ordinary snapshots that create a happening and a community.

DESIGN A FONT: just a few minutes and nine bucks turn your handwriting into a digital font.

GONE BUT NOT FORGOTTEN: preserving and celebrating old photographs.

BINDING RELATIONSHIPS: picture books good enough for the coffee table.

PATTERN IN SPACE: creating a pattern that's targeted for a specific object or space.

LANDSCAPE TWEAKS: the art of enlargements and showing off your best work.

BLOGGING: a way to track and share life's journeys.

COLLABORATIVE COOKBOOK: sharing recipes via the Internet.

WEBISODES: your own melodrama based on snapshots of posing friends.

DIGITAL STORYTELLING: how oft-told stories become polished short movies.

ROGUES' GALLERY: ORDINARY SNAPSHOTS THAT CREATE A HAPPENING AND A COMMUNITY

James is pictured with a manikin he calls "Our Lady of the Hunt". His friends call him Jimmy Fred and suspect he has an odd thing for head coverings.

CASE STUDY: james

James Wood is a lawyer in Denver. He was born in Dallas and recently returned to his roots by buying a small ranch in the Hill Country near Mason, Texas. He is an avid outdoorsman and hunter. The object that organized his rogues' gallery was a Day-Glo hunter's hat.

The Orange Hat has become a near-perfect catalyst for a silly kind of art project. It is the common denominator, the ice-breaker, the creator of things in common, and the conversation starter.

Few refuse the call of the Orange Hat. Most participate gladly and instinctively place the hat on the pate and pose willingly. Debate continues whether to let my subjects view the rogues' gallery before posting. The jury is still out on that one and the experiment continues.

The general rule is that, as with life itself, you only get one shot. That means I only take one picture, and if it's good, it's in the gallery . . . I've made exceptions, though, for poor exposure or focus.

Quick work on my part is essential. Some of the best poses have been when the hat or earflaps sit at an odd angle on my model's head. Similarly, some of the best pictures show the subject baffled by the whole idea and before he or she had time to think about how silly he or she looked.

And the word is out. Folks who visit the house for the first time are often told that something special will happen. Beware of James with the camera . . . he'll take a picture of you wearing a funny-looking hat. But don't worry about it—it's fun, and everybody has to do it. —JW

Mixing performance art and photography can yield explosive fun. This project uses a simple camera and inexpensive printouts to create a home-based installation.

The idea is to create a gallery of photos that share an underlying theme or concept. The trick is finding a gimmick that can help transform ordinary snapshots into something more.

This project has two different but related goals. One is to create an informal gallery of portraits. The deeper goal is a way of celebrating a community.

REQUIREMENTS

time. It will take a couple of minutes to a couple of hours to prepare ideas, designate display space, and set up the hanging apparatus. Acquiring "objects" for your gallery can take as long as you'd like it to—an evening, a month, a year—or it can be an ongoing activity.

gear. Digital camera, small printer (4 x 5–inch prints are big enough), and a set of wires and clips to mount the collection.

space. The gallery works well in narrow corridors where the viewer can walk close to the images, inspect them carefully, and grin at the looniness of it all.

budget. Less than $50 for the gallery construction.

WORKFLOW

step 1. find a "high concept." Find a galvanizing idea that will appeal to your friends and yield a set of images that are fun to compare. Maybe there is a physical stunt they can all do. An object or a prop is a good catalyst.

step 2. start shooting. Start off with a few people you know well. Practice how to cajole them. It's best to start slowly with this kind of participatory project. Over a week or so, you will learn what works best. James used the same head-on shot for his gallery, often done with a flash. This helps establish a uniformity that is valuable.

step 3. mount the gallery. The set of parallel wires that James strung up provides a simple and effective way to create a flexible gallery. But there are a lot of ways to get wire or string in rows on a wall with small nails or thumbtacks. Other options include using a bulletin board, attaching cork squares (ones that come with sticky backs) to the wall, or using a shelf or other ledge to prop the images. Keep the photos in close proximity so that it's easy to compare one against another.

James says, "If you look closely at the photo above, you can see the little clips my friend Mamaru found in Japan. They make it easy to hang a new picture. I used turnbuckle screws from the local hardware store to make the wires that go from door jamb to door jamb in our hallway taut."

step 4. curate and swap out. Keep your project alive. This means you need to constantly add to the gallery. Also, part of the charm for participants is to see what other hapless models have done. To keep things fresh, encourage your models to break new ground. If you track how the images evolve, a good initial concept may morph into a better one.

GALLERY

James's display of his snapshots reaches down a long hallway. The sampling squares off photos that are usually horizontal, but none of the pictures loses its charm.

This is a small sampling of the rogues in James's gallery. James Wood

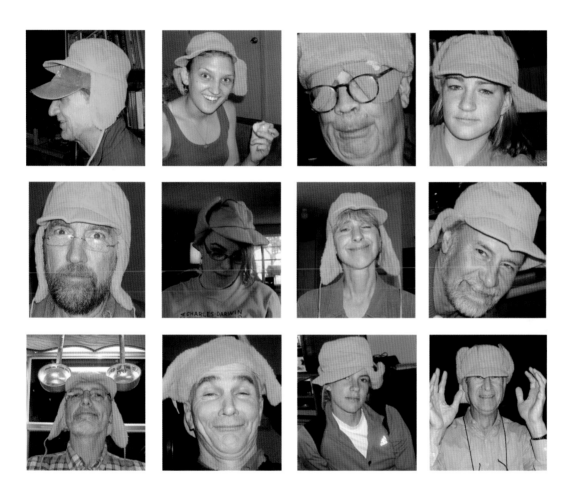

DESIGN A FONT:

Jamie while on residency in the Dunes of Cape Cod.
(The shot shows how sharp focus can be trumped by lighting, gesture, and composition)

CASE STUDY: jamie

Jamie Kruse is a Midwestern transplant living in Brooklyn. She makes her living as a freelance graphic designer, working primarily with art, education, and health-related nonprofits. She also has an art practice in which she and her partner create in-place art exhibitions aimed at calling out environmental qualities and insights. When Jamie needs a break from the screen and the city, she heads for remote locations, such as the tip of Cape Cod, to find inspiration.

Fontifier makes creating your own fonts a quick and seamless process. It is so easy and affordable that it is hard to imagine making just one. I ended up getting a little carried away and making three! I started with my "standard" handwriting.

It is an interesting process to see your familiar "hand" digitized and even more fun to be able to type with it. I then moved on to bubble lettering, but had the most fun creating a "dingbat" font of random icons and drawings. Fontifier made me want to make a font for all my moods and occasions, or even give a personalized font to friends and family as a special gift. —JK

The world of computer graphics can be impersonal and cold. The precision of digital forms brings a uniformity and predictability that we can appreciate, but it misses the quirkiness and imperfections of the human hand.

I'm always on the lookout for things that are slightly unexpected and slightly askew, but that bear the authentic hallmarks of an individual creator. Those qualities are bundled nicely in a remarkable piece of software called Fontifier.

REQUIREMENTS

time: A half an hour to fill in your font and send it in. Hours to play with what comes speeding back.

gear: Mac or PC computer, Internet access, printer, scanner.

space: Your computer desk.

budget: $9, to be paid by credit card.

WORKFLOW

visit www.fontifier.com You will download and print out an 8.5 x 11–inch form that has boxes for upper- and lowercase letters of the alphabet, numbers, and other standard items on the QWERTY keyboard.

Step I. fill out the template. Fill in the boxes assigned to each letter, number, or symbol with a black felt-tip pen. The quality of the pen is important, so you might want to make several copies of the form and try out different writing implements.

Step 2. scan the template. Feed the template through your scanner or place on your flatbed. Fontifier recommends a resolution no higher than 150 dpi. Save this file to your hard drive or desktop.

Step 3. upload, preview, and buy. Fontifier has a stream-lined interface that leads you through all the steps in a quick and painless way. Uploading is the fourth step, and after a few minutes you receive an e-mail that contains a preview of how your font will look. If you are happy, you give your credit card information or pay by PayPal. Each font you design costs $9. You can share this font with as many people as you want and use it in any program.

Step 4. name your font. Fontifier will ask you to assign a name to your font after you preview it. It is important to make note of this name, because it will become the official font title that will appear in your font list on your home computer.

1	**2**	**3**	**4**	**5**	**6**	**7**
Print out the Fontifier template sheet.	Write your characters on the template.	Scan the template and save it.	Upload the template and create your font.	Preview and then buy your font.	Download your font.	Install your font for use with your programs.

The seven steps are easy. The payoff would be worth seventy-seven steps. —JK

This is what my handwriting looks like.

check out my bubble handwriting!

Jamie comments, *"When I made my own font, I played some with making a set of dingbat-type elements: custom arrows, exclamation marks, dashes, slashes, asterisks, bullets of a couple of sizes, rules, boxes, check marks, and so on."* —JK

Step 5. install and use. Fontifier downloads your custom font to your desktop. All you have to do is click on the download and it will automatically install the font into your font library in a format known as true type. You can size the type so it's smaller than the size you wrote it. If you enlarge it past 14 points, you may find that the font begins to get blotchy due to the fact that your original sampling was done very small. The charm, of course, is that you can type fast and furious while composing a handwritten note.

By the way, it is a total rush when you are working away on a document, pull down the font menu in search of something just right, and, ta da, there is your own hand-writing sitting proudly amid all the other fonts that come on your computer. —JK

GALLERY

tHE QUICK BROWN FOX JUMPED OVER THE LAZY RED DOG!

the quick brown fox jumped over the lazy red dog!

THE QUICK BROWN FOX JUMPED OVER THE LAZY RED DOG!

ThP quick brown fox jumped over the lazy rPd dog!

The quick brown fox jumped over the lazy red dog!

the quick brown fox jumped over the lazy red dog!

Six fonts by six personal media makers. Smudge Studio font (top) by Jamie Kruse and Elizabeth Ellsworth; (second) Jamie Kruse; (third) Elizabeth Ellsworth; (fourth) Vichai Chinalai; (fifth) author; (sixth) Jamie Kruse

GONE BUT NOT FORGOTTEN:
PRESERVING AND CELEBRATING OLD PHOTOGRAPHS

"After I digitized everything onto a single DVD, everybody wants me to do the same for their memories. Yikes."

CASE STUDY: carolina

Carolina Correa is from Caracas, Venezuela. She now lives and works in New York, where she has been a video editor and is completing an MA in Media Studies at The New School. Her precise and playful work as a designer appears throughout the pages of *Mediapedia*.

Growing up I always remember my mother with a camera. She took pictures of every important milestone of our lives, and not so important ones too. After years, this love for photography resulted in multiple volumes of photo albums. But wait! These are not small, portable nice-looking albums. My photo albums are from the 1970s and 1980s, which means they are big, heavy, and not very appealing to pull out, show, and share. Also, after some twenty years, some of the pictures have lost their color, and for some reason all the pictures have changed to a charming color of orange. Don't get me wrong, I like the color orange . . . but suddenly all my memories are unicolor.

So, after years of my mother asking me to do something with these pictures and albums, I decided to bring them into the twenty-first century. —CC

The rise of the digital world threatens to bury the snapshots, photos, and home movies of earlier generations. But these family treasures can be easily transferred onto the computer, which offers wonderful flexibility for reworking them. There are many ways to share reclaimed images: You can frame quality prints, make DVDs that archive your holdings, and create slide shows that breathe new life into old artifacts.

REQUIREMENTS

time: Each picture can take between five and ten minutes to scan—longer to retouch and color correct. After the pictures are scanned and adjusted, making a slide show and/or video can take about half a day.

gear: Scanner, photo-editing program, blank DVDs, labels and cases for the final product.

budget: Less than $50.

WORKFLOW

Step 1. Scan. Gather all the pictures you can get your hands on. Photo albums are obvious, but also look for 35mm slides, which can be scanned by a local or online service. Framed photos can be slipped out of their frames for scanning. Before you begin to scan, look at all the photos and make a first selection of your favorite images. Use sticky notes to be sure you digitize the crème de la crème before your energy and time peter out. Scan at high resolution: 300 dpi is best.

Step 2. Repair. Old photos discolor with age and are easily scratched and marred in the photo albums that have held them for years. Again, focus on the pictures that mean the most to you as you begin to repair those that need it the most. Start with color correction and brightness. If you are working in Photoshop, play around with the Sharpen filters. Consider whether some shots can be improved by defocusing backgrounds or editing out distracting elements and filling with the Clone tool. Save the source file first and then the one you've fixed up.

Step 3. Compile into a slide show or video. After you have completed scanning and repairing, you will have a good knowledge of all the photos in your collection. Now is the time to import some of them into a slide-show application or video-editing program. Look for a structure for your piece: chronology, similar shots or locations, a short story about a family event. Add credits. Aim for three to five minutes. It's better to make two or three short movies, each with a distinct approach, than to compile archival stills into longer pieces.

Why so short? Well first of all, you should be aware that three minutes is a long stretch for time-based media. The infomercials you see on late-night TV are often three minutes long, and they feel repetitive and endless. Second is the issue

Many of the photos in Carolina's album became discolored with age (top). These were carefully color corrected (immediately above). A photo of Carolina's mother and aunt, as girls, had been badly damaged with a rip and spillage. Carolina used an application called Paint. net to make the fixes you see (left and right.)

of expectation. Audiences for personal media expect short pieces. Third, the longer the piece, the more variety required between sequences ranging from thirty seconds to three minutes. Viewers need variety or they zonk out. Thus a longer slide show or video needs contrasting segments: voice-driven information dumps, lyrical pieces cut to sound, a first-person account, countering points, montages to set place, montages that establish time frame.

At some point you will want to try "long form"—anything over twenty-two minutes (the default running time in a TV half-hour format). But first get really good at the structure of shorts before taking on the structure of pieces longer than five minutes.

Step 4. Duplicate via DVD. Make copies for all of your family members. A single DVD can contain the full archive and a slide show too. The no-bells-and-whistles approach to making copies is to insert a blank DVD into your computer and hit the Burn Disk button. But here is a second approach: the interactive–let's-celebrate-this-family one. To create an interactive and professional-looking digital album, Carolina used Apple's iDVD software. This lets you add movies and create slides shows directly in the program. With a Mac you can use iPhoto to assemble images and then import them directly into iDVD. Chapter 6 has information on making DVDs on PCs.

Step 5. Share. The last step is to package your new family photo archive in an attractive way. If you simply grab a marker and scribble something on the DVD surface, this project you've completed will quickly get lost. In Chapter 6 you can see how Carolina made a label for her DVD and set it in a slick jewel case. Grateful relatives can now add your archive to their DVD collection.

Carolina's movie—a montage of mother and daughter—is one hour and forty-five minutes long. There is a well-matched music track. The transitions are fade-outs and fade-ins, and there is some in-frame movement to smooth out the flow. A QuickTime version of the piece can be seen at the *Mediapedia* companion site, mediapedia.net.

The frame above shows the interactive interface of iDVD. Carolina divided the stills she had scanned into short slide shows and edited them to show her at different ages, plus shots of Argentina. The video is the final item in the list. Note that iDVD can hold ninety-eight hundred images in one or more slide shows.

GALLERY

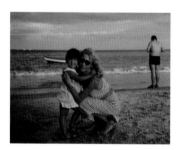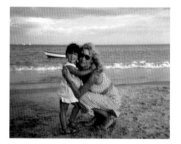

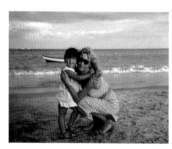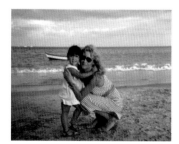

When you archive old photos, you can do lots more than simply repair and copy them. Carolina combined color correction with the elimination of the unknown male figure (top left and right). This focused the image on mother and young Carolina. In the second set, Carolina emphasized the subjects by taking color out of the surrounding background (bottom left). The movie Carolina made for her mother is completely black and white (bottom right), which creates intimacy and the ambience of a bygone era.

BINDING RELATIONSHIPS:

PICTURE BOOKS GOOD ENOUGH FOR THE COFFEE TABLE

Perri was the author's go-to person in writing this book. He owes her big time.

the process of making them is satisfying: choosing your photos, editing them, defining their importance, and creating layouts for them.

A beautiful self-published photo album can be a profound way to celebrate the most meaningful relationships in our lives. This project uses surprisingly low-priced printing and binding services to create a high-quality book.

Paper photo albums will always have a place, even as our culture becomes more digital. A photo album is a product that's touchable and accessible to everyone, great to have and great to give. Unlike digital photographs that are stored on your computer and rarely sifted through, books offer easy, just-for-fun access. And

CASE STUDY: perri

Perri Chinalai has always loved taking pictures and creating scrapbooks. She even studied photography as an undergraduate. Although she knows how to work in a darkroom making prints from traditional film negatives in both color and black and white, she has, since moving to New York in 2005, worked exclusively in digital formats. This case study represents her first attempt at making an album on the computer.

I struggle every year with trying to find a nice gift for my husband, Adam. This year, inspired by some collections of digital "homemade" books that I've seen lately, I decided to create a book for Adam that both celebrates our past few years together and that pushes my artistic sensibilities to the realm of book layout, aesthetics, and scrapbooking. I used iPhoto to compile, lay out, and print the book because I was familiar with the program and because it already housed some of my images in the iPhoto library. I chose to design a large 8.5 x 11–inch navy blue linen hardcover book with a sticker image on the cover. It includes over 150 images. Adam mentioned the other day that sometimes he randomly pulls out the album from our bookshelf to look at it. He said that to him it was better than our regular photo albums because it told a story about that specific time in our relationship. —PC

REQUIREMENTS

time: Five to six hours.

gear: Internet access or a photo program that provides book-printing services. Although not required, it's helpful to have a photo-editing program like Photoshop or Adobe Elements.

budget: You can spend anywhere from $20 to $150 depending on how the book is bound and how many pages you include. Perri's iPhoto book (8.5 x 11–inch hardcover, fifty-two double- sided pages) cost $75.

WORKFLOW

Step 1: Choose a publishing service. Research which service or software you would like to use to print and assemble your book. You may already have experience uploading and sharing images through Web sites like KodakGallery, Shutterfly, or Flickr (all of which will print books), but there are a number of other sites dedicated to printing albums.

Step 2: Decide what you want the book to be. Who is the book for? Is it a gift, a family album, a portfolio of artwork? This will guide your layout choices and image selection.

Step 3: Select a book type. Decide the size of the book and whether you want a spiral-bound book, paperback, or hardcover. If a hardcover, you can select paper, linen, or leather binding materials in a variety of colors.

Step 4: Select photos. Give your book a discernable unity by organizing an intellectual *and* emotional structure. What journey will this picture storybook take viewers on? Each time your reader turns a page, there is an opportunity for a moment of surprise, delight, and insight.

Step 5: Layout and upload. Some programs have a Drag and Drop option (you pull images with the mouse from your photo library and put them directly into the photo-album program) and others ask you to Browse and Choose, just as you would when attaching a document to an e-mail. Once you bring all the images into the program, you can begin to lay them out on the page. Notice the dominant colors in the photos and use this to your advantage when making layouts. Vary the types of photographs you select and the number of images on each page. Be your own art director!

Perri talks about this page from her book: "In these two pages from my book, I tried to gather a variety of pictures from the trip we took to China last year. Included here are classic tourist shots (Adam taking a picture of me as I take a picture), scenery pictures (landscapes, statues), and even images of people we don't know (the young girl, woman with the umbrella)."

Perri Chinalai and Adam Dayem

Step 6: Create captions. Most programs let you write a small blurb or give your images a title. Here's where you can record dates, put in a funny joke about the picture, or simply tell the viewer something about the picture that they wouldn't know from simply looking at it.

Step 7: Print a copy of your book before you place your order This is your final check. No matter how many times you review your book on the computer, once you see it on paper you will find sequences you want to replace or images that deserve more importance.

GALLERY

Adam reads his book (top left). Perri writes, "The cover makes fun of my love for breakfast cereal (which we call 'cereal stuffs'). The title to the book is therefore, *Better than the stuffs? A collection of photographs representing all things good 2004–06* (top right). Perri Chinalai

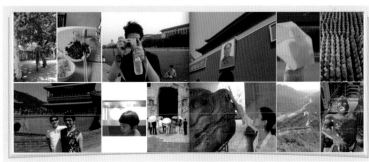

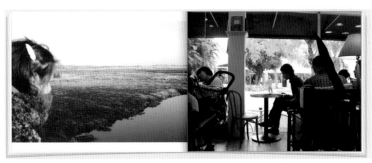

PATTERN IN SPACE: **Creating a pattern that you can overlay on an object or use as a background**

Sara went to school at Rhode Island School of Design and Columbia University. She shows her art internationally and in cities all over the United States.

This project has two parts. The first is to design a flat repeating graphic patterns using Photoshop and Illustrator. This pattern should be made from the shard of an image you shoot or collect. Part of the fun is seeing how something quite mundane can yield a startling and fresh graphic. The second part is to apply your pattern in the real world. You may choose to simulate this application, by pasting your design into a photograph that represents your ultimate vision. Better yet, you can apply the pattern directly onto a real

three-dimensional object or space. Between these two objectives and at the heart of the project is the task of playing with scale.

CASE STUDY: sara

Sara Greenberger Rafferty is a visual artist based in Brooklyn, New York. She assigns computer-generated, repeating patterns as a final project in the class she gives to her Visual Art/ Computer Art class at Suffolk County Community College in Selden, New York. She originally designed this project for her Computer Imaging class at City College in Manhattan.

This project emphasizes both play and planning: two of the best aspects of art production. Play, in the sense that digital imaging allows one to try out different color combinations and generate unexpected patterns. Planning, in the sense that you are asked to design the pattern with the object or space in mind. —SGR

REQUIREMENTS

time: Three to six hours.

gear: Mac or PC, Photoshop, Illustrator (optional).

budget: No additional cost unless you want to actually make the object you design.

WORKFLOW

Step 1: Choose the three-dimensional object or space you are designing for. Examples include garments, rooms, musical instruments, invented objects, skins, architecture, and so on. You might also choose an entire wall or other surface onto which the pattern you design can be copied or stenciled.

Step 2: Find the object you're going to make into a pattern. Choose a photographic image to make into your flat pattern. Shoot a new photo or use one from your archive. You can also find one on the Internet, but if you do this, make sure it has a high enough resolution (300 dpi) so you can work with it.

Crop the image into a square. Try different crops—some colorful and some monochrome, some simple and some complex. The results will vary. Look at wallpaper, textiles, and even gift wrap and see how the design and scale of the pattern affect the look of the objects they cover.

Step 3: Build the pattern. Select at least three different flat, repeating patterns to work with. Build a 9 x 9–inch unit layout of each. The best tools for building patterns are the Pattern Maker Filter in Photoshop, or the Define Patterns menu in both Photoshop and Illustrator. Other useful tools are the Offset Filter and the Shape Tool.

Play with different versions of the same pattern, varying color combinations, scale of the repeated object, and variations within the pattern.

Step 4: Map your pattern onto its target. A big part of this project's fun is in seeing how your pattern works in three dimensions. This is done by simulation, although of course you can also apply the pattern to real-world objects later.

A plate of greens seems an unlikely candidate for a pattern. But behold the opportunities indicated in these three steps. —SGR

Photoshop is the right application for compositing your pattern onto a photograph of the target object or space. Tools you may employ to make this look as realistic as possible include the Transformation Tools, Blending Modes, and Displacement Mapping.

To put your pattern onto an actual 3D object, you need some specialty inkjet papers: either labels with stick-back, printable canvass that you can then sew, or inkjet transfer paper for ironing onto a fabric of your choice. Print out full sheets of these and then make templates for pasting onto board or found object. Make a small change purse or hankerchief by using the fabric-based options.

Sara provided details about how this car got its pattern: *Displacement maps work when you want to make it look like a flat pattern is realistically projected onto a multidimensional surface. There are six essential steps:*
1. Using the image you want to apply the pattern to, view the separate channels and decide which one has the most contrast.
2. Right click that channel, choose Duplicate Channel, save as map.psd, choose New from the Destination Document, and save the newly created file to the desktop.
3. Go back to the original photograph and view it in full color with all levels. Drag the pattern into a new layer in the same file (make sure it is on top of the photograph).
4. With the pattern layer selected, Click>Filters>Distort>Displace.
5. Mask or erase the areas where you do not want the pattern.
6. Choose a blend mode to make the pattern look the most realistic, and voila!—SGR

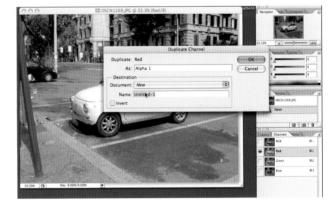

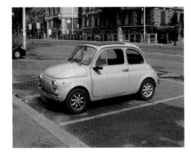

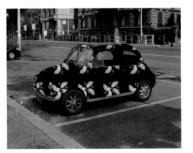

GALLERY

The patterns and eventual real world applications of the projects completed by Ms. Rafferty's students. Top row: AlexTrifiletti; Bottom row: Audrey Eckel

LANDSCAPE TWEAKS: The art of enlargements

John is ferocious in his pursuit of images that are "true" to the photographer's intent. He likes watching his work slide out of the printer.

Why can you see a glorious landscape and take your best shot, only to be disappointed in the result?

It's not easy to capture natural beauty and get it up on a wall. The secret to making successful enlargements is in dozens of tiny adjustments at different stages of production: when you set up your gear, while you are shooting, when you go to the digital darkroom, as you print, and even as you prepare to hang the framed work.

What usually comes last (framing and mounting) comes first in this project, with a special emphasis on steps for creating an art gallery in your home or office.

CASE STUDY: john

John Hall is a lawyer and serious photographer who specializes in portrait and landscape photography. He's a serious technophile, too, with a Nikon digital single-lens reflex camera (D2-X), a Leica range finder (m8), and a closet full of analog gear. John is meticulous in image editing, and when he gets something he judges good enough, he prints it out on his Epson large-format printer.

I got my start in photography with snapshots of my kids. Being a gear-head, I began buying second-hand cameras that were well beyond my needs and skills. The equipment produced mistakes that led to experimentation. The snapshots became portraits, seldom posed but always studied. Then I noticed that I was taking profiles and shots from behind that were more about light and form than the nominal subjects of my work. It was a short step from there to the largely people-free landscapes, cityscapes, and other scenes that dominate my work today.

I love the immediacy of the digital medium. There is no waiting to see how the shot worked out. The digital darkroom lets me play with my captures. I use it, not to repair bad work in the field, but to further abstract my images. Photo editing also lets me increase the coherence of a set of images so that when I hang them they fit together. —JHH

REQUIREMENTS

time: Landscape photography requires patience and countless reshoots. Photo editing and printing add hours more. And planning and hanging framed photographs requires deliberation; figure at least an hour for lining things up before the photo goes on the wall.

gear: All you have. A camera with at least 10 megapixels and a home printer are recommended.

space: Walls for hanging the photos, and space at home to spread out your prints.

budget: John Hall estimates that all his gear, including computer and hard drives, has topped $8,000, but you can start this project with the equipment you have. A single large print and the framing that goes with it can run about $150. For the same amount, you can buy a set of inexpensive frames from Ikea or Target.

WORKFLOW

We are working backward here: Start by hanging the frames and shoot to fill.

Step 1: Lay out the gallery.
Choose a wall in your home or office where you want to display a set of, say, three framed photographs. Consult the sketch below for an example of how to plan your gallery. The most important measurement is the height. Many people hang pictures too high so that you are looking up at them. For better results, the top of the frame (not the center of the images) should be slightly above eye level.

Step 2: Frame. To display large photographs as fine art, frame them with wide mats. A frame shop can usually give you good advice about both size and subtle variations in matte board such as color, texture, and cut. As a general rule, the width of matting should approach half the size of the narrowest dimension of the image itself. Thin, simple, dark frames work well with photographs.

This sketch is a picture of the wall, an elevation drawing. Using graph paper makes planning easy. A box equals a foot. Always start by figuring out where the middle photo will be. Here, it's marked with an X in a circle, centered on the wall between the corner of the room on the left and the doorway on the right.

Step 3: Choose the 'scapes. Pull from your photo library (or shoot anew) a set of landscapes, cityscapes, nightscapes, seascapes, snowscapes, or beachscapes. The horizon should be prominent in all of them. Seek a unifying element in content or visual approach. (The same would be true if you were to build a gallery of portraits, sports shots, or abstract photography.) A unity of subject and approach encourages viewers to compare images; don't let one image upstage the others (for instance, one color shot among a row of black-and-white prints). Keep the quality consistent.

John's dining room. He is not pleased with the lighting.

Step 4: Get the effects you want. Use image-editing techniques to retouch, adjust lighting, or work on the color tones of your images. If you are planning to print at 13 x 18 inches, then work with an uncompressed format. If you want to print at 8.5 x 11 inches, a JPEG file should have a measure of 9 inches on the longest dimension at a resolution of 300 dpi. Run a test print to be sure.

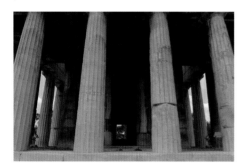
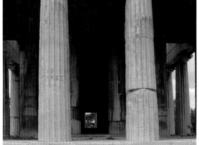

John says, "I wanted to pull the viewer's eye deep inside this ancient temple in Petra, Jordan. With Photoshop I straightened the columns and adjusted the cropping. I also did color adjustments to bring out the earth-tone stains in the stone." John Hall

Step 5: Print. Specialty photofinishing shops or service bureaus print out large format photographs. The cost of a 13 x 19–inch print is around $25 at Kinko's, a chain that provides such services. A 24 x 36–inch glossy print (really big) costs around $75. A large-format printer, such as the Epson R2400, runs about $1,000. It requires eight color ink cartridges, each of which costs $15. A sheet of 13 x 19–inch paper is $1.50 for glossy and $2.00 for archival, ultraluster stock.

GALLERY

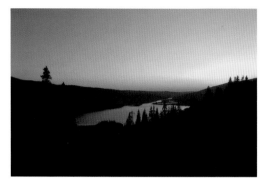

John offers these tips: "Do a set of images of the same scene at different times of day and night. Get a tripod so that you can do long exposures after dark. The digital medium will allow you to expose the details of an image that seems all undifferentiated black on first inspection." John Hall

BLOGGING:

A WAY TO TRACK AND SHARE LIFE'S JOURNEYS

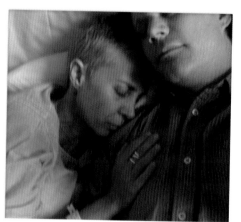

Rosina and Peter catching a nap together at the hospital.

photos combined clear information, narratives of strength and family, and a keen personal perspective he serves up with a light touch. Peter Hastings will keep the blog on-line for the foreseeable future. He and Rosina share their most intimate of blogs with the hope it will help and encourage others.

Rosina had more friends and closer friends than anyone I know. When she was diagnosed with leukemia and decided to undergo the most aggressive of treatments, her community erupted with concerns, questions, and a need to be involved. Her husband, Peter, realized he would have to keep full focus on his wife and their three wonderful kids. So he built a blog. From June 2007 to January 2008 when Rosina succumbed to her cancer, Rosina's Road Trip gathered an ever wider circle of readership. Peter's writing and

CASE STUDY: peter and rosina

Peter Hastings is a director, producer, writer, and musician whose credits include *Pinky & The Brain*, *Animaniacs*, and *One Saturday Morning*. He is currently working on an animated feature, *How to Train Your Dragon*. Rosina Hastings was Brazilian and a jazz vocalist before moving to L.A., where she and Peter were raising three kids when she became ill.

Several times I've questioned the idea of publishing this personal information, but what I hear from everyone who reads it absolutely outweighs those concerns. Friends constantly tell me how grateful they are to know what's going on without having to bug me, and if I see someone who just found out, I can point them to the blog. But it's a lot more than the medical information. It has promoted a wonderful circle of support around Rosina, and also around me, not just because I know others are keeping up, but also because they can leave comments and send e-mail—it's like we get fifteen get-well cards a day. It is an information booth, a tribute, an outlet, a poem, a community; a place of sharing, commiserating, rejoicing, and most of all, supporting dear Rosina. —PH

REQUIREMENTS

time: Setting up a blog takes about half an hour. Contributions range from a few minutes on up.

gear: Computer, digital camera, use of Blogger (but there are many free Internet sites—see Chapter 6).

budget: None.

WORKFLOW

Here are Peter's notes on Workflow. Some frame grabs have been added that sample Rosina's Road Trip (http://rosinasroadtrip.blogspot.com/).

Step I: Write entries. Form follows function here, and the main function is reporting. The process is absolutely directed by what is happening that day or week. When things are busy, there's an entry every day; sometimes a week or two goes by. So there is reporting, then there is reflecting, and then there is thanking. The toughest creative decisions are the title of the entry, and what photos to include. The name of the entry is kind of like a song title— a few words to sum it up, either what's happening or how I'm/we're feeling. And the photos often follow as an illustration, either direct or abstract, of the title. Many times I've written a title and then dug through pictures I wouldn't normally use only to find one that takes on new meaning in this context. Also there are many photos that are simply of Rosina shining on.

This is the head that Peter created.

Step 2: Setting up the blog. Once I had decided to set up some kind of Web-based information booth, I looked at hosting Web sites and Apple's iweb and other things until I decided to use Blogger. It's free, it's easy, and it looks decent. If you want to customize, you can dig deep, but if you don't, the starting templates look good. I chose one of their standard ones, then tweaked the colors a bit.

Blogger is very simple to use. I have a folder on my computer desktop full of possible photos, and once I pick one, it's easy to upload into a new post. I've found that for every dead end I've hit technically, it's easy to find a solution out there in the blogger community. For example, I Googled "photo in blogger header" and got step-by-step instructions. Although generally, as the process continues to move away from strict html, it's pretty intuitive.

Step 3: Decide what information you want to provide along with your commentary. In this case, Peter's blog became a clearinghouse of medical information.

I found myself listening more closely to doctors and making sure that I understood what they were saying, because once I had the blog, it meant explaining this medical info to a bunch of people. Often it also meant getting more info off the Web, and adding the links is an easy way (amazing, actually) to direct someone who really wants to read more. Also, practical things like how to become a bone marrow donor or directions to the hospital or giving blood are links that exploit the Internet in all its glory. It's a great way to add information without taking up a lot of space.

More Info

⊛ City of Hope Visitor info

⊛ City of Hope Directions & Map

⊛ City of Hope Blood Donations

⊛ marrow.org

⊛ REDOME (Brasil)

⊛ REDOME locais de doação

⊛ Cedars Blood donation info

⊛ Becoming a Bone Marrow Donor

⊛ AML and bone marrow transplants

⊛ City of Hope on AML

⊛ Leukemia & Lymphoma Society

These are links about health care that Peter found or that friends and doctors provided.

The frame shows the overwhelming presence of medical apparatus. Peter Hastings

GALLERY

TUESDAY, NOVEMBER 27, 2007

▸ Tread Softly

Day 18 since the transplant, 29 days in the hospital.
I spoke with Doctor Forman this morning. He is pleased with Rosina's progress, but is still cautious about her condition. He said that her marrow is doing really well and the numbers are way up, but this whole process must still be watched carefully. He wants her to stay in the ICU for now to make sure that her lungs are truly good, and stay on top of other things that need watching. So, tread softly.

Last night I sat on the edge of the bed at home, drank some water, pulled up the covers and adjusted the pillows. Right now, Rosina can't do any of these things. The six days that she spent "under" has made her very weak; she can't lift her arms. That's going to take some work to get that going, and she's having daily visits with a physical therapist. It's been difficult for her to talk, but that's getting stronger. Her new favorite activity is chewing ice, although she can't swallow the water. The doctor says that best case scenario, if all is going well, she'll be out in about three more weeks. We've always been told that there will be a big boring stretch of this hospital stay, let's hope it's starts soon!

Soon she'll be able to read the plethora of comments and notes and mail - thanks for all that.

xo
ph

Posted by pedro (peter) at 3:02 PM ✉ 8 comments ✉

Above is a typical entry. It is dated and has a title. In this case Peter chose a picture that provided a metaphor for Rosina's status. Every entry has one or more images. The gallery (right) samples the range of images: from images of the kids to shots from Peter's albums to current shots of the hospital.
Peter Hastings

FRIDAY, JUNE 15, 2007
▢ hair we go

The visual record of Rosina's haircut anticipated the effects of the drugs to come. Peter Hastings

Peter comments, "The camera sits on a rock. The digital SLR will stay open until it decides it has enough light. A person stands behind you with a flashlight and traces your outline. That person is moving too fast to get any real exposure of their body. The ambient reddish mist is from the campfire behind us." Peter Hastings

Peter's entry read, "Inspiration for Rosina. I'm repainting this Corcovado picture because I found the perfect companion for it—two things to look forward to seeing. Love you. ph"

Blog entry was "Mothers Day 2007."
Peter Hastings

COLLABORATIVE COOKBOOK: SHARING RECIPES VIA THE INTERNET

This is Cindy's "piano", the term that chefs use to describe each other's kitchens.

CASE STUDY: cindy & friends

Cindy Ryley is a Cordon Bleu–trained chef who for many years ran a catering business and food shop in Ottawa, Canada. Each summer she spends nearly three months in a nineteenth-century cottage that was dragged across the ice to her island home. A neighbor's children began calling her RiverAunt Cindy, and hence the name of her wiki, RiverAunts.

Something unique happens to people when they gather on the Upper Ottawa River. When they step onto one of the islands, worries and pressures seem to disappear as soon as the shoes come off.

Before anyone arrives for a visit, I begin to plan the meals. Each summer I focus on a couple of cookbooks, often to learn about new types of cuisine.

So while I'm at the cottage, I cook a lot! I spend much of my time in the kitchen, which has proven to be a wonderful gathering spot. It's a place to make pastry, peel vegetables, compare notes on favorite recipes, exchange ideas, and help each other prepare food. It's also where we can please our friends and family and where we also sing and laugh!

Unfortunately, we can't be on the islands together very often. The RiverAunts Web site will allow us to forget for a moment where we are and psychologically move across the mighty Ottawa River and settle into an inviting kitchen to share a wonderful new recipe. —CR

The Internet is a great tool to bring people together, no matter how far apart they are in real life. It also offers many ways for family and friends to share information, history, interests, and even recipes. Here, a family shares its love for cooking, eating, and a stretch of the Canadian North.

A wiki is an online software application and database that allows multiple users to create, edit, and link Web pages. Wiki is a generic name, and many different organizations offer them online. These free devices can be used by individuals, community groups, and businesses.

REQUIREMENTS

time: Five minutes to set up a wiki of your own. After that, there's a definite learning curve as you get familiar with the wiki layout and the procedures for adding new pages.

gear: PC or Mac with Internet access and an e-mail address, digital camera if you want to include photos.

space: All the files your group makes are saved online.

budget: Free! But if you want more memory space, more templates, more security, there are different fees you can choose, ranging from $100 to $1,000 per year.

WORKFLOW

Step 1: Set up and name your wiki. The PBwiki Web site promises:

"Your own ad-free wiki in 30 seconds." It's true. You simply plug the name you've chosen into a blank URL provided at the PBwiki home page. The URL for RiverAunts Cookbook is http://river aunts.pbwiki.com/. How easy is that?! After you've chosen a name, you only need an e-mail address to confirm the creation of the Wiki.

Step 2: Learn the ropes. There are some simple rules to learn. For the sake of security, you will be asked to establish a password for those contributing and editing. You can choose to make your site private or public. The RiverAunts chose the latter, so you are invited to visit. Note that there is a useful array of help offerings that lead you through the process, offer tips and tricks, and coax you to consider upgrading to a premium wiki.

TIPS For RiverAunts

1. TIPS For RiverAunts
2. How do I create a new page?
3. Tips for uploading images
4. How do I create a link?
5. More Help...

Aunts on a log (right). Special directions have been made for RiverAunts who are new to the Internet (left). CES Ryley

Step 3: Delivering the Goods. Upload the content. Too bad you can't upload smells and tastes!

Mat and Lucy's Wedding Cookbook - Cornbread

Mat and Lucy's Wedding Cookbook - Hell's Kitchen Chili

Emmy's Fabulous Roasted Green Beans

Catherine's Orechiette with Sausage, Cauliflower and Rappini

Plum Galette

SideBar

Main Menu

Intro

Recipes

River Gallery

Book Club

Travel Journal

About Us

Tips

Help

Share this

http://riveraunts.pbwiki.com/T

This is the raw Plum Galette

Cooked Plum Galette

This rustic tart is easy to assemble and can be made with different fruits: apricots, peaches, blueberries or apples. This recipe yields 6 servings.

Ingredients:
- 1 batch of pastry (see tomato tart recipe)
- 2 tbsp. cornstarch
- 1 ½ pounds of red or black plums
- 1 tbsp. butter
- ½ cup sugar plus 1 tablespoonful.

Steps:
1. Preheat the oven to 400 degrees.
2. Cut a piece of parchment paper slightly larger than a cookie sheet.
3. Roll out the pastry into a circle approximately 12 inches in diameter on the parchment paper and place on the cookie sheet. Place in the refrigerator while you prepare the plums
4. Slice the plums into a medium-sized mixing bowl.
5. Combine the cornstarch and flour in a measuring cup, mix well, and stir into the sliced plums.
6. Remove the cookie sheet from the refrigerator and pile the fruit into the center of the round of pastry leaving about 2 inches around the edge.
7. Fold the edges up to partially enclose the plums (you may need to pleat the pastry so that it will fold neatly). If possible try not to have any cracks through which the juices may escape. It does happen, however, and the parchment paper which could be folded up on the edges, should protect the cookie sheet and make it easier to remove the cooked galette.
8. Sprinkle the turned up edges of the pastry with granulated sugar and cut the butter in small pieces and distribute them over the plums
9. Place the cookies sheet containing the galette on the middle shelf of the preheated oven and bake for 50 - 60 minutes, or until golden brown.

Note: If using apricots the same quantities of fruit,sugar and cornstarch can be used. For a peach galette use slightly less sugar if the fruit is very ripe and sweet. Blueberry galette will use 4 cups of blueberries, ½ cup of sugar and 2 tablespoons of instant tapioca. An apple galette will require about 4 cups of sliced apples, 1/3 cup of sugar and 11/2 tablespoons of flour.

The photograph shows a plum and peach galette.

The main menu (bottom left) can be customized with categories you like. A selection of the recipes from the front page (top left). A post by RiverAunt Cindy (right).
Cindy Ryley

GALLERY

Recipes are only part of the site, although they are the main feature. There are a bunch of digital photographs of the family and friends who visit the stretch of the Ottawa River north of Pembroke, Ontario.

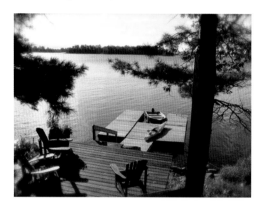

Two shots of the splendid, secluded river (top and bottom left). A map of the area (top right). The guys in this family (well, some) can also cook and have petitioned to be named and pictured as RiverAunts (bottom right).

Anne Kendall; map courtesy Petawawa township; Tim Ryley; Catherine Blake

WEBISODES:

YOUR OWN MELODRAMA, BASED ON SNAPSHOTS OF POSING FRIENDS

Julina on the set with two actors portraying the young lovers in Deep Creek. All the actors were volunteers from the Oxygen staff.

The project here asks you to invent your own soap-opera world, cast it with friends, and produce five or six Webisodes of twenty to thirty pictures each. This undertaking will be a challenge—no doubt about it. I suggest you team up with a friend.

CASE STUDY: julina

Julina Tatlock has most recently been a programming executive at Oxygen Media. But she got her start directing theater, making independent films, and producing interactive narratives such as this one. She lives in Brooklyn, New York, with her writer husband and three kids.

Our team went home one weekend with the assignment to come back with ideas for an online soap opera with no plug-ins and no broadband. Just HTML that would stream fast over dial-up connections. I came in on Monday and pitched a soap featuring two women running for mayor of Deep Creek (as in "Up the creek without a paddle"). Our three-person team then brainstormed the rest of the characters and a plot based on successful formula of soaps. Eventually we hired a professional soap writer and an artist to help with Photoshop and Illustrator.

Every episode had three storylines. We left one of these open ended and asked the audience to vote on what the outcome should be. The polls closed at the Oxygen Web site on Wednesday and a new episode had to be posted on Friday. We added a teenager who was portrayed on our slide show by one of the Oxygen staff. However we hired a real teenager to write daily diary entries on a blog and to answer questions and comments submitted by Web viewers. These interactive elements seem obvious now but blogging and voting was in its infancy at the time.

Our next step was building an audience. We approached AOL and because of their promotion, Deep Creek became heavily visited. The biggest thing I learned was the dual importance of a good story and easy accessibility —JT

REQUIREMENTS

time: Leave yourself a couple of days to write a script and figure out which of your friends will appear in it. As for shooting, we strongly suggest you shoot all the scenes in all the Webisodes over a day to two.

gear: A digital camera that can snap pictures in rapid order, a computer with Photoshop and Illustrator, and any blog or site that allows you to post slide shows. Forego a sound track. Note that Webisodes can also be distributed over the Web as QuickTime movies.

budget: There are very few out-of-pocket costs. You might want to get some pizza for the actors and some props.

WORKFLOW

Step 1: Write the story. Write what is called a *beat outline* of the storyline. This is a simple string of sentences that gives the plot points and suggests the series of photographs you will be taking. A good melodrama begins with a huge dramatic crisis that involves two or three characters. End each Webisode with a cliff-hanger. Don't be intimidated by the scripting phase. There are no lines of dialogue for actors to learn. Instead you are inventing a series of poses into which you will add thought balloons or another convention that represents short spoken phrases.

Step 2: Find actors. Think of who you can wrangle to be your soap stars and let their personalities inspire you. Remember that in melodrama, plot and physical action are dominant—don't go for subtlety. Instead go for big gestures, big story, big action. No acting is really involved, just posing for the camera and a willingness to look silly.

Step 3: Shoot stills. For each scene in your story, you will need just a few shots, so choose them carefully. Shoot your actors against a solid-color, evenly lit background, because this makes it easier to select your actors in Photoshop and put them onto a new background. Try not to crop your actors as you shoot

The series title set the graphic style: bold primary colors, graphics, and stylized photographs.

Julina used a digital still camera to shoot the source photos against a green-screen background. The green background made it easy to cut out the characters. Illio Krumins-Beens and Christy Zelling had fun with their roles.

the setups. Leave space at right and left for dialogue bubbles. With each new location, begin with an establishing shot, a wide shot that shows all the actors and their relative positions to each other.

Step 4: Compose rough layouts. Import the stills into your computer and study which ones will go with each part of your story. Refer back to the beat outline and keep the story moving forward. Think about what viewers need to see to understand and follow the story.

Step 5: Write dialogue. Write short, clever dialogue for each scene. Use vocabulary that reveals something about the personalities you're creating.

Step 6: Photoshopping. Make outlines of each character (use the Trace Tool in Photoshop described in Chapter 2). Use high contrast to simplify the lines you will trace. Then simplify more. Silhouettes are very effective.

Step 7: Use Illustrator. When the characters and screen dialogue are in place, it's time to create very abstract and stylized backgrounds. Illustrator is a good tool for this job. Keep backgrounds simple. One or two details can establish a location. Don't forget to design a great title card and series logo (see type ideas in Chapter 3).

Step 8: Premiere your series. Send this series, one a week or one a day, to a mailing list of your friends. Let the last episode end with the best cliff-hanger yet. Maybe you will want to give the last frame in the last Webisode a graphic that reads like this: "Will John and Mary find true happiness? Let me know if you want to stay tuned . . ." At this stage you get to do what all Hollywood and TV executives do: sit back and wait for the judgment of your audience.

When art directing "Deep Creek," we studied the way comic books use thought balloons to carry dialogue. We chose a simpler version (above). Webisodes need lots of frames that cue the viewer about location and time

Photoshop's Brush Tool was used to create outlines and silhouettes.

Backgrounds should use limited colors to keep file sizes small. These images sample how each location had its own color palette. Illustrator was used to draw and size the elements that make up the backgrounds.

GALLERY

"Deep Creek" had a huge run on Oxygen's Web site as a featured property. It was "very sticky" at AOL. The serial was marketed as a juicy soap with plenty of secrets: voting fraud, adultery, extortion, secret love, black magic, teenage craziness. The eight panels here are from the project's launch episode.

The location and main characters are quickly established (frames 1 and 2). One of the few crowd scenes shows the town's voting polls (frame 3). There is room for straight visual storytelling in this medium (frames 4 and 5). An exchange of dialogue between the seventeen-year-old daughter of the mayor and her trusted twenty-five-year-old political aide (frames 6, 7, and 8). Note how vector graphics permit blow-ups.

The creative team included Julina Tatlock, producer/director; Sean Lightner, lead programmer; Brit Payne, lead animator; Scott Collishaw, writer; Amy Huelsman, illustrations. Dori Berinstein and Kit Laybourne were the executive producers.

DIGITAL STORYTELLING:

HOW OFT-TOLD STORIES BECOME POLISHED SHORT MOVIES

Stuart is a Steven Spielberg look-alike. Here he and Kit are viewing the Thanksgiving Day parade.

Teri Scheinzeit

The fundamental assumption behind digital storytelling is that each of us has many stories we've told over and over again. In their retelling, these narratives become polished, like a small stone in a fast-moving stream. Only the most significant details remain. The often-told story's pace is usually quick, because dragging portions have been eliminated over the course of many tellings. Such stories always have a "capper"—an ending that evokes a laugh or a nod of recognition to a fundamental insight.

CASE STUDY: stuart

Stuart Dworeck is a TV editor with a special gift for animation. At the Oxygen Cable TV network, Stuart developed "Our Stories"—short segments in which ordinary women recorded tracks and sent photos that a team assembled using digital animation techniques.

When we started "Our Stories" for Oxygen Media's Web site in 1999, it was meant to be a place where women who didn't have access to Big Media (broadcast and cable TV) could present their own stories. At Oxygen we were exploring the concept of co-creation. That's where the audience creates content along with the media professionals. Usually when making documentaries and TV shows, we did it to our subjects; now we could do it with our subjects. By having the subject of the story become the active storyteller, the stories would be real, first-person experiences.

One of the first women I worked with told a difficult story about the life and death of her beloved grandmother. After we finished, she said the storytelling process helped her deal with the sadness she felt from her grandmother's death. But the capper for me was when she told me that during our work together was the first time she felt anyone was really listening to her. That's as good as any Emmy Award could ever be in my book.—SD

REQUIREMENTS

time: Writing and rewriting takes about two hours; recording, one hour; taking original photographs, about one hour; scanning archival images—if there are any—one hour. Editing will take as long as you can manage, or as long as needed. This is where you learn the most, and you may discover "holes" that need to be filled.

gear: A digital camera, access to a scanner, a program like iMovie for the Mac or Premier for the PC, a recording setup. See Chapter 5 for details about slide-show applications and techniques.

budget: There could possibly be costs in buying music you want to use.

WORKFLOW

Step 1: Find the story. Your story need only be awakened. But how to do that? Ask a family member, friend, or partner what story he or she has heard often and likes best. Look at old photos or objects around your home or office.

Step 2: Write the script. Put the story into the first person. The script should be no more than 250 words. Here are six characteristics of such personal stories:

- **First person authenticity.** This gives it instant credibility because it really happened to the teller.
- **To the point.** Extraneous detail as been eliminated via the editing that comes with repeated telling.
- **Deep meaning.** Those remaining descriptions have deep meaning.
- **Few, key characters.** There are few characters, but those we meet are important.
- **Dramatic payoff.** The story evolves into a satisfying ending.
- **Built-in wisdom.** There is a "lesson" that is sometimes explicit, sometimes implicit.

The maximum length of the finished piece is two minutes. The project is powered by specific constraints that focus creative energy and heighten the impact. The most important rule is the absolute, rigid, fanatical limit of 120 seconds.

Step 3: Do a dramatic reading. Your movie is built upon a first-person account. Start by making a digital recording of your own voice. Give a spirited reading. Don't be afraid to act out different parts. Have a friend around to give feedback and encouragement. Lock the track, getting it down to two minutes or a bit under. This track will guide selection, duration, and transitions among

the stills. A second track with music can be added later. Also, anticipate adding some sound effects.

Step 5: Use images as filler. My observation from hundreds of digital stories is that audio carries the dramatic flow. The pictures can be directly representative of the story, or they can be somewhat more abstract, creating something that holds the eye while the ears receive the deeper message. Steer clear of appropriated photos ripped from the Web or scanned from printed sources.

Step 6: Edit. Even with a short slide show, it makes sense to follow the guidelines that hold for editing any production. First, make a rough cut. This will show beginning, middle, and end. It ought to be no longer than three minutes. Second, make a fine cut. The voice track and the accompanying images are locked: Transitions and special effects are added. The fine cut is a good time to invite some fresh eyes to view the work. Add music and sound. But before you finish . . .

Step 7: Titles are key, but keep them short. A show title at the beginning should stay on screen for two to three seconds. It plays a powerful role in orienting your audience, so choose the words well. An "end credits" sequence can be placed at the tail of the piece. Resist the urge to thank your mother, unless she is in it or she is a funder!

Step 8: Output and upload. Your movie or slide show should be saved as a QuickTime file that compresses the visuals and audio for use on the Internet. E-mailing a compact version to friends will earn you lots of points!

GALLERY

Although digital storytelling may appear extremely structured in terms of its constraints, the work that results can be dazzling in its variety of tone and subject. See for yourself by going to mediapedia.net and linking to the four shows sampled in these pages. Even without seeing the movies, you can get a feel for these authentic voices.

"THE PUMP" FROM OXYGEN'S "OUR STORIES" SITE (1:30)

In this Webisode, Dworeck collaborated with Lette, the narrator, to build an amusing, spirited piece. Oxygen's Web site no longer accesses the series of the thirty "Our Story" shorts that were originally produced.

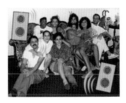

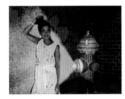

Accompanying an informal retelling of the summer incident, these key frames establish a hot night and a birthday party. Things are getting hot inside, so our heroine, Lette, remembers "the pump," the fire hydrant plus neighborhood "pool." She and friends go outside and get cool. Lette has a momentary fear that the cops will come, but her pals tell her not to worry: "You're in the ghetto!" Stuart Dworeck, producer/editor; Kimberly Mercado, associate producer/interviewer; Dorelle Rabinowitz, visual director; Kit Laybourne, executive producer

"Looking For" by Ivan Becerra (2:00)

I have collected dozens of two-minute digital stories from my students at The New School. Many are intensely personal, sometimes dealing with past traumas. Many go for comedy, with a droll and spirited retelling of an embarrassing incident. The one I have chosen here combines a bit of both.

 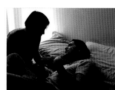

The first half of Ivan's story tells of an antique he buys on impulse, although he and his wife cannot afford it. That night the empty armoire/bureau comes to life, terrifying Ivan in his sleep. The movie goes on to explore the anxieties from childhood evoked by the haunted piece of furniture. Ivan Becerra

"Scissors" by Daniel Meadows (2:12)

In the spring of 2001, the BBC funded a project called "Capture Wales," which brought digital storytelling to television and radio. The leader of this project and a powerful storyteller in his own right is photographer and teacher Daniel Meadows. Visit his site at www.photobus.co.uk. There you will find some great stories and some thoughtful writing about the digital storytelling process. Also browse the Capture Wales site at www.bbc.co.uk/capturewales/. The many stories produced by ordinary citizens of Wales are organized by five thematic categories: challenge, community, family, memory, and passion.

Daniel Meadows's autobiographical piece is a reflection on time and family. It begins with images of Daniel, including one where his face is pushed against the glass of a Xerox capture window. He talks about a family album with a lock of his hair carefully saved by his mother in a handmade envelope. The story then shows the only existing picture of Daniel's father, who went out for a pack of cigarettes one day and never returned. Daniel ends with a question: Were the scissors that cut his hair the same ones that cut his father out of the group photo? Daniel Meadows

"Wish You Were Here" by Teri Scheinzeit (2:56)

Stuart Dworeck writes:

Sedona, Arizona, known for its New Age psychic sites, was also known for a while as the home of the Digital Storytelling Festival. Kit and I presented our work one year and, the next year, I returned to attend the festival with my wife, Teri Scheinzeit. One day during some festival downtime, she took off to explore Sedona's "other worldly" sites. Although Teri had never done a digital story before, she is a singer/songwriter and took right away to the slide show form. I helped with the production. It's all her story, though, with original music.

Teri recounts a hike with a new-age trail guide. We learn her mother has died and that Teri has been reading about her own sense of loss (frame #3). Teri's hike is long and exhausting (frames 5, 6 & 7). But along the way her mother's voice speaks clearly with some characteristically pragmatic advice. Teri Scheinzeit

FURTHER READING AND RECOMMENDED WEB SITES

What kind of learning set-up suits you? That's a big question. The answer seems like it should be obvious, but often it's not. We spend years in school and in the workplace being taught new skills, yet it requires precise self study to figure out how we respond to the different sorts of learning aids available for the ever-advancing world of digital media. There are four obvious options for training and retraining yourself: (1) Online help: It comes in every application. Often there is a search window or, better, an "ask a question" function. (2) Tutorials: Many applications offer step-by-step case studies carefully formulated to lead you through the features and protocols of a program. My problem with these is that the case studies are usually deathly boring. (3) Books: There is a vast library of soft-cover volumes that provide how-to information about all the major applications of computer graphics. These range widely in their editorial/pedagogical approaches. Spend time at a bookstore considering which type feels easiest to move around within.

(4) Online instruction: The Internet provides help that comes in different flavors, too, including "movies" that show a computer screen being operated by an instructor whose voice track leads you through an application. This is my own favorite way to learn software.

There is one more critically important option. (5) Community: The best resources are people. The family member (often younger) who knows more than you. The techie at your computer store or workplace. The friends you make through online discussion groups. People you get to know through classes and workshops about digital media.

The resources that follow start with three volumes about design and creativity in general. I strongly recommend you treat yourself to one or two of these, for they will nourish every aspect of your own work. Resources are then organized according to chapter categories. Mediapedia.net—this book's companion Web site—has a far more comprehensive collection of resources. Each entry is annotated and

initialed by the reviewer. The site will be getting bigger and better as folks like you share favorite books, journals, organizations, and links.

The limited space here requires a highly personal compilation. There was no other way to whittle down lists of lists into just a few pages. So I am going with resources that have shaped my own thinking about personal media and that I found myself revisiting as I worked on this volume.

CREATIVITY AND COMPUTERS

Lidwell, William, Kritina Holden & Jill Butler, *Universal Principles of Design,* RockPort Publishers, 2003. This volume covers the core precepts of design—not just graphic or media design, but design in its broadest range of disciplines. Very smart and beautifully presented. Its subtitle: "100 Ways to Enhance Usability, Influence Perception, Increase Appeal, Make Better Design Decisions, and Teach Through Design."

Maeda, John, *The Laws of Simplicity,* MIT Press, 2006. This is the epitome of design thinking: clear, focused, useful, and elegant. Four simple words on the book's cover point to the worlds it speaks most clearly to: Design, Technology, Business, Life.

McKim, Robert H., *Experiences in Visual Thinking,* PWS Publishing, 1980. In the intro to his seminal book, Robert McKim writes, "One way to use this book is to view it as a manual of alternative strategies for expanding the power and range of your thinking." Every exercise in each chapter is a strategy that can be applied to any problem.

Organizations

American Institute of Graphic Artists: www.aiga.org. The largest of professional associations with membership and also general education resources.

Cooper-Hewitt National Design Museum: www.cooperhewitt.org. Located on 5th Avenue in NYC, it is a dynamic museum working in all aspects of design. Check out Education, National Design Awards, and store with Design Books.

Periodicals

***How* magazine:** www.howdesign.com. How magazine has expanded to offer events, conferences, competitions and digital products—all for the professional designer. Good coverage of technology.

CMYK **magazine:** www.cymkmag. com. A quarterly collection of student work in illustration, photography, design, web design. Mission is "Inspiring Visual Communication."

Digital Photography

Daly, Tim, *The Digital Photography Handbook,* Amphoto Books, 2003. Nicely layed out and proves a thorough overview to the digital technology of modern still cameras.

Grover, Chris & Barbara Brundage, *Digital Photography,* Pogue Press/ O'Reilly, 2006. This is a volume in the excellent line of how-to books called The Missing Manual Series, which is edited by *New York Times* media critic David Pogue. This volume covers both shooting and image processing.

Digital Cameras Hardware/ Evaluations

Digital Photography Review: http://dpreview.com

Digital Camera Resource Page: www.dcresource.com

Camera Tutorials

Jodie Coston's Free Online Photography Course: www.morguefile. com/archive/classroom.php

Lynda.com online training library: www.lynda.com

Short Courses.com—library of Digital Photography: www.short courses.com/using/index.htm

Stock Libraries

iStockphoto: www.istockphoto .com

Getty Images: www.gettyimages. com

Corbis Images: www.corbis.com

Free Photo Bank: www.freephoto bank.org

Library of Congress Digital Collections: www.loc.gov/library/ libarch-digital.html

History of Photography

Masters of Photography Site: www.masters-of-photography.com/

American Photography TV series: www.pbs.org/ktca/american photography

Smithsonian Photography Initiative: http://photography.si.edu

IMAGE EDITING

Adobe Creative Team, *Photoshop CS3 Classroom in a Book,* Adobe Press, 2007. The Adobe CS3 Bookstore features books on all the apps, plus demo videos and free downloadable tutorials. There are over 10,000 titles about Photoshop.

Dayton, Linnea & Cristen Gillespie, *The Photoshop CS/CS2 Wow! Book.* **Peachpit Press, 1998.** At just under 800 pages, this is a most complete and most skillful designee book. There are color prints on every page.

Giordan, Daniel, *The Art of Photoshop, Sams Publishing,* **2006.** Striking gallery of images constructed within the digital darkroom. Includes some step-by-step breakdowns.

Software

Photoshop CS3 Editions (Adobe): www.adobe.com/products/photoshop

Picasa (Google): http://picasa.google.com

Photosmart Essentials 2.5 (Hewlett Packard): www.hp.com/united-states/consumer/digital_photography

Paint.net: www.getpaint.net

Plug-Ins

Third-party plug-ins for Photoshop: www.adobe.com/products/plugins/photoshop

Free Photoshop-compatible plug-in: http://thepluginsite.com/resources/freeps.htm

Galleries

Photoshop Contests & Galleries: www.worth1000.com/default.asp?display=photoshop

On-Line Tutorials

Lynda.com—17 training movies for PS: www.Lynda.com

Photoshop Tutorials Plus: www.photoshop-tutorials-plus.com

Photoshop 262 tutorials: www.photoshoptalent.com/photoshop-tutorials

TYPE AND LAYOUT

Heller, Steven and Seymour Chwast, *Graphic Style: From Victorian to Digital,* **Abrams, 2001.** The authors are heavy hitters in the design world. The volume traces the evolution of visual style. It provides a great perspective for spotting today's emerging trends. Besides scads of great examples, this book has a dense but discerning text.

Leborg, Christian, *Visual Grammar,* **Princeton Architectural Press, 2006.** An elegantly conceived and simply illustrated book that offers a fresh look at the most basic elements of visual design. "Visual language has no formal syntax or semantics, but the visual objects themselves can be clas-

sified," writes the author. Mr. Leborg, a Norwegian designer, does just that.

Lupton, Ellen, *Thinking with Type,* Princeton Architectural Press, 2004. The book divides typography into 3 sections: letter, text, and grid. Each begins with a short and erudite history. The volume is a manifesto for consideration of design in general as the interface for the current digital transformation of culture. Highest possible recommendation. And a fun read.

White, Jan V. *"Editing by Design." * R.R. Bowker, 1974. This volume was written before the digital era and is helpful because of it. The focus is on magazine layout—a discipline that closely parallels Web design and many domains in desktop publishing. A comprehensive primer on everything that type and layout can be.

Software

InDesign CS3 (Adobe): www.adobe.com/products/indesign

Word (Microsoft Office 2007 for PC): www.office.microsoft.com

Mactopia (Microsoft Office 2008 for Mac): www.microsoft.com/mac/default.mspx

Snap X Pro screen capture: www.ambrosiasw.com/utilities/snapzprox

Fonts

Émigré digital type foundry: www.emigre.com

Font shop: www.fontshop.com

Urban Fonts: www.urbanfonts.com

Fonts N' Things: www.fontsnthings.com

Font Pool: www.fontpool.com www.acidcool.com

On-Line Tutorials

Sessions online School of Design: www.sessions.edu/courses/All_couses/LogoDesign.asp

InDesign CS3—5 training movies: www.lynda.com

ILLUSTRATION

Cross, David & Matt Kloskowski, *Illustrator CS2 KillerTips,* New Riders, 2006. Jammed with hundreds of useful "tips" for Illustrator users of all levels. Each tip is about a half a page, visually annotated, and ranges from the fun to the practical. The middle of the book includes a small gallery of Illustrator artists working in the field and links to their personal sites.

Dodson, Bert, *Keys to Drawing,* North Light Books, 1990. There are many books that introduce the particular ways of seeing and the rendering techniques that artists use.

This one focuses on pencil drawings seen through the eyes of a wonderful teacher, Bert Dodson. I have a library of such books and this is my favorite.

Montague, John, *Basic Perspective Drawing,* John Wiley & Son, 2005. Through simple drawings, the author provides extremely accessible, yet comprehensive instructions on how to construct perspective views. This is a topic that confounds many for it seems so counterintuitive. A practical guide to the optical world and how it works.

Steuer, Sharon, *The Illustrator CS3 Wow! Book,* Peachpit Press, 2007. This won awards as the Best Computer book. Almost 450 pages. Very clearly conceived and beautifully produced. Disc included.

Software

Illustrator CS 3 (Adobe): www.adobe.com/products/indesign/ Corel Graphics Suite

Windows Vista Paint (Microsoft): http://windowshelp.microsoft.com

Paint Shop Pro (Corel): http://store.corel.com

Corel Painter (bitmap) & Corel Draw (vector): www.corel.com

Clip-Art

Corbis Stock Photo Search: http://www.fotosearch.com/corbis

Dover Publications: http://store.doverpublications.com/index.html

Getty Images: www.gettyimages.com

iStockphoto: www.istockphoto.com

On-Line Tutorials

Lynda.com—7 Training Movies for AI CS3: movielibrary.lynda.com

SLIDE SHOWS

Plummer, Mary, *Garage Band 3,* Peachpit Press, 2006. Why not be creative all the way, including music track? Apple's Garage Band is a secret weapon for slide show audio tracks. Especially helpful are sections about Creating Pod casts and scoring an iMovie or QuickTime video.

Lambert, Joe, *Digital Storytelling: Capturing Lives, Creating Community,* Digital DFianer Press 2002. This volume is based on the author's experiences developing the Digital Storytelling Workshop, which has been offered around the world, helping to create more than 5,000 video works. The volume is both pragmatic and vision-

ary in its passion for democratizing the new media. Lambert is co-director of the Center for Digital Storytelling in Berkeley, California.

Software

iMovie (Apple): www.apple.com/ilife/imovie

Garage Band (Apple): www.apple.com/ilife/garageband

Apple QuickTime (Apple): www.apple.com/quicktime

Power Point Home Page (Microsoft): office.microsoft.com/en-us/powerpoint/default.aspx

Windows Movie Maker (Microsoft): www.microsoft.com/windowsxp/using/moviemaker

Premiere (Adobe): www.adobe.com/products/premiere

Logic Express (Apple): www.apple.com/logicexpress

Audacity: The Free, Cross-Platform Sound Editor: http://audacity.sourceforge.net

On-Line Tutorials

Lynda.com—6 Training Movies for Power Point: http://movielibrary.lynda.com; 3 Movies for iMovie; 6 movies for Power Point; Mov-ies for GarageBand; 2 Movies for QuickTime; 7 Movies for Premier; 1 Movie for Movie Maker.

PowerPoint—Help and How-To: http://office.microsoft.com/en-us/help/default.aspx

Galleries

BBC's Capture Wales Project: www.bbc.co.uk/capturewales

Tech Head Stories: http://tech-head.com/dstory.htm

"Jody Saddles Up" (slide show): Mediapedia.net

DISPLAY AND DISTRIBUTION

Studio 7.5 (Carola Zwick, Burkhand Schmitz, Kerstin Kuhl), *Designing for Small Screens,* **AVA Publishing, 2005.** Demonstrates (very convincingly) how the user interface of small devices requires a unique set of software strategies. The authors are members of an international design team located in Berlin, Germany.

Software

Acrobat 8 and Reader 8 (Adobe): www.adobe.com

iDVD (Apple): www.apple.com/ilife/idvd

InterVideo WinDVD 8 Platinum (Corel): http://store.corel.com/webapp/wcs/stores

Online Hosting, Printing, Storage and Swag

Flickr: www.flickr.com

Kodak Gallery: www.kodakgallery.com

Shutterfly: www.shutterfly.com

Snapfish: www.snapfish.com

Zazzle: www.zazzle.com

YouTube: www youtube.cm

Vimeo: www.vimeo.com

4 Over 4: 4over4.com

Myspace.com: www.myspace.com

Facebook: www.facebook.com

Blogger: www.blogger.com

Live Journal: LiveJournal.com

Word Press: www.wordpress.org

Tumblr: www.tumblr.com

Wikipedia: www.wikipedia.org

PB Wiki: www.pbwiki.com

Del.icio.us: www.del.icio.us

Google: www.google.com

Epson Printers: www.epson.com

PROJECT IDEAS

Lupton, Ellen, editor, *D.I.Y. Design it Yourself,* Princeton Architectural Press, 2006. Written by students and faculty at Marland Institute College of Art (MICA) and edited by Ellen Lupton. A nice section on the theory behind the DIY (Design-it-Yourself) movement. Twenty-eight categories ranging from business cards to t-shirts to zines. See also www.designityourself.org.

Sites/shows referenced in Case Studies

Fontifier (personal handwriting on a computer): www.fontifier.com

"Rosina's Roadtrip": www.Rosinasroadtrip.blogspot.com

Digital Storytelling slide shows

"Scissors": www.photobus.co.uk

"The Pump": mediapedia.net

"The Armoire": mediapedia.net

"Wish You Were Here": mediapedia.net

"Deep Creek" video: mediapedia.net

INDEX

A

abstract photography, 17
action photography, 17
aliasing, 100
alignment, 124
alphabets, 103
anchors, 150–52
anti-aliasing, 100
applications
 display and distribution,
 228–31
 illustration, 168–69
 image editing, 86–89
 images, 52–55
 slide shows, 203–7
 type and layout, 127–29
art, clip, 139
art, display, 139
art, spot, 138
artifacting, 63
artsy/designy structure, 191
asymmetrical resizing, 161
asymmetry, 115
auto focus, 41

B

balance, 115
binary system, 19
bipod bias, viii–ix, 26
bitmap graphics, 134
bitmaps, 134–35
bits, 20, 21
blending, 81
blendo, 61
blogs, 219–21

blur, 43–45
blur, intentional, 45
borders, 77
boundries, 142
bracketing, 31
brightness, 71–74
brush tool, 155
bytes, 20

C

call outs, 126
calligraphy, 102
camera position, 27
camera shake, 45
cameras
 digital, 9
 lens choice, 28–29
 overview, 8–9
 still-camera anatomy, 10
 system, 11–12
captions, 126
CD-ROMs, 222–24
CDs, 222–24
charts, 138
chunking, 94–95
classifications of font, 107
clip art, 139
cloning, 81
collages, 60
color, 71–74
color blends, 159
color theory, 71
compositing images, 60–61
composition, 38–39, 114–21
compression of files, 84–85
compression schemes, 85
containers, 166
contrast, 116

contrast ratio, 32
creativity, viii
cropping, 37, 69
cropping, freeform, 79

D

data, measuring, 84
deep focus, 42
depth, illusion of, 144
depth of field, 40–42
design, 93–94, 176–77
desktop printing, 211–13
diagrams, 137
dingbats, 111
direction, 118
display
 applications and file for-
 mats, 228–31
 branding, 210
 CDs, CD-ROMs, and DVDs,
 222–24
 desktop printing, 211–13
 file naming protocol,
 226–27
 online storage, galleries,
 and publishing, 216–18
 overview, 210
 project, 232–33
 services outside the home,
 214–15
 social networks, Web sites,
 blogs, and wikis, 219–21
 swag, 225
display art, 139
display size, 64
distribution
 applications and file for-
 mats, 228–31

branding, 210
CDs, CD-ROMs, and DVDs, 222–24
desktop printing, 211–13
file naming protocol, 226–27
online storage, galleries, and publishing, 216–18
overview, 210
project, 232–33
services outside the home, 214–15
social networks, web sites, blogs, and wikis, 219–21
swag, 225
documentary structure, 190
dramatic agency, 25
drawing conventions, 140–45
drawings, technical, 137
drop shadows, 79
duotones, 73
duration, slide show, 195
DVDs, 222–24

E

edge treatments, 77–79
exposure, 30–33

F

feathering, 78
figures, 117
file formats
 applications and layout, 127–29
 display and distribution, 228–31
 illustration, 168–69

image editing, 86–89
images, 52–54
 slide shows, 203–7
fills, 76, 158–59
filters, 83, 164
fish eye lenses, 29
flash units, 50
flipping images, 70
focus, 40–42
focus, auto, 41
focus, deep, 42
focus, selective, 41
focus, soft, 40
folds, 123
font families, 109
font styles, 109
fonts, 106
fonts, classifications of, 107
formats, page and screen, 123
frames, 78
framing, 34–37
framing, in-camera, 36
framing, panoramic, 35
framing, standard, 34
freeform cropping, 79

G

galleries, online, 216–18
global manipulations, 69–70
glyphs, 108
gradient mesh, 159
gradients, 76, 159
graphic styles, 164
graphics, bitmap, 134
graphics, vector, 135
graphs, 138
grid systems, 125

ground, 117
groupings, 119

H

handles, 150–52
handmade letters, 111
headers, 124
highlighting, 101
histograms, 73
hue, 72

I

icons, 136
illusion of depth, 144
illustration
 anchors, handles, paths and strokes, 150–52
 applications and file formats, 168–69
 bitmaps vs. vectors, 134–35
 drawing conventions, 140–45
 fills, 158–59
 inputting, 146–47
 kinds of, 136–39
 overview, 132–33
 project, 170–71
 scaling and manipulations, 160–61
 special effects, 162–65
 tool selection, 153–55
 tracing with Illustrator, 156–57
 type and text, 166–67
 vector-based, 148–49
illustration, vector-based, 148
Illustrator, 156–57
image, type as, 105

image editing
 applications and file for-
 mats, 86–89
 color and brightness, 71–74
 compositing, 60–61
 compression of files, 84–85
 doctoring, 80–82
 edge treatments, 77–79
 filters, 83
 global manipulations, 69–70
 layers, 75–76
 overview, 58
 Photoshop vs. Photoshop
 Elements, 59
 Photoshopping, 58–59
 project, 90–91
 resolution and resizing,
 62–65
 selecting parts of pictures,
 66–68
images
 applications and file for-
 mats, 52–55
 blur, 43–45
 color vs. black and white,
 46–48
 composition, 38–39
 digital advantages, 3–4
 exposure, 30–33
 focus and depth of field,
 40–42
 framing, 34–37
 kinds of, 14–17
 light, 22–25
 lighting setups, 49–51
 optical illusions, 5–6, 7
 overview, 3

points of view, 26–27
principles of, 4–5
projects, 56–57
visual thinking, 6–7
in-camera framing, 36
indents, 124
intent, photographer, 27
intentional blur, 45
ISO, 33
isolation of objects, 66

K

kerning, 110, 167

L

landscape photography, 16
layers, 75–76
layout
 applications and file for-
 mats, 127–29
 composition and, 114–21
 elements of, 122–26
letters, 102–5
 overview, 98
 project, 130–31
 structure, 112–13
 style and, 98–99
 text, 100–101
 typography, 106–11
leading, 110, 167
legibility, 100
lens choice, 28–29
letterforms, 103
letterforms, computer, 105
letters, 102–5
letters, anatomy of, 104
letters, handmade, 111
light, 22–25

light, reflected, 24
light quality, 22
lighting effects, 74
lighting gear, 51
lighting setups, 49–51
lighting techniques, studio, 50
linear perspective, 145
lines, 141
logos, 137

M

macro lenses, 29
manipulation of illustrations,
 160–61
margins, 124
masking, 67
megapixels, 13
mirroring, 119
monitor resolution, 65
monochromatic images, 48

N

narrative structure, 189–90
nature photography, 16
negatives in image, 117
normal lenses, 28

O

objects, isolation of, 66
overall cast, 72

P

page
 aesthetics, 96–97
 design, 93–94
 overview, 93
 simplicity and, 95–96

skimability, first read, and chunking, 94–95
painting, 234–35
panoramic framing, 35
paths, 150–52, 166
pattern fills, 158
pen tool, 154
pencil tool, 154
photographer intent, 27
photojournalism, 15
Photoshop, 58–59
pixels, 18–19
planes, 142
point of view, 26–27
points, 140
portraiture, 16, 56–57
position, 118
positives in image, 117
print resolution, 64
projects, ix–x
 Binding Relationships, 248–51
 Blogging, 260–63
 Collaborative Cookbook, 264–67
 Design A Font, 240–43
 Digital Storytelling, 272–77
 Gone But Not Forgotten, 244–47
 ideas, 235
 Landscape Tweaks, 256–59
 overview, 234
 Pattern In Space, 252–55
 Rogues' Gallery, 236–39
 sketching vs. painting, 234–35
 Webisodes, 268–71

publishing, online, 216–18

R
red-eye repair, 82
reflections, 161
reflectors, 51
refraction, 24
repeating patterns, 39
repetition, 120
resizing, 62–65
resizing, asymmetrical, 161
resolution, 13, 62–65
rhythm, 121
rotating images, 70
rotations, 161
rule of thirds, 38

S
saturation, 72
scaling, 160–61
screen resolution, 63
screen structure, 189–93
scrolling, 123
selective focus, 41
sepia, 47
shadows, 23
sharing
 design and, 176–77
 overview, 173–75
 slide shows, 178–80
sharpening images, 68
shearing, 161
shutter speed, 43
silhouettes, 25
simplicity, 95–96
size, 116
size contrast, 39
sketching, 234–35

skimability, 94–95
slide shows
 applications and file formats, 203–7
 audio, 200–202
 in-frame movement, 196
 overview, 178–80
 project, 208–9
 screen graphics, 198–99
 screen structure, 189–93
 timing and rhythm, 194–95
 transitions, 197
 types of, 181–88
slide shows, picture-driven, 184–85
slide shows, story-driven, 186–88
slide shows, text-driven, 182–83
social networks, 219–21
soft focus, 40
softening images, 68
solarization, 48
solid fills, 158
solids, 143
special effects, 162–65
sports photography, 17
spot art, 138
storage, online, 216–18
street photography, 15
strokes, 150–52
stroking, 167
structure, 112–13
structure, artsy/designy, 191
structure, documentary, 190
structure, emotional, 192
structure, narrative, 189–90

studio lighting techniques, 50
style sheets, 125
subject, speed of, 44
swag, 225
symbols, 136
symmetry, 115

T

technical drawings, 137
telephoto lenses, 29
text, 100–101, 166–67
text blocks, 101
thumbnails, 122
tiling, 165
timing, 194–95
toning, 73
tracing, 156–57
transforming, 80
transparency, 76

transparent fills, 158
triangulation, 49
type
 applications and file
 formats, 127–29
 composition and, 114–21
 illustration and, 166–67
 letters, 102–5
 overview, 98
 project, 130–31
 style and, 98–99
 text, 100–101
type as image, 105
type outlines, 167
typography, 106–11

U

user's guide, x–xiii

V

value, 72
vector graphics, 135
vectors, 134–35, 148–49
visual frequency, 121

W

white balance, 46
white space, 120
wide-angle lenses, 28
wikis, 219–21
wingdings, 111

Z

z axis, 143
zoom lenses, 29